Aftermath

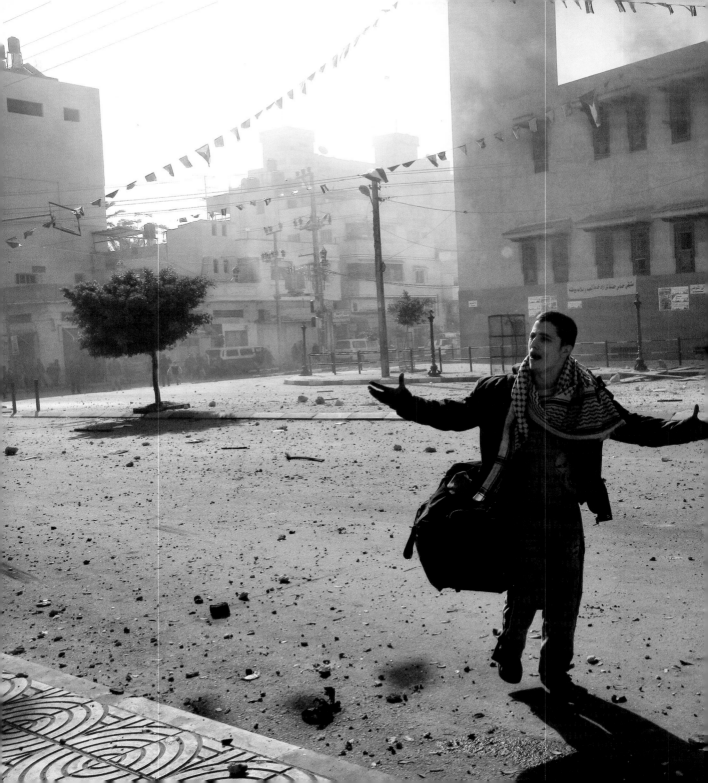

Aftermath

The Fallout of War—

America and the Middle East

Edited by Carol McCusker

Samuel P. Harn Museum of Art

University of Florida · Gainesville

Frontispiece: Eman Mohammed, *Anguish outside Al Saraya police compound, December 28, 2008*

Dedication: Gloriann Liu, *Mohammed and Daughter, Dara, Irbid, Jordan, December, 2012*

Table of contents: Rania Matar, *Hanging Towel, Aita El Chaab, Lebanon, 2006*

Copyright © 2016 The University of Florida Board of Trustees for the benefit of the Samuel P. Harn Museum of Art

All rights reserved

All photographs are courtesy of the artists unless otherwise noted.

Printed in Canada on acid-free paper

21 20 19 18 17 16 6 5 4 3 2 1

Library of Congress Cataloging-in-Publication Data
Names: McCusker, Carol, editor.
Title: Aftermath : the fallout of war—America and the Middle East / edited by Carol McCusker.
Description: Gainesville : Samuel P. Harn Museum of Art, University of Florida, [2016] | Includes bibliographical references.
Identifiers: LCCN 2016020208 | ISBN 9780983308546 (pbk.)
Subjects: LCSH: War photography. | Documentary photography. | War and society—Pictorial works. | United States—History—20th century—Pictorial works. | Middle East—History—20th century—Pictorial works. | War—Pictorial works.
Classification: LCC TR820.6 .A34 2016 | DDC 779—dc23
LC record available at https://lccn.loc.gov/2016020208

Production by the University Press of Florida

Design and composition by Louise OFarrell

Published by the Samuel P. Harn Museum of Art
University of Florida
3259 Hull Road
Gainesville, Florida 32611-2700

www.harn.ufl.edu

This catalogue was published in conjunction with the exhibition *Aftermath: The Fallout of War— America and the Middle East*, organized by the Samuel P. Harn Museum of Art, University of Florida.

SAMUEL P. HARN MUSEUM OF ART
University of Florida, Gainesville, FL
August 16, 2016–December 31, 2016

GUND GALLERY
Kenyon College, Gambier, OH
January 2017–April 2017

THE JOHN AND MABLE RINGLING
MUSEUM OF ART
State Art Museum of Florida / Florida State University, Sarasota, FL
September 2017–January 2018

Aftermath: The Fallout of War—America and the Middle East exhibition and catalogue were made possible through the generous support of the following sponsors:

The Andy Warhol Foundation for the Visual Arts
The National Endowment for the Arts
The University of Florida Office of Research
The John Early Publications Endowment
Florida Division of Cultural Affairs
Joanne and Edward Block

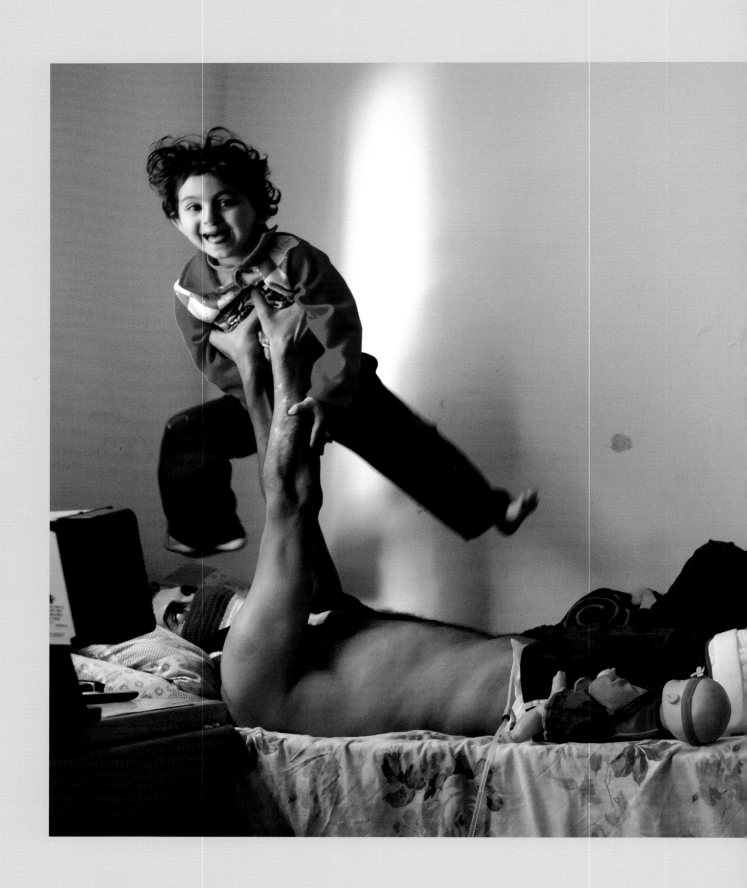

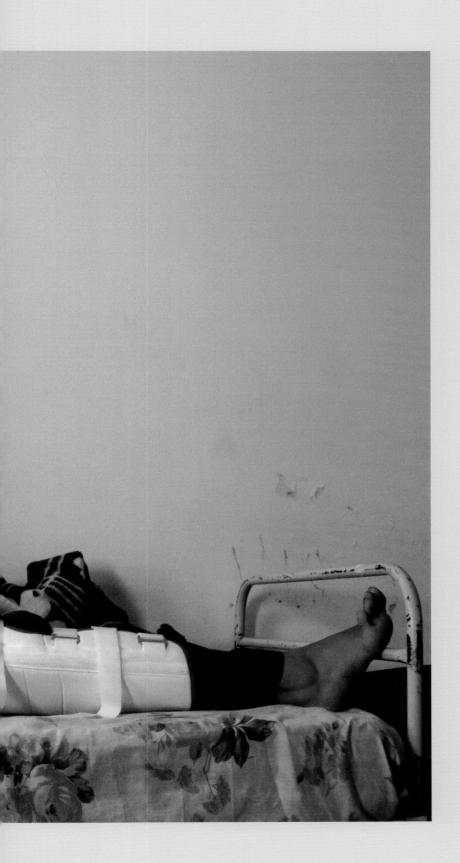

Dedication

To former president Jimmy Carter, whose book *A Call to Action: Women, Religion, Violence, and Power* inspired *Aftermath*. With intelligence, empathy, and persistence, he has worked for peace in the Middle East and for the universal emancipation of women, with the hope of one day seeing a more just and equitable world.

And to the women around the globe who work for peaceful coexistence and a more verdant Earth: their collective empowerment could change the course of this troubled century.

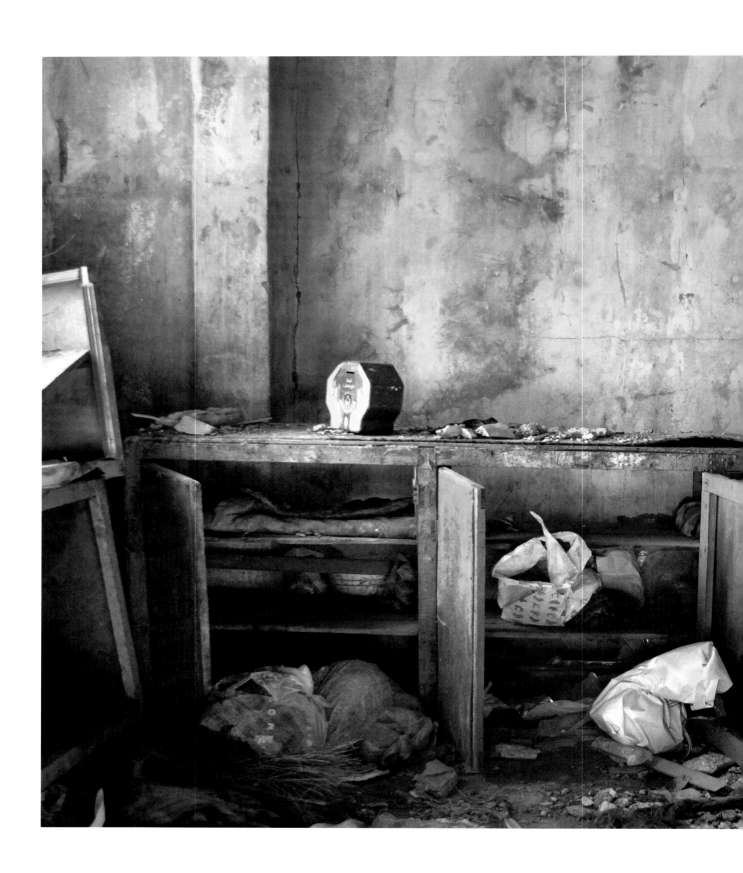

Contents

In "aftermath," the future is written.

—Sara Terry (founder/director,
The Aftermath Project, Los Angeles)

Foreword

REBECCA M. NAGY

Director, Harn Museum of Art

It is my pleasure to congratulate Carol McCusker, the Harn Museum of Art's curator of photography, on the landmark exhibition *Aftermath: The Fallout of War—America and the Middle East*. After years of researching, looking, and thinking about the ways artists respond to the residual impact of war on people and environments, she has selected twelve remarkable artists who are active in the United States, Iraq, Afghanistan, Syria, Lebanon, Israel, and Palestine. Nine of the artists are women and five artists live in or originate from the Middle East. They comment powerfully through photographs and video installations on issues that confront each of us daily, whether through the barrage of reports in the media or through personal experience of the aftermath of armed conflict. Almost everyone has a family member or friend who has been deployed to the Middle East, and many visitors to the exhibition will see themselves reflected in the experiences chronicled there. Seeing these images will be difficult for some, and the issues the exhibition raises may elicit strong differences of opinion and powerful emotions. For this reason the thoughtful contributions of our community advisory committee for the exhibition have been particularly valuable. During the formative phase of the exhibition, committee members gave generously of their time to help us think about effective ways to present and interpret the works of art through the installation, publication, and learning opportunities. In her acknowledgments, Carol thanks each of these committee members by name.

I share Carol's profound gratitude to the artists who have made their works available for the exhibition and to the scholars and journalists who have contributed insightful essays for this catalogue. We are indebted as well to the numerous funders whose support has made the exhibition possible, including the Andy Warhol Foundation for the Visual Arts and the National Endowment for the Arts for their endorsement of the project and their generous grants to support it. Carol names the other donors to the exhibition in her acknowledgments, and all of us at the Harn are deeply appreciative of their support as well.

Museums are safe places where everyone is welcome to spend time viewing exhibitions, participating in programs, reflecting quietly on matters of concern, or engaging in deep conversation with others, both those of like mind and those with differing perspectives. As a university-based museum the Harn is committed to presenting thought-provoking and enlightening exhibitions that address issues of local, national, and global concern. *Aftermath* is an exhibition that is certain to reach and touch people in areas of intimate daily experience while also contributing to their consideration of issues of national and international importance. The images are powerful, often disturbing, and sometimes hauntingly beautiful. We are eager to hear from our visitors and hope that they will share their thoughts and impressions after experiencing *Aftermath* through the exhibition or book.

Gloriann Liu, *Apartment Buildings, Shatila Camp, Lebanon, March 2012*

Following spread: Lynsey Addario, Syrian Refugees, Northern Iraq, August 20, 2013

Acknowledgments

CAROL McCUSKER

Curator of Photography, Harn Museum of Art

Even in the darkest
of times we have the
right to expect some
illumination . . . from
the . . . light that some
men and women, in
their lives and their
works, will kindle
. . . and shed over the
time span that was
given them on earth.

—Hannah Arendt,
Men in Dark Times

Foremost, I want to thank the artists in *Aftermath: The Fallout of War—America and the Middle East* for their "light," in the form of their photography and commitment: Lynsey Addario, Jananne Al-Ani, Stephen Dupont, Jennifer Karady, Gloriann Liu, Ben Lowy, Rania Matar, Eman Mohammed, Simon Norfolk, Farah Nosh, Suzanne Opton, and Michal Rovner. I am grateful for their courage and vision. I also want to thank the writers Dexter Filkins, Aida Hozić, Phil Klay, Terje Østebø, and Phillip Prodger for their insight and experience, and poets Lisa Suhair Majaj and Kirun Kapur for their verses in the catalogue and on the walls of the exhibition.

Aftermath: The Fallout of War and its catalogue would not have been possible without the generous support of the Andy Warhol Foundation for the Visual Arts, the National Endowment for the Arts, the University of Florida Office of Research, the John Early Publications Endowment, the Florida Division of Cultural Affairs, and Joanne and Edward Block. I am continually grateful to Mary Ann Cofrin and the Cofrin family for their support of the Harn. The Cofrins have been the heartbeat of the Harn Museum since its inception.

All of the photographs in the exhibition were lent by the individual artists or their galleries: Gallery Luisotti, Santa Monica, California; Pace Gallery, New York; and Eastwing, Dubai, United Arab Emirates. The Harn Museum appreciates their generosity and cooperation.

I extend special thanks to the exceptional staff members at the Harn Museum, who create and support its exhibitions with grace and good humor; I feel privileged to be working with each of them. Special acknowledgment goes to Betsy Bemis, Ivy Chen, Tim Joiner, Michael Peyton,

Eric Segal, Jess Uelsmann, and Tami Wroath, and to my curatorial colleagues, Dulce Román, Kerry Oliver-Smith, Jason Steuber, Susan Cooksey, and Allysa Peyton. And special recognition goes to Harn director Rebecca Nagy, and Mary Yawn, director of finance and operations, for their support and encouragement throughout this project.

Sincere appreciation also goes to the people at the University Press of Florida: Meredith Morris-Babb, director; Michele Fiyak-Burkley, editorial, design, and production manager; Jennifer Boynton, freelance editor extraordinaire; and Louise OFarrell for her elegant design.

Appreciation goes to my family who keeps me buoyant, and to several friends and colleagues near and far who read early drafts of my essays, gave valuable feedback, looked at images with me, coordinated museum correspondence, and created illustrated checklists. They are Lorelei Esser, Julie Thaler, Louise Brown, Myron Brown, Lee Savary, Ann Miksovic and Harn interns Calen Bennett, Yasemin Altun, and Izabella Faria.

Lastly, two years before *Aftermath* was due to open, a Harn advisory committee was formed, consisting of University of Florida faculty and students, Gainesville community members, Veterans for Peace, and the Wounded Warriors of Jacksonville. We met on several occasions, as a group and individually, to discuss *Aftermath's* content, and the best possible way to create meaningful dialogue through programming for students and the public alike. I thank Joanne Block, Louise Brown, Andrew Coughlan, Patti Fabiani, Lauren Hill, Aida Hozić, Bill Hutchinson, Tony Oliver-Smith, Terje Østebø, Robert Sanchez, and Patricia Woods for their sensitive discussions on photography's power (for good or ill) to shape our perceptions of the world and one another.

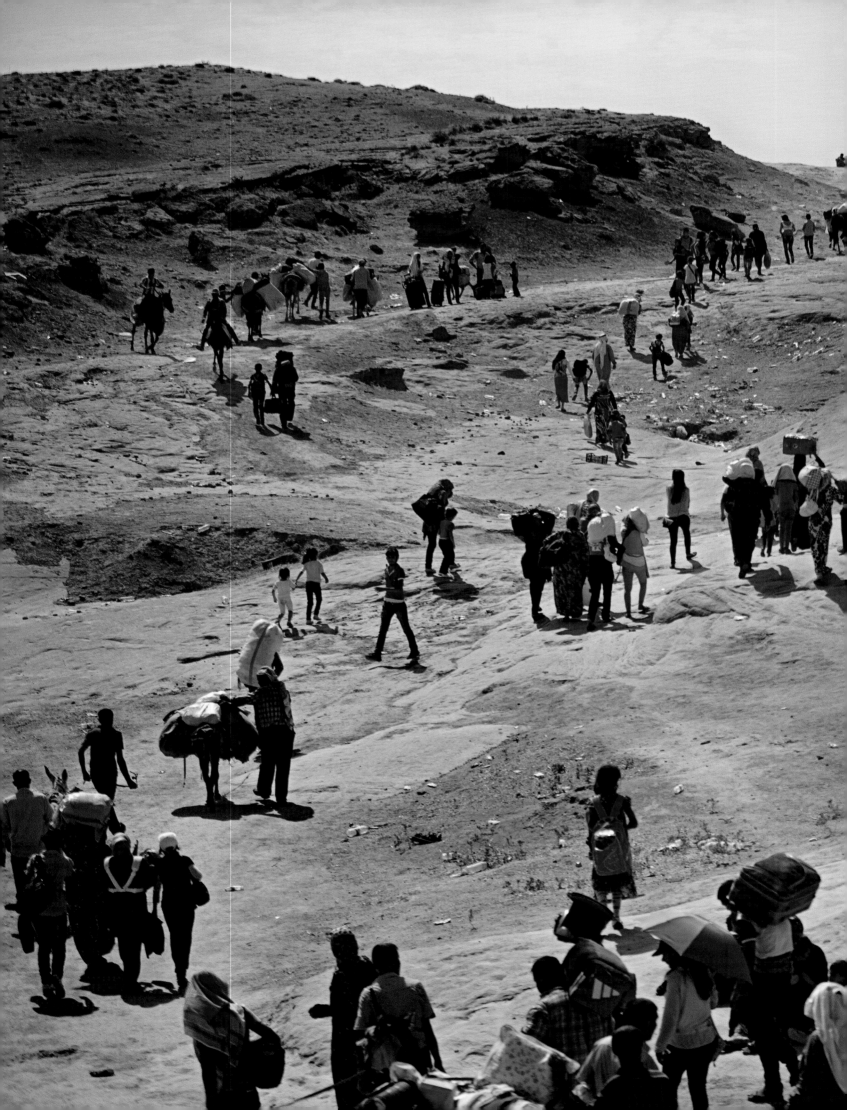

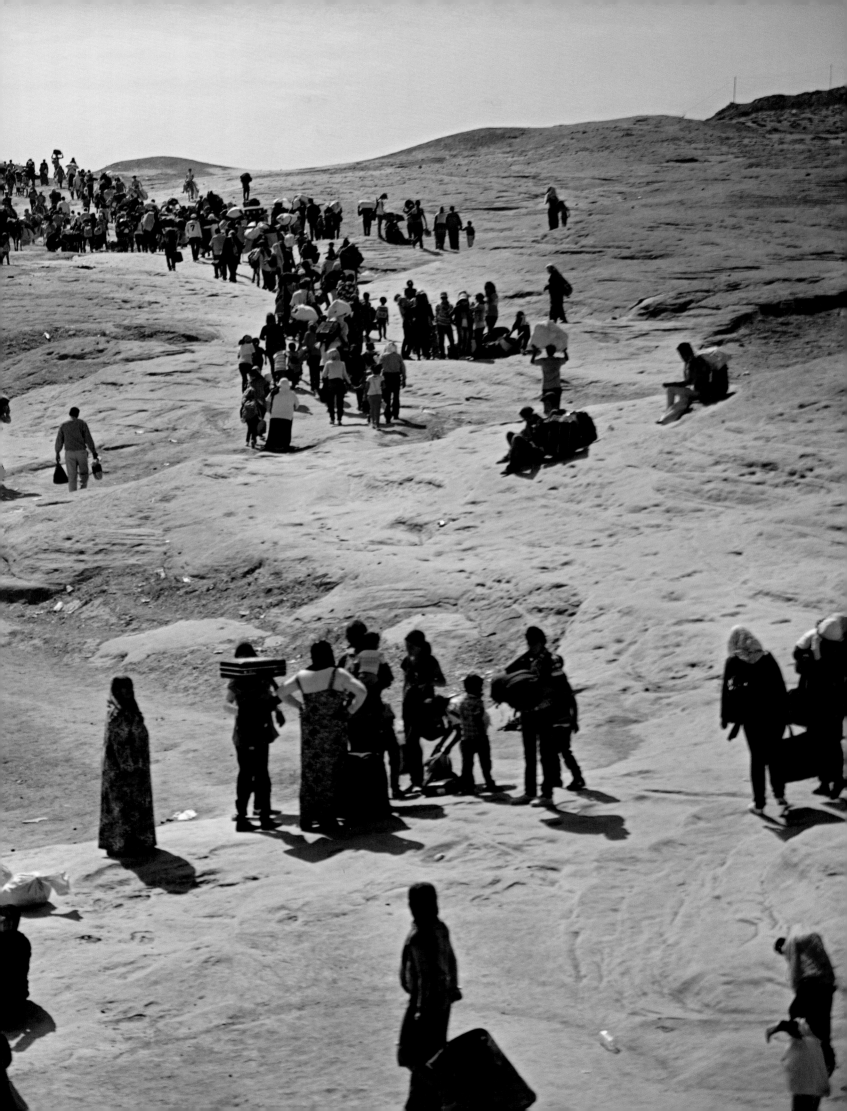

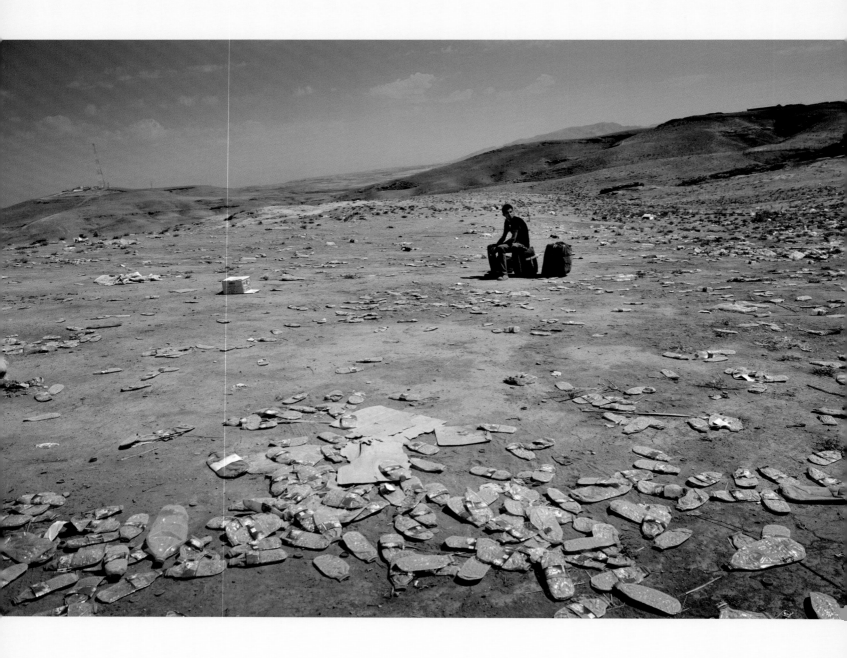

FuturePerfect, from Fear to Empathy

CAROL McCUSKER

Let's begin with a photograph: it pictures a young man in a desert surrounded by trampled plastic water bottles. He sits on one suitcase with two others beside him. No one is around. He is slim, T-shirted, looking like so many twenty-five-year-olds around the world. (This could be the last day of a rock festival or Burning Man.) Lynsey Addario's photograph, however, documents a Syrian war refugee in 2013—one of thousands waiting to flee across the border into Iraq, from one war zone into another. Other photographs showing World War II refugees, or the massive 1947 migrations from India and Pakistan, focused on *people* as their explicit subject. We look at this image and wonder: Where *are* all the people? What is next for this man sitting alone? Should we be suspicious of him? Too much suffering, we are warned, can radicalize youth. Addario's photograph brings together several existential crises and opposing conditions defining our nascent twenty-first century: mass movement/stasis, hope/fear, connection/isolation. We stare into the near future along with him, poised on the edge of a rapidly changing world, seeing—largely through the mass media—the domino effect that our behavior has on one another.

Something else in this image interests the photographer: war's assault on the environment, which is another kind of war wound. Plastic bottles threaten the environment, as does spent or live ordnance that can kill or maim and leach toxins in war zones worldwide. Conflict also encourages the harvesting, hoarding, or depletion of natural resources such as water. Mass exodus; economic, emotional, and physical exhaustion; and environmental degradation are the fallout

of war, present or implied in this portrait of a man. Apocalyptic in tenor, it serves up a major narrative in our present human story. In the wake of continual conflicts, our futures are now enmeshed, and this interdependence could be our hope or our endgame.

The images in *Aftermath: The Fallout of War— America and the Middle East* are by twelve acclaimed photographers and artists: Lynsey Addario, Jananne Al-Ani, Stephen Dupont, Jennifer Karady, Gloriann Liu, Ben Lowy, Rania Matar, Eman Mohammed, Simon Norfolk, Farah Nosh, Suzanne Opton, and Michal Rovner. Their photographs are the result of years of commitment, experience, resilience, and vision. Seen together, they generate a dialectic that provides a more complex picture of American and Middle Eastern lives impacted by war. The catalogue for *Aftermath* is enriched by essays from award-winning writers Dexter Filkins and Phil Klay, and scholars Aida Hozić, Terje Østebø, Phillip Prodger, and myself. Each would agree that the Old World Order of the last several centuries is in free fall. The world's new footing insists on an interdependent multiculturalism, which threatens many who are not yet ready to embrace it. *Aftermath* describes some of the conditions of this new sociopolitical and economic hybridity that includes uncontainable borders, scarce jobs and resources, climate change, technology, social media, human rights, changing gender roles, minority empowerment, and religious differences. If only we could know what viewers of these photographs will know a hundred years from now. Will we be judged apathetic, willfully xenophobic, collusive? Or

did we manage an effective humanist response to one another, and the planet, that started with empathy?

My intention for *Aftermath* is empathy, which is another way toward understanding. This exhibition asks audiences to put aside prejudices and politics in order to simply see something familiarly human in the photographs and videos. What we see are people from America and the Middle East surviving against dreadful odds, all needing similar things: food, water, shelter, medicine, family, comfort, education, work. What we see in the images by Norfolk, Al-Ani, and Rovner are the messages embedded in history. The images offer a brief respite from old narratives that keep us separate. They make us see "difference" in a way that is not so estranged. "It is now time to look *less* at our differences and more at what makes us the same," writes Kaja Silverman in *Flesh of My Flesh*. Seeing our "differences over our similarities is half the story, and a dangerous half at that". . . . but our resemblance to each other can have a profound influence in our thinking about the world and about one another.[1] My hope is that viewers will come away from *Aftermath* seeing a shared path that steers our new century toward *possibility* for everyone, and for the planet's survival. Lisa Suhair Majaj's poetry, which is featured on the walls of the exhibition and in the pages of this catalogue, also urges empathy toward, and recognition of, our shared human need.

The photographers in *Aftermath* picture people, places, circumstances, and history. There is an urgency in what they show us, asking us to be open, to learn something that expands our thinking. They are neither opportunistic "parachute photographers" who, with little knowledge of their subject, jump in and out of an area for quick news stories, nor do they practice an "orientalist" view of Arab culture, warned against by Edward Said, which exaggerates or exoticizes people of the Middle East.[2] Like human-rights workers, they are diligent in their protection or championing of people, principles, and the specifics of events. Their images are rendered with such intensity and, in many instances, such beauty, that it is difficult to look away. That is their intention. We are beyond the old argument leveled by critics against photographers who combine tragedy with aesthetics.[3] Beauty has long been a criterion for attraction. If beauty makes viewers pause long enough to look, there is hope that identification and compassion might follow.

The iconoclastic writer William Vollmann famously said, "What a daunting thing RECOGNITION is."[4] In his 1982 travelogue through Afghanistan, Vollmann mistakenly went about photographing *his* idea of the country and its people to bring back to Americans. The Afghans quickly disabused him of his agenda, and looked back at his lens to communicate something urgent about themselves to him and us, if we have the inclination to see. Taking photographs was not about him "nailing" his subject, but about his subject communicating with him. Likewise with the photographers in *Aftermath*, they look and receive.

Each photographer works in a distinct style, describing his or her experience through a variety of devices including traditional handheld cameras, video, cellphones, Polaroids, and a large field camera and tripod. Each has honed an

instinctive ability to know where to stand, to anticipate quick-moving events, and to understand history and theater, as well as how to frame, light, and edit. Several were born in the Middle East; others return frequently because they are drawn to the people, situations, and terrain that give them more than just a photograph. A common explanation for their work is "to bear witness," but it is also to reengage with family and/or friends, to inform and broaden their thinking about changing politics and events, and to experience a way of life that feels less artificial and more grounded in essential living. They use their cameras to establish a rapport with the people of Kabul, Beirut, and Brooklyn. Or they dig into historical archives and ideas that show how the past is still present, or reveal the parallel effects of post-traumatic stress disorder (PTSD) on soldiers in both the Free Syrian Army and the U.S. military.

Nine of the photographers are women; five are from the Middle East. Women photographers have access to situations where "aftermath" is most seen and felt. In war zones, female civilians are left to pick up the fragments of shattered lives, their men either dead, injured, or exiled. Inheritors of the chaos, they reorganize the most vulnerable: children, the wounded, the ill and elderly, along with themselves. Female photojournalists can capture this content by accessing the lives of Muslim women, a sphere off-limits to men. Yet many also travel embedded with the military or are escorted by locals or nongovernmental personnel. They get inside the anecdotal and personal, giving voice and presence to marginalized populations generally left invisible. The documentary photographs by

Lynsey Addario, Gloriann Liu, Rania Matar, Eman Mohammed, and Farah Nosh describe the specificity of these lives in the details of clothing, gestures of protection, expressions of sorrow or resiliency. Suzanne Opton and Jennifer Karady work in the United States, inspired by stories from the media about veterans returning from Afghanistan and Iraq. They get under the skin of military service by staging complex, or disarmingly simple, scenarios that give their subjects the means to express something of war's reality—a realm largely alien to civilians during America's longest wars. In Ben Lowy's and Stephen Dupont's photographs, we sense their energetic movement through the streets of Kabul or Benghazi. There is no sense of holding back, of authorities saying no, even when a policeman does so with Dupont. The streets are theirs. Simon Norfolk also photographs independently; for him, this is the only way to know a place and its people. Walking at dawn or dusk, studying the light and terrain alone or with a local friend or student, he carries a tripod and a digital 4×5 inch or 8×10 inch field camera. His process takes time, which, arguably, his gender affords.

The images in *Aftermath* make associations among themselves. For instance, in Norfolk's series of diptychs *Burke + Norfolk*, photographs from 1878 by John Burke (an Irish photographer in service to Queen Victoria) of Afghans and British soldiers in Afghanistan are paired with Norfolk's contemporary portraits from 2010/2011 of similar subjects in the same poses and occupations. They are portraits that constitute a kind of transtemporal community of people spanning almost two centuries. Norfolk's

project brings to life people (past and present) who might occupy the landscapes in Jananne Al-Ani's haunting *Shadow Sites II*, a masterfully edited video compilation of old and new aerial footage of Middle Eastern deserts that blends archaeological ruins with modern dwellings. It is accompanied by the timeless and ageless sound of wind, occasionally interrupted by drones or a pilot's garbled voice. Norfolk's and Al-Ani's works are in concert with Michal Rovner's LCD videos of constructed ancient landscapes burdened by a procession of human figures that continually appears and disappears into hills and vales. Together these artists ask what many astronauts have noted from space: Who owns this Earth, this small, vulnerable globe in the face of history, time, and the universe? Why can't we figure this out? Like Sisyphus, we seem doomed to an existence of eternal repetition, fated to relive history again and again.

There are no nationalist flags or loaded guns in *Aftermath* (a deliberate choice). But there are images of death, a frequent result of war that is banned, vexingly, from American news. It takes a certain kind of person to do what these photographers do, to look at and record loss and death. They go to tough places. There is the cliché that they are "adrenaline junkies," but it takes guts, which adrenaline aids, to go into the dangerous and unknown, and be among people who question or condemn your presence. (The number of deaths among photographers and journalists has never been so high.) Their photographs are our collective narrative made visible.

Death, or its proximity, has something profound to teach us. A recent radio program aired a story about male prisoners who were transformed after they became hospice care-givers to older fellow prisoners.[5] The younger prisoners went from being violent gang members to sensitively tending to the dying. In the face of death, they were made painfully aware of the poverty of their choices in life. There was recognition of themselves in relation to another facing the actual, personal act of dying. If we acknowledged and accepted the fact that we all must die—a fact largely hidden from our culture except as entertainment—could we transcend our differences? "[Dying] is the most capacious and enabling of the attributes we share with others," writes Kaja Silverman, "because unlike the particular way in which each of us looks, thinks, walks, and speaks, that connects us to a few other beings, it connects us to *every* other being. . . . Our refusal to acknowledge that we are limited beings has devastating and often fatal consequences for others."[6]

The photographs in *Aftermath* show loss of many kinds, and its lingering anguish. In this, we are all susceptible. Our cultural and gender differences are important up to a point, but beneath the surface of difference is a universal longing for connection and peace. The binaries of "good/evil, black/white" are no longer good for our collective futures; rather, "us/them/*we*" (women beside men) unites us somewhere in the middle. This union is also something author David Foster Wallace sought for his own writing, to "comfort the disturbed and disturb the comfortable":

In dark times, the definition of good art would seem to be art that . . . applies CPR to those elements of what's human and magical that still live and glow

despite the times' darkness. [It] could have as dark a worldview as it wished, but it'd find a way both to depict this world and to illuminate the possibilities for being alive and human in it. . . . If a piece of fiction [or a photograph] can allow us . . . to identify with a character's pain, we might then also more easily conceive of others identifying with our own. This is nourishing, redemptive; we become less alone inside. It might just be that simple.[7]

Notes

1 Kaja Silverman, *Flesh of My Flesh* (Stanford, CA: Stanford University Press, 2009), p. 4.

2 Edward Said, *Orientalism* (New York: Vintage Books, 1978); and Edward Said and Sut Jhally, "Edward Said on Orientalism" (Northampton, MA: Media Education Foundation, 1998), video, 40 min., https://www.youtube.com/watch?v=fVC8EYd_Z_g.

3 Michael Kimmelman, "Can Suffering Be Too Beautiful?" *New York Times*, July 13, 2001, http://www.nytimes.com/2001/07/13/arts/photography-review-can-suffering-be-too-beautiful.html?pagewanted=all. It would be interesting to survey audiences to determine if—after viewing photographs by Sebastião Salgado, James Nachtwey, and others—they donated money or services to people or organizations, thereby weighing the "cause and effect" of front-page-news photographs, exhibitions, books, and so forth. Claims have been made that beauty numbs and makes us passive, but I have not seen evidence of this.

4 William Vollmann, *An Afghanistan Picture Show: Or, How I Saved the World*, rev. ed. (New York: Farrar, Straus and Giroux, 1992), p. 224. In his revised introduction, Vollmann writes:

I cannot reread portions of this book without shame—at my ignorance, my smug conviction that I could somehow do the Afghans a favor, my physical inability to keep up with the Mujahideen, my utter uselessness. And this puts me on the track of why An Afghanistan Picture Show *may be of value. It is not a political analysis, although it hoped to be. It is hardly even much of an "adventure memoir." But it delineates, with an honesty I remain proud of, the attempt of one young man to be of service to others.*

It continues to astonish me how easy it is to harm people and how difficult it is to help them. . . .

I wanted to "help the Afghans." I assumed that good-will . . . would be enough.

I believed, and still do, that every human being is my brother and sister, and therefore that we are all of us equally deserving of help.

5 Nancy DeVille, "Sitting Vigil Behind Bars," National Public Radio / Latino USA, aired October 23, 2015, http://latinousa.org/2015/10/23/sitting-vigil-behind-bars/.

6 Silverman, *Flesh of My Flesh*, p. 4.

7 Hubert Dreyfus and Sean Dorrance Kelly, *All Things Shining: Reading the Western Classics to Find Meaning in a Secular Age* (New York: Free Press, 2011), p. 28; and Larry McCaffery, "A Conversation with David Foster Wallace," *Review of Contemporary Fiction* 13, no. 2 (Summer 1993), transcript available at Dalkey Archive Press, http://www.dalkeyarchive.com/a-conversation-with-david-foster-wallace-by-larry-mccaffery/.

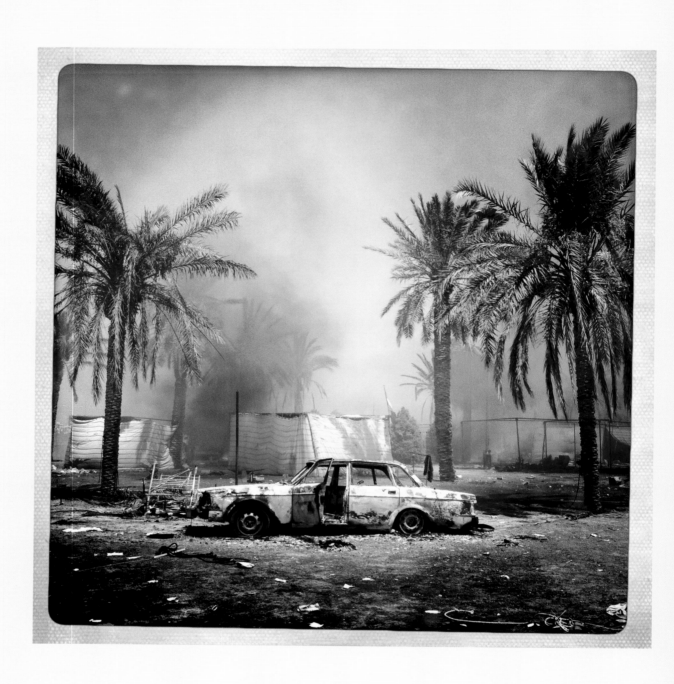

CHAOS AND HOPE

Dexter Filkins

For a fleeting moment, the anarchy that has gripped the Middle East for so much of our modern history seemed finally about to subside. It was the spring of 2011. The long and catastrophic American war in Iraq, which killed nearly five thousand Americans and tens of thousands of Iraqis, was drawing to a close, with an uneasy calm prevailing over much of the country. In Afghanistan, White House envoys were talking directly to the leaders of the Taliban, in an effort to end the even-longer conflict there. Osama bin Laden, the mastermind of the 9/11 attacks and an inspiration to violent jihadis everywhere, was dead. And across the Arab world, from Tunis on the Mediterranean to Sanaa on the Red Sea, ordinary people were rising en masse to rid themselves of the dictators who had gripped their countries for generations. In Cairo and Tripoli, young revolutionaries, deploying social media to astonishing effect, electrified the world with their savvy and sophistication. Together, the events of 2011 cast a fresh and even hopeful hue across a part of the world that had been known primarily for chaos and despair.

And now, only a few years later, that hopeful moment seems lost. U.S. soldiers, who had left Iraq in December 2011, have returned to that country, to try to rescue a faltering government and a disintegrating state. President Obama, worried that Afghanistan would crumble in a similar way, reversed course and ordered several thousand American soldiers to remain there, to bolster the government and save it from what seemed a likely Taliban victory. Bin Laden and his confederates have been replaced by an equally bloodthirsty gang who call themselves

Ben Lowy, *Car torched at a Gaddafi encampment, Libya, 2011*

the Islamic State, and who hold much of eastern Syria and western Iraq in a medieval thrall. Across the Arab world, the broad popular revolt, once so hopeful that it was dubbed the Arab Spring, has either collapsed into civil war—as in Syria, Libya, and Yemen—or reverted to dictatorship, as in Egypt. As the tumult spread across the Middle East, a quieter but no less profound drama unfolded in the United States, as millions of Americans who fought in Iraq and Afghanistan grappled with the age-old challenges of soldiers coming home.

The photographs assembled here are an attempt to capture the drama of our recent history, and to make sense of it. The photographers whose work appears in *Aftermath* have roamed over wide and various terrains: across dunes and mountains, into riots and morgues and refugee camps, and, in both the United States and the Middle East, into the most intimate corners of people's homes. They have tried to document the extraordinary human drama that is unfolding across the Middle East, in all its sadness and poignancy and hope; the most novel images represent an effort to allow us to comprehend, or maybe just imagine, what is happening inside the minds of the men and women who have served abroad and who are now trying to make sense of their experiences. You will find sadness, hope, and anguish in these pages, and the whole range of the human condition.

The road that brought us to the world represented by these photographs is marked by dips and turns and switchbacks. When the American military was ordered to go to war following the attacks on September 11, 2001,

first to Afghanistan later that year and then to Iraq in 2003, the two conflicts took sharply different paths. The first appeared to go unusually well, with the Taliban—protectors of bin Laden—routed from the capital in a matter of weeks, and the majority of the Afghan people genuinely happy with the result. And then, in no small part because of the other war that the United States embarked on in Iraq, the project in Afghanistan was neglected—indeed, at times, almost forgotten. Starved of resources and attention, the campaign to rebuild the Afghan state and nurture Afghan democracy foundered, and the Taliban, taking shelter in the remote tribal areas of Pakistan, mounted a comeback. By 2006, it was clear that, far from being over, the war in Afghanistan had just begun.

In Iraq, the American forces crossed the Kuwaiti border and marched to Baghdad in a mere nineteen days, with the invaders watching in astonishment as Saddam's soldiers peeled off their uniforms and ran away before them. But disaster began to unfold the moment the Americans entered the capital, on April 9, 2003. Saddam's government imploded, and—it became rapidly clear—the Americans had no plan to deal with the upheaval that followed. Across the country, Iraqis poured into the streets, many of them to loot the offices of their erstwhile government and trash and burn the emblems of Saddam's rule. With American soldiers standing by, disorder flourished: thievery and mayhem spread to hospitals and schools, and many Iraqis took the opportunity to settle old scores. The chaos raged for many, many days before finally burning out.

But by then, the die was cast. The Iraqi state lay in ruins, without an army or a police force;

most of its essential institutions—its schools and ministries—were hollowed out or destroyed. The Americans, who had been greeted with varying combinations of fear, gratitude, and/or loathing, were suddenly seen as paper tigers—neither powerful nor omniscient. The decision by the U.S., made soon after its entry, to disband the Iraqi Army, and to ban the Baath Party—the party that had given jobs and status to millions of Iraqis who had taken no part in the state's repressive activities—created an ocean of angry and disenfranchised men and women only too ready to oppose the American occupation. The guerrilla insurgency, a small thing in the early days, began to metastasize, and within weeks of Saddam's fall it had bloomed into a virulent, adaptive force that was killing Americans and Iraqis every day.

The shattering events of 2003 set the stage for the next eight years. The American mission was now to rebuild the Iraqi state that had been destroyed in the invasion—creating a state that was healthy enough, and democratic enough, to allow them to leave—all the while battling an insurgency that grew deadlier by the day. This proved to be a monumental task, one that required hundreds of billions of dollars and tens of thousands of American soldiers working around the clock for yearlong tours, and one that often forced U.S. soldiers to return to Iraq again and again.

The strain on American servicemen and servicewomen who fought in Iraq and Afghanistan was often severe, not only in terms of fatalities and terrible physical injuries but also in the personal and psychological damage they sustained. Often, the strain did not show until the

soldiers returned home, where it revealed itself in the form of post-traumatic stress, alcoholism, drug abuse, suicide, and divorce. While not all soldiers were afflicted, almost no one emerged from the conflicts completely unscathed.

Two factors intensified the stress of serving overseas. The first was that the U.S. military did not have sufficient personnel for the undertaking. That meant that the typical soldier did not just serve a twelve-month tour in the war zone. It meant repeated tours: three and four and even five were not unusual. In the later years of the wars, it was not uncommon, but no less startling, to encounter soldiers embarked on their fifth combat tour, and who had been married, become a parent, and gotten divorced, all before they were thirty years old.

The second factor was the lack of any sort of sacrifice on the part of Americans outside the military. Indeed, in a perverse way, the men and women who served comprised a form of America's 1 percent: over the course of the wars in Afghanistan and Iraq, around 2.5 million Americans served—about 1 percent of the total U.S. population. For the rest—for the 99 percent—the wars were an abstraction: something to talk about, something to argue over, but certainly not something to pay for with higher taxes. And there was never any talk of a draft; indeed, it's interesting to consider how long these longest of American wars would have lasted if all the myriad segments of its population—rich and poor, rural and urban—had suddenly been faced with the prospect of having to fight.

This bifurcated nature of the home front often heightened the stresses the returning soldiers had to endure, because there were fewer people around who might understand what they had experienced overseas. Patriotic-minded Americans might wish to show their gratitude by thanking uniformed military personnel in shopping malls and airports, but soldiers and Marines sometimes privately expressed anger or bewilderment over such gestures.

By the time Barack Obama was elected president in 2008, most Americans had turned against the wars, or had concluded, not unreasonably, that they had been terribly managed. Afghanistan continued to slowly spiral downward, unchecked—indeed, in many ways, driven—by the corruption that permeated the government of President Hamid Karzai, who held power in the country from 2001 until 2014. As in Iraq, the Americans had set out to rebuild the Afghan state, but the thing that emerged could barely function by itself.

Iraq was in somewhat better shape, after passing through an astonishingly brutal phase. In the years after 2003, the insurgency in Iraq had gone through a steady, and horrifying, evolution, from essentially an anti-American revolt led by members of Saddam's Baath Party, and more generally by the country's Sunni minority, to a murderous, bloodthirsty movement led by al-Qaeda in Iraq, a franchise of the one founded by bin Laden. Al-Qaeda in Iraq was led by an equally murderous Jordanian named Abu Musab al-Zarqawi. Over the course of the years that Zarqawi led the movement, al-Qaeda in Iraq embarked on a campaign of sectarian murder—one that was explicitly designed to provoke a civil war. Zarqawi succeeded to a remarkable degree, and by 2006 Iraq was embroiled in a full-scale sectarian bloodbath, pitting the

country's newly empowered Shiite majority against its Sunni minority. At the height of the civil war, a thousand Iraqis were dying every day—their bodies often bearing grim signs of torture.

But then, beginning in 2007 and 2008, Iraq pulled back from the brink—helped by the U.S. counteroffensive known as the "surge." The surge got most of the press, and it was highly effective, but perhaps the greater turning point—the one that helped to decimate al-Qaeda in Iraq—was called, in Arabic, al-Sawah, the "Awakening." This series of deals, often consummated with American money, turned the Sunni tribes against al-Qaeda. Back in 2006, violence had begun to drop precipitously. By 2008, the surge and the Awakening together had brought the levels of violence in Iraq to lows unseen since the early days of the occupation. For the first time since the U.S. invasion, Iraqis began to fill the streets again. That enabled President Obama to begin the final withdrawal of U.S. forces from the country in 2011. A similar drawdown was under way in Afghanistan, although it was not quite as rapid. For a time—in early 2011—it looked as though, at least for Americans, the long wars were finally winding down.

As 2010 drew to a close, a humble Tunisian vegetable seller named Mohammed Bouazizi, who lived in a village south of the capital, was fined for not carrying a vendor license. When Bouazizi tried to pay, he was slapped and insulted by a Tunisian police officer. In protest, Bouazizi, who was twenty-six, set himself on fire and burned himself to death. Fellow Tunisians began to rally in protest, mostly against

the president, Zine al-Abidine Ben Ali, who for nearly twenty-five years had ruled the country as if it were his family business. The demonstrations spread rapidly. In less than a month, faced with nationwide revolt, Ali fled the country. The Arab Spring had begun.

Riding a wave of hope, the protests quickly spread across the Arab world—to Libya, Egypt, Yemen, and Syria, where dictators had, in every case, held power for years. Within months, the leaders of Yemen and Egypt were gone, with mass protests in Cairo captivating the world. In Libya, ruled by Colonel Muammar Gaddafi, one of the world's strangest and cruelest strongmen, protests broke out, too. When Gaddafi ordered his troops to prepare for what appeared to be a massacre of civilians, a coalition led by the United States, France, and Britain began air strikes. Within weeks, Gaddafi fled his palace; he was soon tracked down by Libyan rebels and killed. For a moment, the American-led Libyan intervention seemed a resounding success.

Finally, there was Syria. Since 2000, the country had been ruled by a soft-spoken ophthalmologist, Bashar al-Assad, who, like his father before him, has acquired one of the most ruthless reputations in the region. The Syrian rebellion, similar to others in the Arab world, began full of hope, with demonstrators marching peacefully. However, they were fired upon by the regime and, within days, the revolt spread across the country. For a while, it appeared that Assad would go the route of Gaddafi, hustled out of town and ignominiously killed.

But it was not to be. Assad struck back savagely, employing a whole range of barbaric tactics, including torture, the bombardment of

civilians, and on several occasions, even poison gas. At the same time, Assad's allies—the regimes in Iran and Russia—rode to the dictator's rescue. With Saudi Arabia and the other Gulf Arab states sending weapons to the anti-Assad rebels, the Syrian war quickly bloomed into a massive, internationalized conflict that appeared to have no end.

In 2013, another element became active in the chaos of Syria. Despite the success of the surge and the Awakening, a tiny remnant of al-Qaeda in Iraq survived, mostly in the northern city of Mosul. Its leader was Abu Bakr al-Baghdadi, a former graduate student who had spent time in an American prison. With the uprising sweeping Syria, Baghdadi saw his opening: he and a small group of men, perhaps fewer than a dozen, crossed into Syria and began recruiting fighters. Within months, Baghdadi's men were carrying out operations across the country. Baghdadi renamed his group the Islamic State of Iraq and al-Sham: ISIS.

With two merciless foes facing off—the Assad regime and ISIS—the war in Syria turned into one of the largest humanitarian catastrophes of our time. The numbers are staggering: by the end of 2015, more than a quarter of a million people were dead. Twelve million people—half the country's population—were driven from their homes, many of them into the neighboring countries of Jordan and Turkey and Lebanon. In the summer of 2014, Baghdadi's forces had swept into Iraq, conquering large swaths of the northern and western parts of the country. Baghdadi declared himself the caliph—God's chosen ruler—and the area he had conquered, the caliphate, thereby restoring, at least symbolically, the state that had disappeared with the collapse of the Ottoman Empire nearly a hundred years before. Baghdadi imposed a medieval rule over the areas he conquered, which included barbaric punishments for violators. Soon, ISIS's videotaped executions—of prisoners, of gay people, of curators of ancient artifacts, of at least seven American hostages—began appearing on the internet. The barbarism of ISIS, the sheer joy that its fighters took in inflicting their punishments, has few parallels in modern history.

The civil wars in Syria and Iraq were the two largest of numerous forces driving what appeared to be, at the end of 2015, a fundamental reordering—or even a general collapse—of the Middle Eastern state system that was established at the end of World War I. An arc of crises spanned the whole of the Middle East—from Libya, across Egypt, and into Lebanon, all the way into Afghanistan and to the very border of China. Together, the catastrophes fueled the greatest refugee crisis since the end of World War II. By the end of 2015, some sixty million people had been driven from their homes.

It would be tempting, at this point, to reach for some hopeful sign—a glimmer of optimism on which we might base a more hopeful vision of the future. But seen with clear eyes, the crisis now gripping the Middle East appears to condemn millions of ordinary people to a long night of turmoil and uncertainty. The spring of 2011, which once appeared to hold such promise, seems very far away.

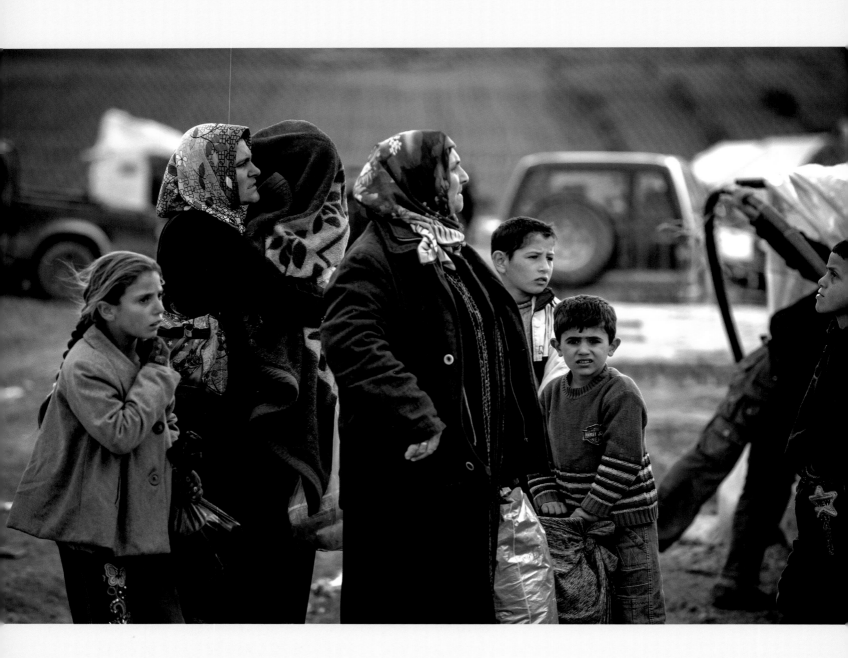

MAKING WARS VISIBLE

AIDA A. HOZIĆ

The refugees vanished into the night. It was the beginning of April 1999, in the early days of the North Atlantic Treaty Organization (NATO) air campaign against Serbia. After squatting in no-man's-land between Kosovo and Macedonia for more than a week, under intense media scrutiny and in conditions described as beyond unsanitary, between twenty and forty thousand Kosovo Albanians—people supposed to have been protected by NATO bombing—simply disappeared overnight. In the morning, the journalists who had been following the refugees' every move worked themselves into a frenzy with fears and rumors. The refugees, they reported, were being moved to unknown locations; the refugees were being sent back to their homes to be killed by Serbian forces; the refugees would be chained to military targets to be bombed by NATO; the refugees were being used as human shields to prevent bombing by NATO. Eventually, it turned out, the truth was much simpler: at dawn, the Macedonian government, without consulting with the United Nations High Commissioner for Refugees, had sent buses to transport the refugees into makeshift camps on the other side of the border. No one noticed. What remained in the valley were piles of rubbish and the stench.

It would seem that refugees often vanish, despite the watchful eye of governments, relief agencies, and the media. In 1997, over a hundred thousand Rwandan refugees went missing from a camp in Zaire. In 2015, more than five thousand unaccompanied refugee children disappeared in Italy. Even at present, in Somalia, Ethiopia, and Eritrea, women are being kidnapped and "disappeared" from camps daily. Somehow the movements of hundreds, sometimes thousands, of refugees can easily go unnoticed, even when they are guarded, observed, and placed under surveillance. One must wonder: What is it that makes refugees sometimes so visible (as in a "refugee crisis") and, at other times, so utterly invisible ("missing")? How can the gaze of those watching the refugees—closely watching, presumably—be so blind and blinding at once?

The photographs exhibited in *Aftermath* speak directly to this blind gaze. They return it and refract it. They make known the conditions of refugees' (in)visibility—as inconvenient reminders of wars gone badly; as discomforting illustrations of life's fragility; as injured bodies marred by long shadows of imperialism, carrying the weight of a messy, intractable history. In these photographs, wars do not simply end when missions are declared accomplished—they linger and gnaw on their victims and soldiers, their relatives and the relatives of their relatives. What's more important: in these photographs, the wars come home. They sit in a living room. They go to college. They fear hidden explosives on the side of the road. They go swimming. Simply put, these wars are—or could be—us.

Here in the United States, we do not often see wars in relation to our daily lives, even if they involve the U.S. military, perhaps because the public image of wars has been staged for so long. Thomas Alva Edison filmed the Spanish-American War of 1898 in New Jersey. The battles, which took place in Cuba, were reenacted in Edison's studios with the help of National Guard troops, and then filmed and distributed around the country as newsreels. Controversies and suspicions of staging surround one of America's most iconic photographs—Joe

Gloriann Liu, *Atmeh Refugee Camp, Syria, March 2013*

Rosenthal's photo of the five U.S. Marines and a Navy sailor raising the flag on Iwo Jima. More recently, serious doubts were cast on the moment that defined public perception of the Iraq War—the toppling of Saddam Hussein's statue on Baghdad's Firdos Square. The removal of the statue, which was organized by the U.S. Marines, may not have been psyops, as suspected, but it was definitely reimagined by the U.S. media as a moment of spontaneous Iraqi jubilation.[1]

But then, one could say, photographs are always staged, always just slivers of some reality which remains inaccessible to those who were not present at the moment the photograph was taken. The distancing of wars—this acute separation of war and everyday life in America—requires far more elaborate powers, practices, and technologies of visualization. For instance, a war can be declared against invisible enemies—the war on drugs, the war on poverty, and, most importantly, the war on terror. Such wars are not just imperceptible; they are also infinite. They can never end because, by definition, it can never be known if the enemy has been defeated.

Wars can also be made less significant, U.S. involvement less obvious, if their consequences—the human toll, the destruction—are suppressed. For eighteen years, the U.S. media was banned from photographing the flag-draped caskets of America's soldiers as they were brought back to the United States. The ban was initially put in place by Secretary of Defense Dick Cheney in 1991, during the run-up to the first Gulf War. It was reinforced in March 2003, just before the onset of the Iraq War. Framed as a policy intended to protect the privacy and dignity of fallen soldiers and their families (although they had no say in the matter), the censoring of images was also meant to defer the public costs of war. As General Hugh Shelton explained in 2001, the so-called Dover Test—named after Dover Air Force Base in Delaware, where coffins of dead soldiers usually arrive in the U.S.—could be regarded as a standard for America's preparedness for war. Is the country ready to view "our most precious resource coming home in flag-draped caskets" or not?[2] Instead of taking the test, successive American administrations chose to sidestep it. The ban was eventually lifted in 2009 by Secretary of Defense Robert Gates, despite significant opposition within the Pentagon.

Conversely, wars can elicit more sympathy, even be viewed as inherently good, positive affairs, if seen only through the eyes of one's own military forces. By "embedding" journalists with the U.S. forces in Iraq and not offering protection to independent, "unilateral" journalists, the Department of Defense hoped to actively "shape public perception of the national security environment now and in the years ahead."[3] Embedded journalists in Iraq were granted better access to the battlefield than in the first Gulf War or during the first years of the War in Afghanistan. In return, the Pentagon hoped, journalists placed with U.S. soldiers, sharing their fate, would develop an understanding for the military point of view and be better positioned to educate the public about this perspective. By seeing only as much of the war as the unit with which they were embedded, and by empathizing with the soldiers, journalists could counter any pro-Iraqi propaganda while simultaneously being less likely to gather or reveal strategic information that could be of help to the enemy.

There are, of course, other ways to prevent wars from intruding upon everyday life.

Technology, for one, can make wars invisible. In the first Gulf War, the public had a chance to watch live coverage of America's bombing of Baghdad—night skies illuminated by missiles hitting targets, jets taking off from aircraft carriers positioned in the Persian Gulf, aerial shots of Iraqi troops fleeing the battlefield. The journalists themselves were kept at a distance, most of them reporting from hotel rooftops in Saudi Arabia, without ever disclosing to their audiences that they were not in Iraq. Consequently, the nonstop coverage resembled video games more than news. In the decades since, video games in the coverage of wars have become the war itself: drone bombings keep joystick operators of these unmanned aircraft, and the public, far away from their targets. So far away that the people who operate the drones call their human victims *bug splats*, "since viewing the body through a grainy-green video image gives the sense of an insect being crushed."[4]

But nothing makes wars less visible—and more distant—then their hyper-visualization —the constant stream of images from various theaters of war around the world, all looking very much the same (bomb victims, rubble, men with machine guns, women screaming for help), fighting for our attention with entertainment, soft news, advertisements. In the world of virtual empathy we now live in, we express our opinions and concerns with "likes" on Facebook or by retweeting the news—and then move on, to our jobs, families, shopping. Wars—like refugees—get lost in the speed of life, in the mountain of other problems. It seems no one notices them anymore.

That is why this exhibition of photographs from America's recent wars and their aftermath is so important. There are no remote controls in museums. It is not possible to change channels or click on a different link. The photographs on gallery walls demand our time and draw us into their time. The time spent waiting in refugee camps. The time spent forgetting a lost home. The time spent dealing with PTSD. The time spent mourning. The time spent posing for a portrait. The time spent conquering foreign lands and resisting occupation. The time spent looking at the photographs, being transposed, experiencing the fallout of wars.

Aftermath is about making wars visible again, reconnecting them with the banality and comfort of our daily lives. Wars—like refugees—are right here, among us. They have not vanished into the night. We must start noticing them.

Notes

1 Peter Maas, "The Toppling: How the Media Inflated a Minor Moment in a Long War," *New Yorker*, January 10, 2011.

2 Mark Shields, "Time to Take the Dover Test," CNN/Inside Politics, November 3, 2003, http://edition.cnn.com/2003/ALLPOLITICS/11/03/column.shields.opinion.dover/.

3 U.S. Department of Defense, "Public Affairs Guidance (PAG) on Embedding Media During Possible Future Operations/Deployments in the U.S. Central Commands (CENTCOM) Area of Responsibility (AOR)," February 2003, https://www.fas.org/sgp/othergov/dod/embed.pdf.

4 Michael Hastings, "The Rise of the Killer Drones: How America Goes to War in Secret," *Rolling Stone*, April 16, 2012, http://www.rollingstone.com/politics/news/the-rise-of-the-killer-drones-how-america-goes-to-war-in-secret-20120416?page=2.

AFTER WAR, A FAILURE OF THE IMAGINATION

PHIL KLAY

"I could never imagine what you've been through," she said.

As a former Marine who served in Iraq, I'd heard the sentiment before—it's the civilian counterpart to the veteran's "You wouldn't know, you weren't there." But this time it struck an especially discordant note. This woman was a friend. She'd read something I'd written about Iraq—about the shocked numbness I'd felt looking at the victims of a suicide bombing—and it had resonated. As a survivor of child abuse, she knew feelings of shocked numbness far better than I did. And yet, midway through recounting some of what happened to her as a young girl, she said it again: "I'm sorry. I don't mean to compare my experience to yours. I could never imagine what you've been through."

It felt inappropriate to respond, "Sure you could." I'd had a mild deployment. She'd mainly have to imagine long hours at a cheap plywood desk in a cheap plywood hut in the middle of a desert. True, there were a handful of alarming but anticlimactic mortar attacks on my forward operating base, and the wounded and damaged bodies I saw at the trauma center, but that was all. Her childhood, though, was full of experiences I couldn't have handled as an adult, let alone as a child. And what was particularly bewildering was that, even as my friend was insisting that what I'd been through was beyond the limits of imagination, she never once told me, "You aren't a victim of child abuse. You couldn't understand." She wanted me to understand. At the very least, she wanted me to try.

I know an airman who suffered a traumatic brain injury during training just a few years after being in a car accident where he watched his twin brother die. When he tells people about the TBI and the accident and his service, he invariably gets the "I could never imagine" line. "It makes me angry," he told me. Sure, he wants to say, you don't think you could understand, but what if I want you to?

It's a difficult spot to be in, for both. The civilian wants to respect what the veteran has gone through. The veteran wants to protect memories that are painful and sacred to him from outside judgment. But the result is the same: the veteran in a corner by himself, able to proclaim about war but not discuss it, and the civilian shut out from a conversation about one of the most morally fraught activities our nation engages in—war.

The notion that war forever separates veterans from the rest of mankind has been long embedded in our collective consciousness. After World War I, the poet and veteran Siegfried Sassoon wrote, "the man who really endured the war at its worst was everlastingly differentiated from everyone except his fellow soldiers." During World War II, Hemingway called combat "that thing which no one knows about who has not done it." After Vietnam, Tim O'Brien claimed that a true war story can't even be told, because "sometimes it's just beyond telling." Given the way American history, unlike Iraqi or Afghan history, allows for a neat division between soldiers who see war and civilians who don't, it's not surprising that the idea has taken root.

When I returned from Iraq, people often asked me what it was like, usually followed by, "How are we doing over there?" And I'd tell them. I'd explain in bold, confident terms about the surge and the Sunni Awakening. The Iraq I returned from was, in my mind, a fairly simple

place. By which I mean it had little relationship to reality. It's only with time and the help of smart, empathetic friends willing to pull through many serious conversations that I've been able to learn more about what I witnessed. And many of those conversations were with friends who'd never served.

We pay political consequences when civilians are excused or excluded from the discussion of war. After all, veterans are no more or less trustworthy than any other group of fallible human beings. Southern veterans of the Civil War claimed the Confederacy was a noble lost cause. Nazi leaders who had served in World War I claimed that the German troops had all but won the war, only to be stabbed in the back by civilians in thrall to Jewish interests. The notion that the veteran is an unassailable authority on the experience of war shuts down conversation. But in a democracy, no one, not even a veteran, should have the last word.

The problem is compounded on a personal level. If we fetishize trauma as incommunicable then survivors are trapped—unable to feel truly known by their nonmilitary friends and family. At a recent Veterans Day performance put on by Arts in the Armed Forces, Adam Driver, the organization's founder, a former Marine turned actor, spoke of his feelings of alienation after leaving the corps. "Not being able to express the anger, confusion and loneliness I felt was challenging," he said, until theater exposed him "to playwrights and characters and plays that had nothing to do with the military, that were articulating experiences I had in the military, that before to me were indescribable."

It's a powerful moment, when you discover a vocabulary exists for something you'd thought incommunicably unique. Personally, I felt it reading Joseph Conrad's *Lord Jim*. I have friends who've found themselves described in everything from science fiction to detective novels. This self-recognition through others is not simply a by-product of art—it's the whole point. Hegel once wrote, "The nature of humanity is to drive men to agreement with one another, and humanity's existence lies only in the commonality of consciousness that has been brought about."

To enter into that commonality of consciousness, though, veterans need an audience that is both receptive and critical. Believing war is beyond words is an abrogation of responsibility—it lets civilians off the hook from trying to understand, and veterans off the hook from needing to explain. You don't honor someone by telling them, "I can never imagine what you've been through." Instead, listen to their story and try to imagine being in it, no matter how hard or uncomfortable that feels. If the past ten years have taught us anything, it's that in the age of an all-volunteer military, it is far too easy for Americans to send soldiers on deployment after deployment without making a serious effort to imagine what that means. We can do better.

This essay was previously published in the *New York Times* on February 9, 2014.

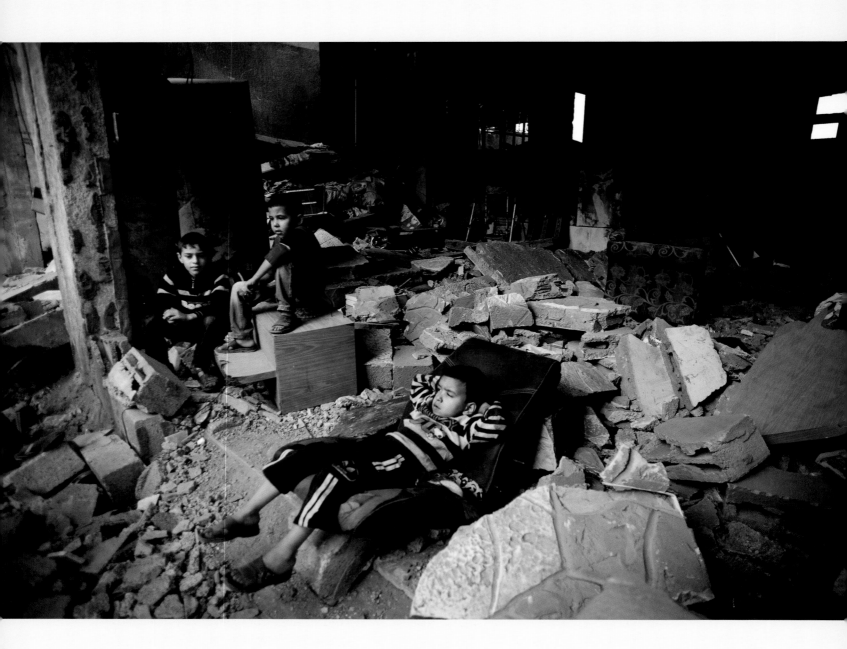

MUSLIMS CAUGHT IN THE AFTERMATH

TERJE ØSTEBØ

Photography is, according to Teju Cole, a memorial art: "It selects, out of the flow of time, a moment to be preserved, with the moments before and after falling away like sheer cliffs."[1] Yet inasmuch as photography enables us to remember the past, it creates connections between us and current and unfolding events. Surely, photography freezes a particular moment, but these moments may not be finite and concluded, but rather representations of active realities running parallel to our own.

The term *aftermath* denotes the present and inconclusive aspects of conflict and peace. While signaling a shift from war to peace—the decision to cease fighting and to end violence—there is a clear continuity of the former into the latter. It can bring promise of new beginnings, yet for those who were caught in the crossfire, with the sound of shelling still ringing in their ears, aftermath is often devoid of promise. For those coming out of the shelters, it is the accounting for lost ones, the tending to visible and invisible scars, the making sense of a landscape in ruins. For them, aftermath remains an unremitting struggle in deserted battlefields.

The exhibition *Aftermath: The Fallout of War—America and the Middle East* is not about returning heroes and victories. Neither do the images constitute celebratory statements legitimizing the necessity of war. Rather, they drive our attention toward the survivors, the victims of war, those forced to continue living in the aftermath. And who are those victims? The vast majority of the images in *Aftermath* are from war-torn countries such as Afghanistan, Iraq, Syria, Lebanon, and Libya. These areas have witnessed brutal wars and conflicts; some

Eman Mohammed,
Baraa Azam sits in front
of his ruined house.

have lasted for decades, some flared up recently, and others are ongoing. Yet what they have in common is that they are countries dominated by Muslims. What the photographs in *Aftermath* manage to do, in a simple yet telling way, is point to the fact that the overwhelming majority of these conflicts' victims are Muslim, thus reversing the dominant image of the Muslim threat in which we see non-Muslims under attack by Islam. As such, they add complicating colors to our simplified black-and-white perspectives, reminding us how human suffering cuts across boundaries of race, nationality, and religion.

Real statistics are hard to come by, but a recent report showed that up to 97 percent of all casualties related to Islamic terror are Muslims.[2] Muslim civilians executed by ISIS alone amount to more than three thousand.[3] Much of this violence is, in other words, intrareligious, something that blatantly undermines the thesis of Samuel Huntington's *Clash of Civilizations and the Remaking of World Order*.[4] What we are seeing is an internal battle over the souls and minds of Muslims, where the imposition of certain sets of ideas—and the denunciation of these—translates into violence.

This could easily serve to confirm the oft-heard perception of Islam as a religion of the sword, a religion of aggression. References are made to Islam's scriptures—statements such as "kill them wherever you find them, and turn them out from where they have turned you out"[5] and "fight in the cause of Allah"[6]—essentializing Islam as a religion of war. Its early expansion is said to be through violent means, an image that has been reinvigorated post-9/11 in which Islam and terrorism appear as inseparable synonyms.

As a result we have become overcommitted to monitoring the movements of Muslims both globally and locally.

When seeking to nuance such a simplistic understanding of Islam as a religion of war, one needs to be careful not to retreat to the opposite—and similarly one-dimensional—notion of depicting Islam as a religion of peace. There is no denying that Muslims are engaged in acts of violence, or that terror is committed with reference to Islam. The point, however, is that Islam is neither a religion of peace nor one of war; rather, it is what its believers make it to be. Islam, like Christianity, Judaism, Buddhism, or any religion, is constituted by individuals, and these individuals actively and creatively use their religion's sources as divine imperatives to both instigate violence and establish peace. It is impossible to think of Islam as an abstract object separate and detached from its body of followers. It is these followers who constantly try to make sense of the scriptures, who seek answers about the nature of God, and who provide guidance for correct ethical behavior. The ambiguity of scriptures invites a range of interpretations dependent upon the readers' hermeneutic universe. That is why it is impossible, for example, to ask what Islam says about suicide bombings, the veiling of women, or the rights of minorities. Islam does not provide clear answers to these issues but Muslims do, and their opinions are often at odds with one another.

While we strive to balance such established perceptions of Islam by adding shades of gray to the picture, the question remains: Why are there so many wars and conflicts in the Muslim world? Yet again, the reality is more of a composite. Looking at the period after World War II, we see that Muslim countries have not been more involved in interstate conflicts than non-Muslim countries. Such conflicts have in this period been relatively few, surpassed by a gradual increase in civil wars and other internal struggles. Yet in neither of these types do we find Muslims overrepresented. What we do see, however, is a dramatic increase in the number of Islamic insurgency groups, particularly after September 11, 2001, and a subsequent surge of Muslims involved in conflicts. It is important here to recognize that many of these conflicts are directly and indirectly related to Western policies in general, and to the "war on terror" in particular. And it is important to remember that Muslims—as civilians—are carrying the heaviest burden. A recent study argues that the number of Muslims killed by the "war on terror" is grossly underestimated, and that the death toll could be as high as 1.3 million.[7] Moreover, we should not forget that these war zones are restricted to particular areas, and that large parts of the Muslim world have remained peaceful.[8]

When looking at the issue of terror attacks, we see a similarly multifaceted picture emerging. Since 9/11 there have been far more attacks in the United States by white supremacists than by Muslim jihadists, with forty-eight killings by the former and forty-five by the latter.[9] The high number of people killed by Muslim jihadists is attributed to the attack in Fort Hood and San Bernardino. In the European Union, fewer than 2 percent of all terror attacks between 2009 and 2013 were committed by Muslims.[10] Again, this is not an attempt to overlook Muslim involvement in acts of terror, but rather to remind us

that we often are presented with an image that does not always resonate with the reality.

Numbers and percentages have the unfortunate effect of concealing brutal reality and desensitizing us from the human suffering they represent. The images in *Aftermath: The Fallout of War* give us the opportunity to move from the abstract to the concrete, enabling us to grasp the actuality behind the statistics. Through aesthetic depictions of faces, expressions, and gestures, they give us embodied glimpses of daily realities and confront us with the brutality of people's suffering.

What immediately catches the viewer's eye in *Aftermath* is destruction and disfiguration. Gloriann Liu's and Rania Matar's images leave us with shattered cities, bombed-out buildings, scarred homes. Destruction is, in itself, brutally real, yet constitutes, at the same time, a powerful metaphor for what has happened—and still is happening—in many parts of the Muslim world, helping us understand the recurrence of conflict in these areas. In addition to being physically real, destruction is also about shattered political and societal structures. Continued war has had severe negative impacts on political institutions and governing bodies, often creating a situation of instability, insecurity, and a lack of law and order. Destruction also speaks to the crumbling of the social fabric of a community: time-honored patterns of human interaction are demolished, institutions and hierarchies are destroyed, leaving those who remain behind, in the aftermath, in an ambiguous void.

Destruction speaks directly to the notion of emptiness—another potent aspect of *Aftermath*. As the photographs confront us with shattered

city streets and war-torn landscapes, we are left with a feeling of desolation and absence. Again, this is vividly depicted in Liu's and Matar's photographs, as well as in Ben Lowy's images from Libya, where buildings resembling empty bookshelves are left standing in empty streets. At the same time, the photographs depict presence in the emptiness. Matar's images take us into private Lebanese homes, in ruins, yet with traces of human lives, traces of somebody once there, making presence merely a quiet memory of lived lives—like photography itself.

Emptiness, together with destruction, signifies how aftermath constitutes a void with undefined futures. When reality is in flux, it provides opportunities for actors to exacerbate this volatility, actors who exploit the absence of order, and who, under the guise of mending the situation, replace fragile peace with renewed chaos. These are the crucial reasons why aftermath often becomes an intermezzo before renewed conflict, in turn creating a spiraling effect of recurring conflicts, which easily spreads into new areas. It is not about Islam, about violent religious doctrines, but about vulnerable political contexts where the nation-state is a nascent phenomenon, and where those who remain are robbed of any resources to prevent further instability. Each recurring aftermath thus becomes a place in which it is increasingly difficult to create a meaningful future.

Emptiness in these photographs also has a more direct meaning related to spaces left vacant because the people have gone. This is where aftermath becomes an escape, not from war, but from a peace that never arrives. It becomes unbearable to the extent that people are forced

to leave their shattered homes and destroyed landscapes, embarking on an exodus toward the promise of an uncertain future. Such journeys of dislocation and relocation have occurred throughout human history, yet in recent years the number of refugees has reached new heights. In early 2016, it was reported that sixty million people were forced to flee their homes. While Afghanistan has produced more than six million refugees over the past three decades, images of Syrian refugees have captured our attention in recent months, and nearly nine hundred thousand have applied for asylum in Europe.[11] We tend to forget that there has been a steady stream of refugees leaving Syria for several years, and that there are millions of Syrians stranded in neighboring countries. There are more than five million people in camps in Lebanon, Turkey, and Jordan, and over seven million are internally displaced.

This situation is made visible in the photographs by Lynsey Addario, which depict endless rows of people on the move, of faces caged behind barbed wire, of hands reaching for help. In addition to speaking in a strong visual language about despair, the images reveal how aftermath for these millions of refugees stranded in camps is about being forced to flee, yet not reaching any promised land. Aftermath represents an intermediate stage of no return and no new beginnings. Addario's photographs reveal another aspect of emptiness, in particular the image of a lone man sitting on his suitcase in a barren landscape littered with empty water bottles. The water bottles illustrate the absence of people who once were there, and point to a brutal fact about the situation in Syria: out of a population of around twenty-two million, more than

half have fled their homes.[12] Such emptiness constitutes a significant dilemma for an eventual rebuilding of a destroyed society.

It can be said that the refugees' escape is a way of voting with their feet; a way of saying no to war and violence, to suppression and subjugation; a Muslim vote of "no confidence" to ISIS, al-Shabaab, and the Taliban. This demonstrates how unpopular these movements are, making it blatantly clear how inaccurate it is to equate Islam with terrorists. On the other hand, it is hard to talk about escape as a vote, as a matter of choice. Driven to the brink of despair, forced out of one's home, and journeying into the unknown is simply an act of desperation.

Victimhood knows no racial, religious, or national boundaries, and although *Aftermath* is related to distant conflicts, it is intrinsically connected to us. This is something made clear in Jennifer Karady's and Suzanne Opton's images of American soldiers. Through Karady's reconstruction of returning soldiers' traumas and Opton's display of naked faces, aftermath is brought to our shores and made our own. For many of these soldiers, aftermath represents no victory but an endless reliving of the horrors of war. This should open the doors to rooms where we could rethink the "war on terror." Is this a war we are winning, or are we producing constant aftermaths that spiral into new conflicts? Are we succeeding in "winning the hearts and minds" of so-called moderate Muslims, or are we losing them? And are we risking losing our own hearts and minds?

Yet, in the midst of all the suffering—*Aftermath* is also defiance. Defiance in the shape of Liu's wounded Syrian fighter playing with his daughter, or Lowy's picture of a smiling young

woman waiting in line to cast her vote. Or perhaps most telling of all, Eman Mohammed's images of a man feeding pigeons in front of the remains of his house, and of a boy stubbornly relaxing in what remains of a recliner in a bombed-out Gaza living room. Defiance is very much about stalwartness and the unwillingness to give in, and the determination to continue living. Our human history contains numerous aftermaths, telling the stories of ruins that can be rebuilt, of wounds that can be healed. Yet the aftermaths are also unfolding in a world marked by new interconnectivities that erase distance, and that remind us about our shared humanity. It calls for our engagement and is right here in front of us, on the walls of this exhibition and in these pages.

Notes

1 Teju Cole, "Memories of Things Unseen," *New York Times Magazine*, October 18, 2015, p. MM22.

2 Office of the Coordinator for Counterterrorism, U.S. Department of State, "Country Report on Terrorism 2011," July 3, 2012, http://www.state.gov/j/ct/rls/crt/2011/195555.htm (accessed October 14, 2015).

3 John Hall, "ISIS has killed 74 children and 86 women among the 3,000 civilians it has had executed in just one year, report reveals," *Daily Mail*, July 2, 2015, http://www.dailymail.co.uk/news/article-3146888/ISIS-killed-74-children-86-women-3-000-civilians-executed-just-one-year-report-reveals.html (accessed October 15, 2015).

4 Samuel Huntington, *The Clash of Civilizations and the Remaking of World Order* (New York: Simon & Schuster, 1996).

5 Qur'an 2:191.

6 Qur'an 2:244.

7 Physicians for Social Responsibility, *Body Count: Casualty Figures after 10 Years of the "War on Terror": Iraq, Afghanistan, Pakistan* (Washington, D.C.: Physicians for Social Responsibility, 2015), http://www.psr.org/assets/pdfs/body-count.pdf (accessed October 15, 2015).

8 Ida Rudolfsen, "Islam and Conflict," *PRIO Blogs*, April 15, 2015, http://blogs.prio.org/2015/04/islam-and-conflict/ (accessed October 13, 2015).

9 New America Foundation, International Security, "Deadly Attacks since 9/11," 2015, http://securitydata.newamerica.net/extremists/deadly-attacks.html (accessed October 14, 2015). If we exclude the 2009 Fort Hood incident, where a Muslim U.S. Army psychiatrist killed thirteen individuals, the scale shifts to 13–48.

10 Europol, *Te-Sat 2014: European Union Terrorism Situation and Trend Report 2014* (Netherlands: Europol, 2014), https://www.europol.europa.eu/content/te-sat-2014-european-union-terrorism-situation-and-trend-report-2014 (accessed October 11, 2015).

11 United Nations High Commissioner for Refugees, Syria Regional Refugee Response, "Europe: Syrian Asylum Applications," November 3, 2015, http://data.unhcr.org/syrianrefugees/asylum.php (accessed November 4, 2015).

12 "Syria's Drained Population," *Economist*, September 30, 2015, http://www.economist.com/blogs/graphicdetail/2015/09/daily-chart-18 (accessed October 14, 2015).

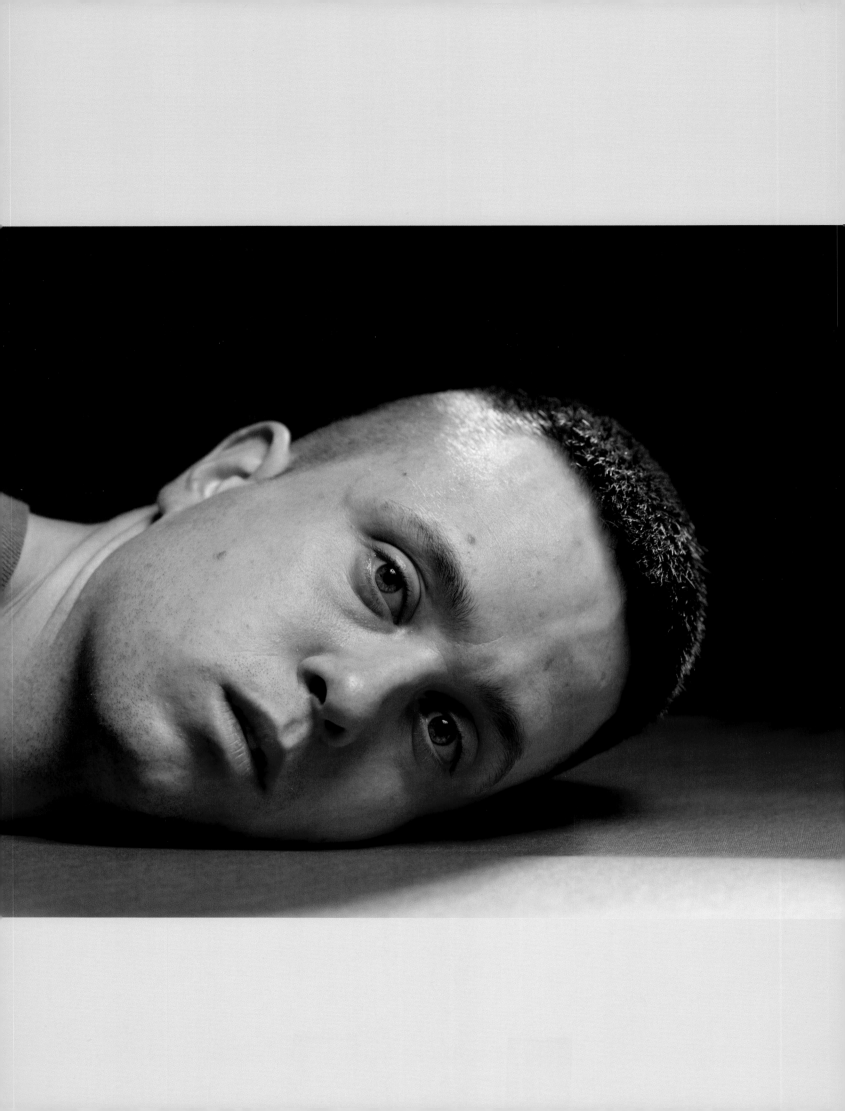

FALLEN: Suzanne Opton's Heroic Heads

PHILLIP PRODGER

Suzanne Opton's *Soldier* photographs first came to widespread public attention when they began to appear on billboards in numerous American cities in autumn 2008. Working with curator Susan Reynolds, Opton installed enlarged images from the series in prominent locations in Atlanta, Columbus, Denver, Houston, Miami, Minneapolis, and Troy, New York. This followed a related project in which photographs from the same series had been shown in Syracuse and Buffalo, on bus shelters, banners, and billboards; and climaxed in spring 2010 when a selection was exhibited on advertising sidings in the Metro in Washington, D.C. On billboards, the photographs were blown up as large as forty-eight feet wide, explained only by the word *soldier* appearing enigmatically in capital letters, and accompanied by a web address where interested viewers could see additional images and comment on them. They were spectacular and unmissable—a provocative counterpoint to the intimacy and ambiguity of the portraits themselves.

For an artist who conceives of her work as largely performance-based, installing photographs on billboards was a calculated experiment designed to add a layer of meaning to a project already rich in significance. To make the *Soldier* portraits in the first place, Opton received permission to shoot at Fort Drum, New York, where she invited active-duty soldiers to participate in a mysterious photography project, the precise nature of which was not made clear. Upon arriving in her temporary studio, subjects were given the simple direction to kneel and lay their head on a table. The reason this particular pose was necessary was not explained, and the

Suzanne Opton,
*Soldier: Bruno—355
Days in Iraq*

action must have been baffling to the sitters. Opton gave her subjects time to negotiate the discomfort of the situation, and their construal of the unusual instruction contributes to the pictures' interest. Some sitters strained to lift their heads. Others relaxed and closed their eyes as if in sleep or deep reflection. Because the images are in vibrant color, tightly focused, and have few environmental clues, every detail of the heads takes on heightened significance. Some stare into space. Others engage the camera directly.

Opton started photographing soldiers in response to the second Iraq War, which began in 2003. The soldiers who agreed to participate were veterans (or were about to commence service) of the American wars in Iraq and Afghanistan. All were military volunteers, and nearly all were about to return to combat. To Opton, the soldiers were both individuals with their own unique personalities and ambassadors from an unfamiliar world. Because the artist has never experienced frontline conflict herself, each soldier served as a sort of rhetorical Mars probe, forged by the unfathomable situations he or she has witnessed, and returned to bear witness. Although injuries are not conspicuously apparent, the people Opton photographed have nevertheless been affected by their experiences, the subtleties of carriage and demeanor sometimes hinting at what they have been through. Seen this way, each face and every piercing set of eyes is an enigmatic window onto occurrences far removed from civilian life.

Opton's *Soldiers* intersected with presidential politics during the 2008 Democratic National Convention in Denver, when then candidate

Barack Obama pointed to "the faces of American citizens" in his acceptance speech. With rhetorical flamboyance, he described "the face of that young student who sleeps just three hours before working the night shift," explaining, "I think about my mom, who raised my sister and me on her own while she worked and earned her degree."[1] He mentioned that "in the faces of those young veterans who come back from Iraq and Afghanistan, I see my grandfather, who signed up after Pearl Harbor, marched in Patton's army, and was rewarded by a grateful nation with the chance to go to college on the GI Bill."[2] Obama may not have realized it, but at that very moment, Opton's *Soldier Claxton* hovered on a prominent billboard just a few blocks away. Installed at Lincoln and 18th Streets, it showed exactly what Obama said had moved him—the face of a soldier who had served in Afghanistan.

It was a timely, if ironic, coincidence. Like the photographs themselves, Opton's billboards were equivocal in their meaning, calculated to spark thought rather than make a specific political point. The large, cryptic pictures became blank slates on which pundits could project their own theories. Enlarged to supernatural size, they clearly said *something*. What that something might be became a matter of sometimes heated speculation. The images were quirky, intimate, and inscrutable, while the presentation was bold, forceful, and direct. The soldier of Obama's rhetoric was heroic, determined, and proud—the type of valiant soldier so often depicted in traditional military portraits. Claxton, by contrast, lies with his head almost flat, his face half-bathed in shadow,

and his eyes vacant. He is isolated, singular, and curiously beautiful—a physical presence, raw, human, and imperfect.

Opton's photographs clearly express unease about the toll combat can take on members of the armed forces; however, the artist is careful not to associate her photographs with a particular political party or cause. Opton had planned a parallel showing the following week, during the Republican National Convention in Minneapolis–St. Paul, with five *Soldier* billboards spread out across the city. However, CBS Outdoors, which owned the structures, withdrew permission the week before they were to be installed. "Out of context," CBS Outdoor's executive vice president Jodi Senese explained, "the images, as stand-alone highway or city billboards, appear to be deceased soldiers. The presentation in this manner could be perceived as disrespectful to the men and women in our armed forces."[3] They are, Senese said, "Gigantic, larger than life—just heads with blank eyes staring out at you."[4] Eventually rival company Clear Channel agreed to rent their billboards for Opton's project, but by then the convention was over.

Senese's concern that Opton's photographs could be interpreted as meditations on death hint at the multifaceted readings possible in the *Soldier* series. With their subjects lying prone, looking toward the viewer at close distance, they afford a privileged view that few ordinary people have of military men and women. As Senese suggests, they might be seen as the final gaze of a mortally wounded soldier, or of a fallen hero on a mortuary slab. Alternatively, they could be interpreted as a prisoner about to be beheaded,

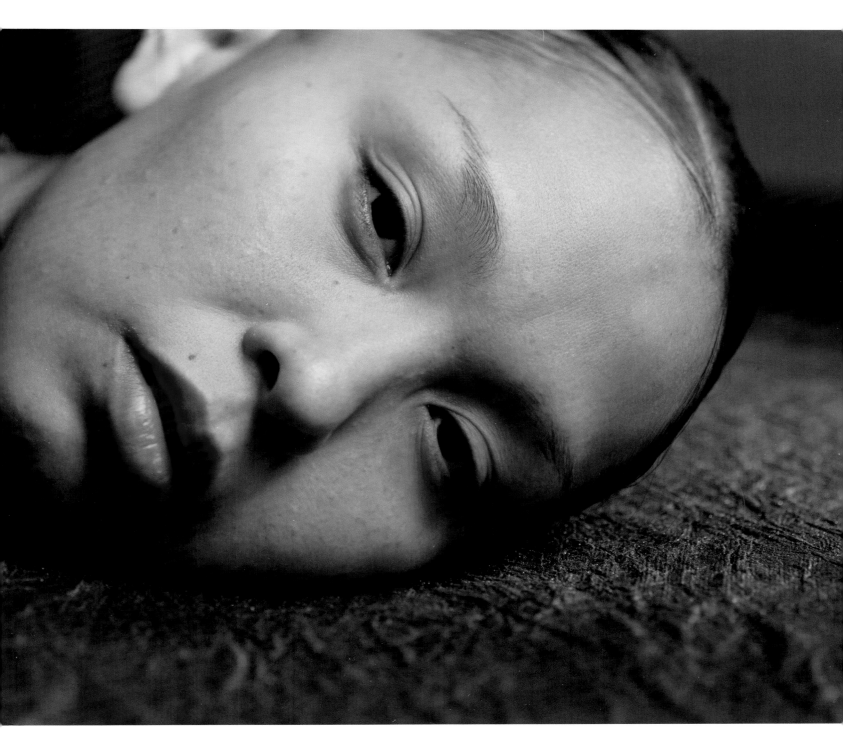

Suzanne Opton, *Soldier: L. Jefferson—Length of Service Undisclosed*

a practice prevalent in Iraq at the time these pictures were made. Their pose also mirrors the position of a statuary head toppled from its pedestal, as when former Iraqi president Saddam Hussein's bronze likeness was brought down in Firdos Square, Baghdad, in April 2003. Yet there are other, less ominous interpretations. The same level view could be that of a bunkmate in barracks before lights out, or of a lover looking across an adjacent pillow. Or it could be the view a mother has of her child before tucking him or her in at night.

The image of the warrior in American society, as in most cultures, is intensely charged. Soldiers are meant to be fearless and resolute, but in Opton's pictures they appear vulnerable, personable, and ambiguous. Traditionally, military portraits show men of action—Jacques-Louis David's *Napoleon Crossing the Alps* (1801–1805), for example, or Emanuel Leutze's *Washington Crossing the Delaware* (1851)—and in such images, the patriotic message is clear and virtue is apparent. Opton inverts this convention, curbing any temptation toward pomp and self-congratulation. Whereas in traditional military portraits, leaders look down from on high, replete with military garb and showy weapons, in Opton's pictures, the figures are shown close, at the same height as the viewer or slightly below, and stripped of decor. In place of nationalism, she invites compassion. Instead of zeal, she encourages contemplation.

Opton's photographs cleverly co-opt conventions from the commercial world. They resemble fashion shots more than traditional war photographs, an association ultimately reinforced by the use of billboards for exhibition. Her neutral backdrops, sharp focus (albeit with narrow depth of field), and pared-down use of props parallel the techniques of Richard Avedon, who sought to emphasize personality by minimizing extraneous information, and whom Opton cites as a conscious influence. The concordance with fashion photography contributes to the equivocal air of the series: Opton is portraying serious subject matter with techniques normally identified with comparatively lighthearted publications.

Several writers have remarked on the similarities between Opton's *Soldier* photographs and the sculptures of recumbent heads that Constantin Brancusi produced in the 1910s.[5] Brancusi's sculptures, disembodied ivory-white stone heads lying on their sides, do exhibit a similar ethereal appearance and assume the same unusual pose—the dissociated heads appearing like so much fruit in a still life. However, there is a critical difference. Unlike Brancusi, Opton has used photography to execute her pictures, with the empirical associations that entails. Despite its well-known susceptibility to manipulation, photography is still perceived largely as an objective medium, and its evidentiary function is critical to Opton's approach. Her photographs are, in this sense, evidence *of evidence*—the photograph records the person, while the person represents things that happened in another time and place. Opton maintains that the experience of war is written in the faces of the people she photographs. She believes that photography, with its special reputation for objectivity, is the best way to convey that.

The captions that accompany Opton's photographs echo the artist's desire to convey elusive

narratives. In the *Soldier* series, each portrait appears with the sitter's last name, and the number of days and place served. By providing quantifying information, Opton encourages the viewer to weigh the relative effects of military mobilization. Can we see the difference between a long or short tour of duty? Is one theater of war more punishing than another? Such questions give the pictures a cinematic edge, almost as though they are stills from a macabre film. In Opton's work, text and image perform an intricate dance, each conveying elements of a story that can never be truly absorbed. This failure to connect fully is one of the reasons for the portraits' effectiveness. Closeness and distance are inextricably linked, as the viewer is brought face-to-face with people who are intensely real, but whose experiences are so far removed from quotidian concerns they are impossible to fully comprehend.

Although her portraits play on traditions of "documentary" photography (a category which is itself increasingly acknowledged as problematic), they are artfully constructed to convey just the right amount of detail. Never retouched or made up, her soldiers are shown as they really are, their acne and razor burns visible for all to see. At the same time, they are subtly ennobled, photographed against neutral backdrops, and artificially illuminated with dramatic studio lighting. An array of color gels was used in the *Soldier* portraits to lend them an otherworldly quality, from shimmering blue green to orangey red. Referencing nineteenth-century photographer Julia Margaret Cameron, Opton frequently photographs with shallow depth of field, allowing only a narrow plane of a sitter's face to come into focus. And like Cameron, she uses bold washes of shadow to charge her pictures with emotion.

Much of Opton's art lies in her ability to cleverly walk the line between providing and withholding visual information, as when she takes an intimate picture of a soldier's head and enlarges it to the size of a billboard. She constantly sets up expectations, only to confound them later. At heart, her pictures are whispers—sensitive, uncertain, and insistent. But they are spoken through a megaphone.

Notes

An earlier version of this essay appeared in *Suzanne Opton: Soldier/Many Wars* (Seattle: Decode Press, 2011).

1 Senator Barack Obama, "The American Promise" (speech, Democratic National Convention, Denver, CO, August 28, 2008).

2 Ibid.

3 Daniel Nasaw, "US Election: Billboards of US Soldiers Cancelled in Host City of Republican Convention," *Guardian*, August 28, 2008, n.p.

4 Susan Saulny, "Battles over Billboard Space Precede G.O.P. Gathering," *New York Times*, August 30, 2008, p. A10.

5 See, for example, Vicki Goldberg, "On Guard: Soldiers Off Guard," *Contact Sheet* (March–June 2006), pp. 2–4.

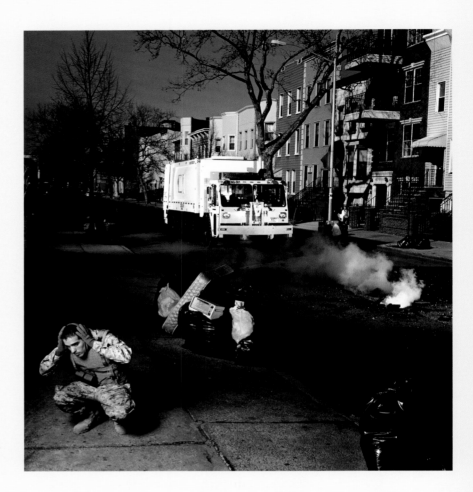

Jennifer Karady, *Former Sergeant Jose Adames*

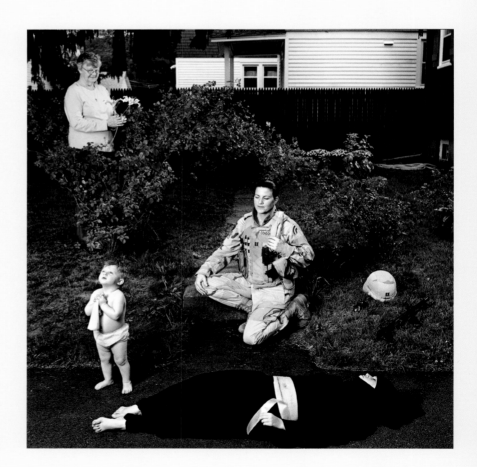

Jennifer Karady, *Captain Elizabeth A. Condon*

SIGHT UNSEEN

CAROL MCCUSKER

Memory . . . is the diary that we all carry about with us.

—Oscar Wilde

We transform our past as a gesture of faith in the future.

—Tristine Rainer

As night falls on a quiet Brooklyn street, a soldier in full uniform drops to a crouch, hands to ears, anxiously blocking the sound of a dump truck hitting a pothole.

In a backyard garden, a toddler raises her face toward a beatific light. Beside her, a woman in a black burka lies unconscious, her stomach exposed to reveal a wound held together by household tape. In the center, under an arch of roses, kneels a female soldier; an older woman looks on.

These aren't descriptions of the political paintings of twentieth-century artists Leon Golub or Sue Coe; they are the meticulously composed photographs from the series *Soldiers' Stories from Iraq and Afghanistan* (2006–present) by artist Jennifer Karady, whose subject is things we cannot see. Karady photographs the memories and emotional impressions of veterans returning from Iraq and Afghanistan—the invisible war carried home internally. Most of us go through our day with thoughts and associations triggered by sounds or by seasons simultaneously layered into routine activities such as driving to work or making dinner. The flashbacks of a veteran, however, are of such a different nature that overriding them with routine or reassurances takes work.

For former Marine sergeant Jose Adames, the soldier on the Brooklyn street, that is a fact. He can't forget an ambush that took place in Al Asad Canyon, outside Baghdad, that left him with post-traumatic stress disorder (PTSD). In Karady's photograph, Adames's dual realities are played out. He occupies the same domestic space as his fellow New Yorkers, yet another internal reality, triggered by sound, sets him apart. Blown

sideways, knocked unconscious, and suffering from severe wounds during the ambush, he was medevacked first to Baghdad and then to Germany. Once stateside, he experienced mild blackouts when he heard garbage trucks hit potholes, a sound dreadfully similar to incoming mortar fire. His return home also led to five months of homelessness, signified in the photograph by the domestic items (a mattress and toaster oven) stacked on the sidewalk behind him. Now living in Queens, Adames works with homeless veterans and studies accounting in Brooklyn.

The human mind has often been compared to a camera, "a light sensitive material with repeatedly exposed frames, recording indelible experiences that re-present themselves when prompted."[1] With care and full collaboration, Karady coaxes these delicate experiences out into the light and onto the paper, "laying the ghost," as Richard Avedon said about photographing difficult subject matter.[2] Karady's final image is, in essence, a single-frame movie—a documentary and feature film combined. Working with individual soldiers, she carefully listens to their stories and then stages their memories for the camera, finding props, locations, clothing, and additional actors (often family members and friends) to bring their specific narratives to life. "I'm trying to represent what it feels like for the veteran coming home to sometimes live in two different realities at once," Karady says, "whether in the form of a flashback, memory, or image that pops into their head uncontrollably. That's where the surreal juxtaposition comes in, not a dream state, but quite a real one for those experiencing it."[3]

In the past decade, there have been concerns that photography's role as a reliable source of

documentation has been undermined by staged fictions and computer manipulation, thereby throwing every image into doubt. However, photography critic Vince Aletti wrote, "If absolute truth were the only thing photography had to offer, it would have disappeared a century ago. Photography isn't merely a window on the world, it's a portal into the unconscious, wide open to fantasies, nightmares, obsessions, and the purest abstraction. . . ."[4] Indeed, staged, single-image narratives are not new to the medium. Nineteenth-century photographers such as O. G. Rejlander and H. P. Robertson pieced together multiple negatives to form complex, single-frame stories that addressed the social concerns of their time—moral turpitude, death from tuberculosis (the AIDS of their era)—or as simple entertainment. Many contemporary photographers are doing the same. Rather than photographing what *is* in the world (as, for example, Robert Frank and Nan Goldin), they create poignant, alternate realities inspired by the major art form of our time, cinema. And, like cinema, the photographs are concepted, often storyboarded, and constructed as full sets, complete with lighting, props, cast, and crew.

Jeff Wall, whom Karady names as an influence, is a master of this genre. His work openly acknowledges the narrative power of filmmaking as well as the narrative tableaux found in traditional painting since the Renaissance. Fittingly, in addition to being a photographer, Wall is an art historian. In dynamism, emotive intensity, epic metaphors, and size (his photographs can be as large as 7×13 feet), his *Dead Troops Talk* (1992) is similar in scale to grand history paintings such as Théodore Géricault's *Raft of the Medusa* (1818–1819) and Jacques-Louis David's

Oath of the Horatii (1784). There are also traces of Leonardo's *Last Supper* in Wall's cluster of two to three soldiers together, each in an insular state of reverie or animation. The work's subtitle is "*A vision after an ambush of a Red Army patrol, near Moqor, Afghanistan, winter 1986.*"

Based on an actual event, the "vision" is Wall's, and portrays the bloody aftermath of an ambushed Soviet patrol as he imagined it. The photograph was shot in a temporary studio, and the artist employed actors, props, special effects, and makeup professionals. He photographed the figures separately or in small groups on different days, as time allowed, and the final image was assembled from various files into a digital montage.

Dead Troops Talk is not unlike Karady's *Soldiers' Stories*. Both hold real events and internal impressions in close proximity, merging them to produce a third entity: factual invention. Karady, however, works with real people who are dramatizing *their* stories through literal depiction and some allegorical devices. Her technical process doesn't involve digital montage. Instead, many sheets of film are exposed during her shoots, from which she chooses the best-resolved image. Light, gestures, expressions, ambience, and locale are realized in a single frame—the product of twenty years' work as a fine art and commercial photographer, during which time Karady mastered both her craft and an intelligent approach to her practice.

As an undergraduate at Brown University, Karady studied critical theory, art history, film, and literature, and this interdisciplinary background informs her image making. In 1998, she earned an MFA from Rutgers University, where she studied with Dawoud Bey and Martha Rosler. Karady acknowledges Bey's sensitive

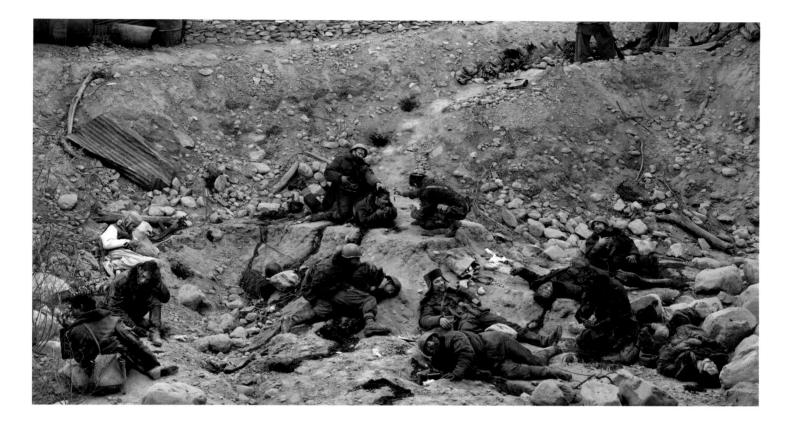

Jeff Wall (Canadian, b. 1946), *Dead Troops Talk* (a vision after an ambush of a Red Army Patrol, near Moqor, Afghanistan, winter 1986), 1992. Transparency in lightbox, 90⅕ × 164⅕ in. (229.0 × 417.0 cm), courtesy of the artist.

approach to portraiture as influential, recently noting the parallels between his ongoing *Class Pictures* series and *Soldiers' Stories*. Using a large-format camera, which slows down the picture-making process, Bey engages his sitters through conversation, preparation, and collaboration. He also asks them to write personal testimonies that complete and deepen the portrait, and the result is perceptive and respectful. In Rosler's politically charged and timeless work *Bringing the War Home: House Beautiful* (initially about Vietnam, but continually updated), the artist has collaged war photography with images of domesticity gleaned from contemporary interior-design magazines. The combination forces a cognitive connection between war trauma and the remove of most Americans from that experience. Rosler and Rutgers University, both promoters of feminist art practice, enlarged Karady's approach and curiosity toward gender expectations and social conditioning.

With *Soldiers' Stories*, Karady wanted to examine male expectations within a theoretical feminist framework. This led to an increasing

interest in military life, and Karady's awareness of the psychological trauma plaguing returning veterans. After reading and seeing numerous reports about PTSD in the news, she contacted several soldiers to see if she could help. They responded, and so began the *Soldiers' Stories* collaborative. Karady is reluctant to say that her images are politically motivated, but the personal *is* political in what we choose to read, consider, and speak and act on. Hers may not be antiwar photographs per se, but they speak to the physical and psychological well-being of returning soldiers that has hit a critical nerve in the present zeitgeist. Consider the recent photographs of Stephanie Sinclair, Lori Grinker, Andrea Bruce, Suzanne Opton, Ashley Gilbertson, and Jason Hanasik, as well as Kathryn Bigelow's film *The Hurt Locker*. Each includes a view into war from a personal or psychological perspective, thereby informing and expanding our understanding of it, one experience at a time. This is the nexus of feminist art at its best: the legitimization of the subjective narrative and knowledge through the body.

In this way, Karady is political. Her photographic practice allows veterans to openly acknowledge the depth of their experience, which informs their families and others who care about them. According to Dr. Jonathan Sherin, a Veterans Administration mental health clinician who uses Karady's art in local and national conferences, the images "help us understand our soldiers so that we can heal together as a people. There is no higher calling for our arts, humanities, sciences or politics."[5]

With *Soldiers' Stories*, Karady could fall into the historical lineage of the many female war photographers who came before her, such as Gerda Taro, Margaret Bourke-White, Thérèse Bonney, Catherine Leroy, and Susan Meiselas, among others. Karady is not a successor to their documentary approach, but perhaps to their intentions. Bonney, Meiselas, and the other female photographers were firm in their personal politics, sought direct experiences, held uncompromising points of view, and were capable of expressing them with a camera (or pen) on par with the men of their generation. They took risks, actively negotiated the terms of their careers, traveled widely, and worked their entire lives. Each faced the consequences of her actions, and turned them into popular cultural forms—photo essays, books, films, and exhibitions. Unlike many of their male contemporaries, they didn't self-destruct through alcoholism, depression, suicide, or the constant daring of odds that can lead to fatal outcomes.

The result is that their collective output visualized the emotional intimacy, vulnerability, and solidarity of underrepresented populations. During World War II, the Vietnam War, and the war in Nicaragua, these photographers made visible the effects of mass combat on civilians caught in the crossfire. They may not have produced photographs as dramatic as those of Robert Capa, whose proximity to battle was a male privilege, yet they forged another way toward connection and compassion. Their images and stories refused the silence allotted to the marginalized. Karady's staged photographs are equally as powerful in that they are loaded with symbolic objects and gestures, psychological referents, and nods to art history and cinema, "transforming what may be a negative experience into a positive one."[6] Like the female photographers before her, Karady gives visibility to a terrible truth, and coaxes the realm of memory toward new possibilities.

Notes

1 Jason Evans, "Fade to Black: Sarah Pickering's 'Incident' Pictures," *Photoworks* 11 (Autumn/Winter 2008).

2 Richard Avedon, in "Richard Avedon: Darkness and Light," *American Masters*, season 10, episode 3, directed by Helen Whitney, aired January 24, 1996 (PBS), 90 min.

3 Jennifer Karady, in an interview with Chuck Mobley in *Jennifer Karady: In Country: Soldiers' Stories from Iraq and Afghanistan*, ed. Jennifer Karady and Chuck Mobley (San Francisco: SF Camerawork, 2010).

4 Vince Aletti, "Is Photography Over?" San Francisco Museum of Modern Art Symposium, April 22–23, 2010, transcript available at https://www.sfmoma.org/watch/photography-over/.

5 Jonathan Sherin, in *Jennifer Karady: In Country: Soldiers' Stories from Iraq and Afghanistan*, ed. Jennifer Karady and Chuck Mobley (San Francisco: SF Camerawork, 2010).

6 Karady, *Jennifer Karady: In Country.*

Plates

How do you make people see that everyone's
story is now a part of everyone else's story?

—Salman Rushdie (interview in *The Paris
Review* 174, summer 2005)

Lynsey Addario

American

The Blade

first appeared
in my heart, a thick wall
of muscle, accustomed
to beating. It hardly hurt.

Then I began to feel it
in further regions, sloped
liver, the coastal spleen.
I knew it could maneuver

and multiply, laying waste
to my forests, making camp
in the gravel and fear. I tried
to explain: tent after tent,

a sharp army. Everyone
thought I was crazy. My brother
begged me to write it all down,
imprison my deserts on paper

we'd burn late at night. Then,
my body stopped being able
to contain all the heat
and the metal. There were blades

in the earth, in the sky, under
everyone's feet. We struggled
to locate our voices. *Come,*
we said to each other. *Pack up*

your pillow and teapot. We
must travel even further inside.

—KIRUN KAPUR

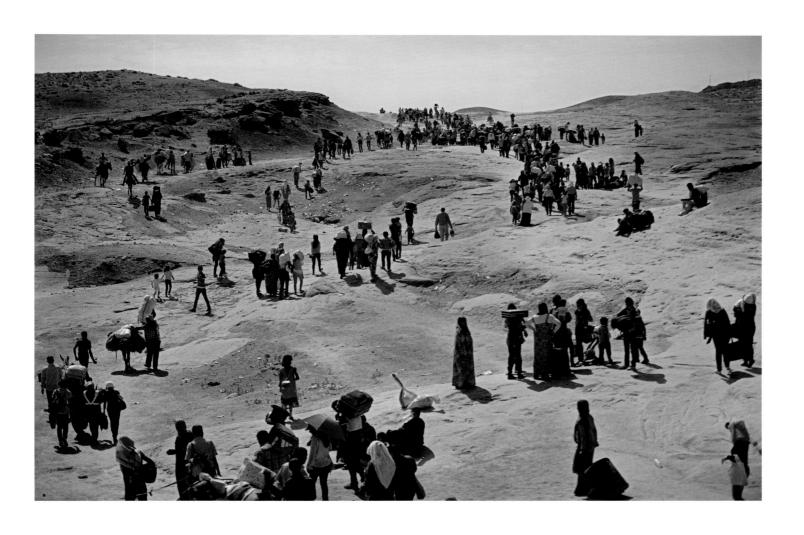

Lynsey Addario
Syrian Refugees, Northern Iraq, August 20, 2013
Archival pigment print

After crossing into northern Iraq near the
Peshkhabour border in Dahuk, refugees from
Kamishli, Syria, wait to be transported to a refugee
camp. Ethnically, most of the refugees are Kurdish,
and they are fleeing increased economic strife and
insecurity as well as shortages of electricity, water,
and food.

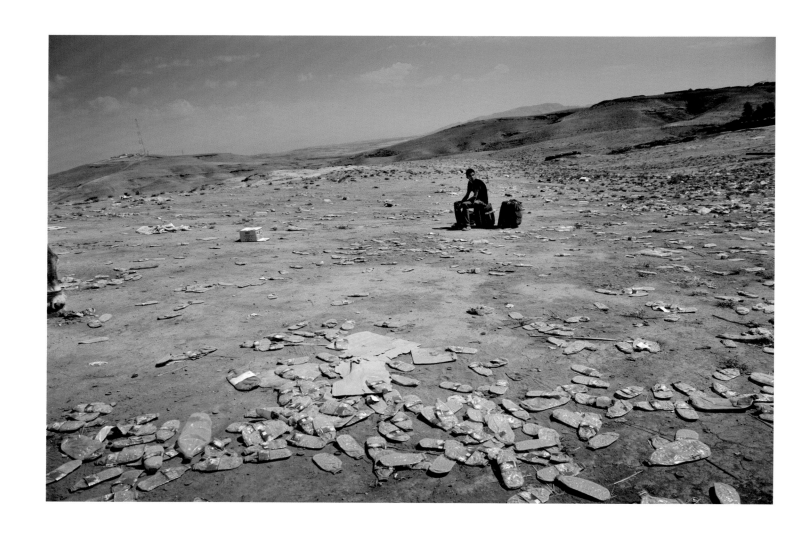

Lynsey Addario
Syrian Refugee, Waiting to be Transported,
Northern Iraq, August 21, 2013
Archival pigment print

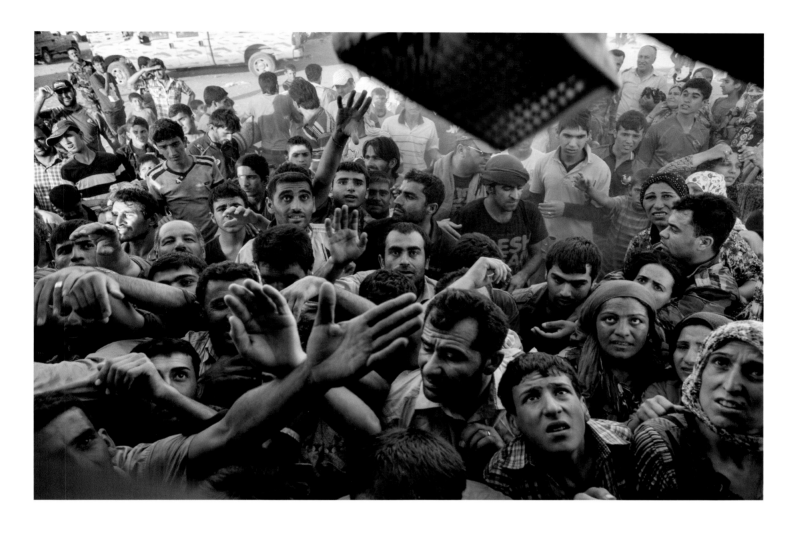

Lynsey Addario
Kawrkos Camp, Northern Iraq, August 20, 2013
Archival pigment print

Syrians who arrived with a recent wave of refugees
fight for clothes and other items distributed by
Kurdish people at the Kawrkos camp outside Erbil,
northern Iraq.

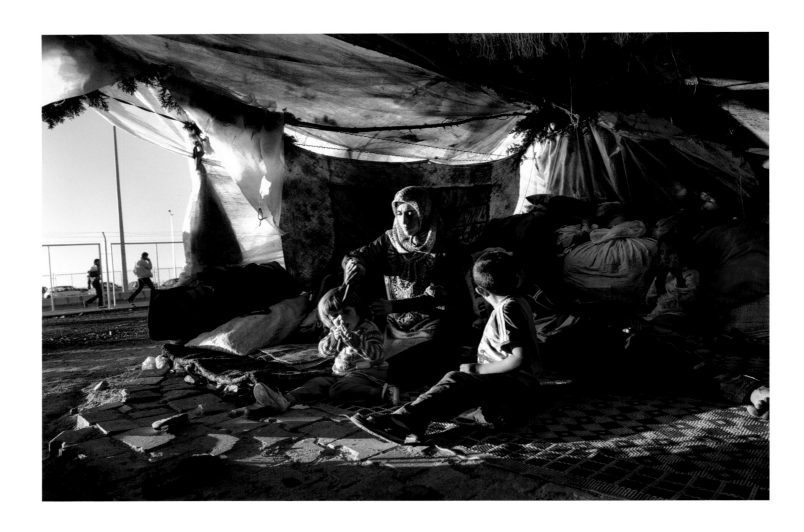

Lynsey Addario
Killis Camp, Turkish/Syrian Border in Turkey,
October 22, 2013
Archival pigment print

Iman Zenglo, age thirty, sits with her five children
in a tent. She and her husband set up the tent three
months earlier, in the squalid squatters' camp outside
the Killis camp, which is on the Turkish side of the
Turkish/Syrian border. Many Syrian refugees cross
back and forth from Syria into bordering countries to
work as laborers and visit family.

Lynsey Addario
World Food Program, Zaatari Refugee Camp in Jordan, April 8, 2013
Archival pigment print

Syrian refugees collect their daily bread ration from the World Food Program (WFP) at the Zaatari refugee camp in Jordan. WFP distributes five hundred thousand pieces of bread each day to roughly one hundred thousand Syrian refugees living in the camp; at this distribution site, riots erupt almost daily as the refugees fear they will not receive their rations.

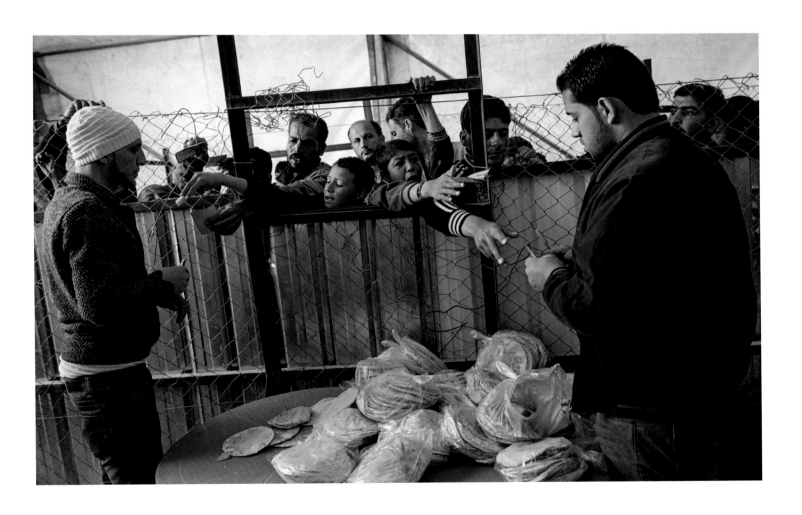

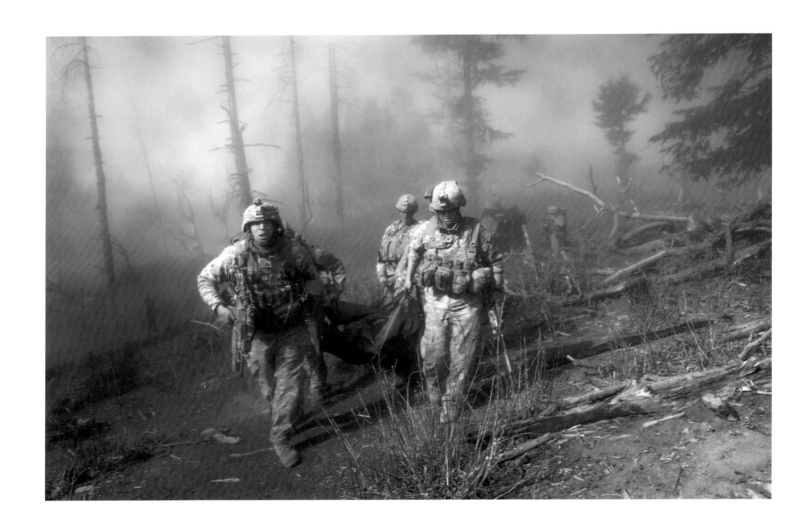

Lynsey Addario
Battle Company Is Out There, Korengal Valley,
Afghanistan, October 2007
Archival pigment print

U.S. troops carry the body of Staff Sergeant Larry
Rougle, killed when insurgents ambushed their squad
in the Korengal Valley.

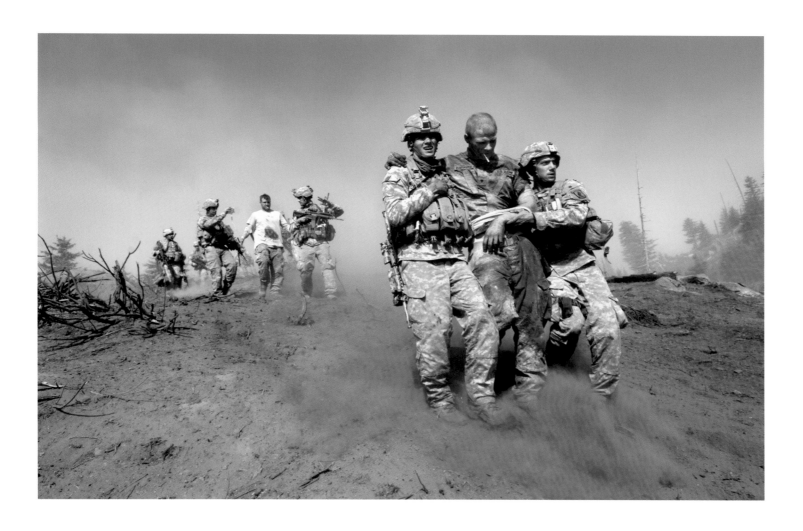

Lynsey Addario
Subduing the Korengal Valley, Afghanistan,
October 2007
Archival pigment print

Specialist Carl Vandenberge, center, and Staff
Sergeant Kevin Rice, behind, are assisted as they walk
to a medevac helicopter after being shot by insurgents
during a Taliban ambush.

Suzanne Opton

American

From the series *Soldier*

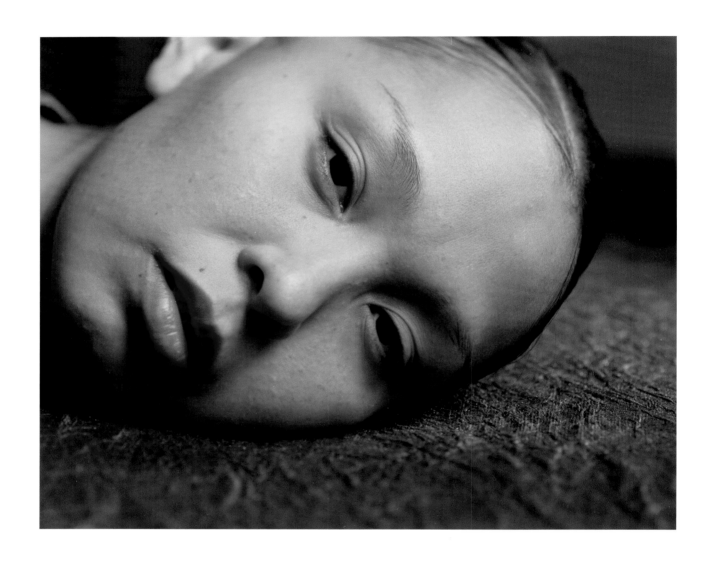

Suzanne Opton
Soldier: L. Jefferson—Length of Service Undisclosed
2004–2005
Archival pigment print

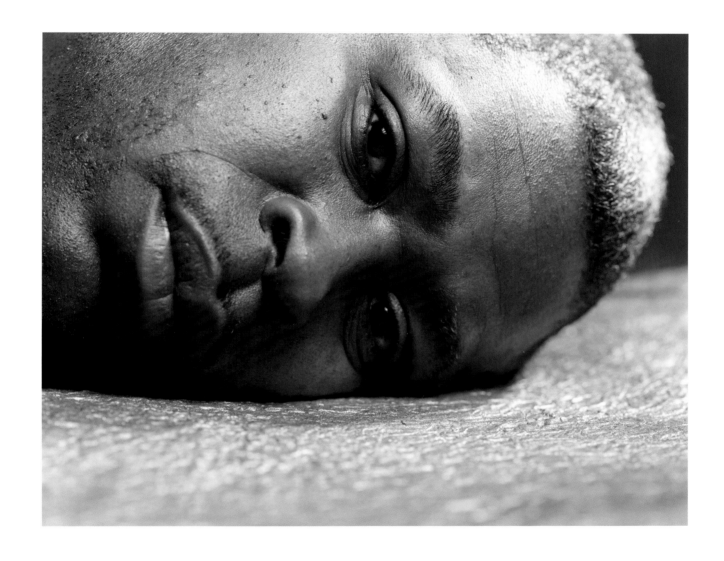

Suzanne Opton
Soldier: Williams—396 Days in Iraq
2004–2005
Archival pigment print

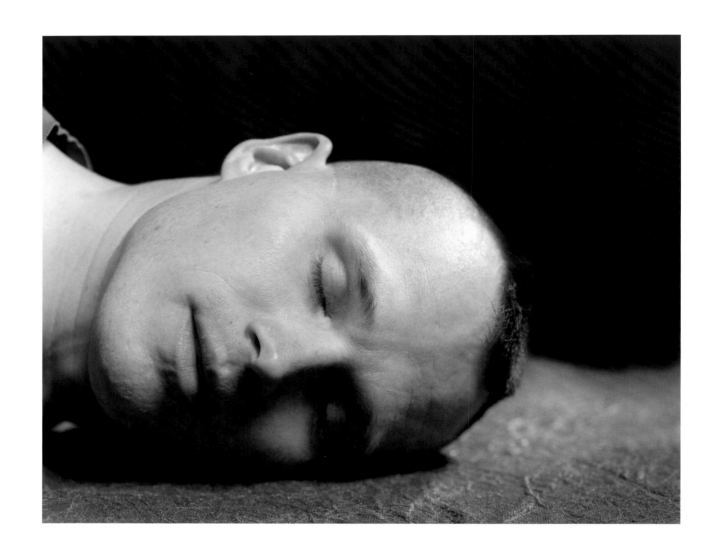

Suzanne Opton
Soldier: Pry—210 Days in Afghanistan
2004–2005
Archival pigment print

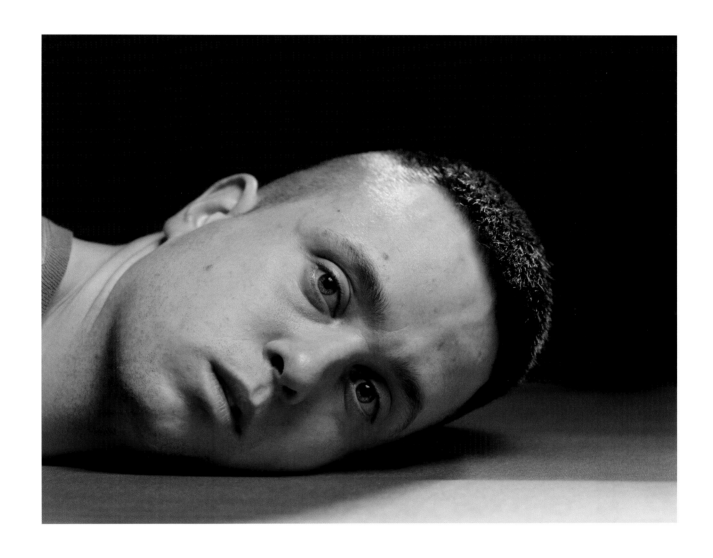

Suzanne Opton
Soldier: Bruno—355 Days in Iraq
2004–2005
Archival pigment print

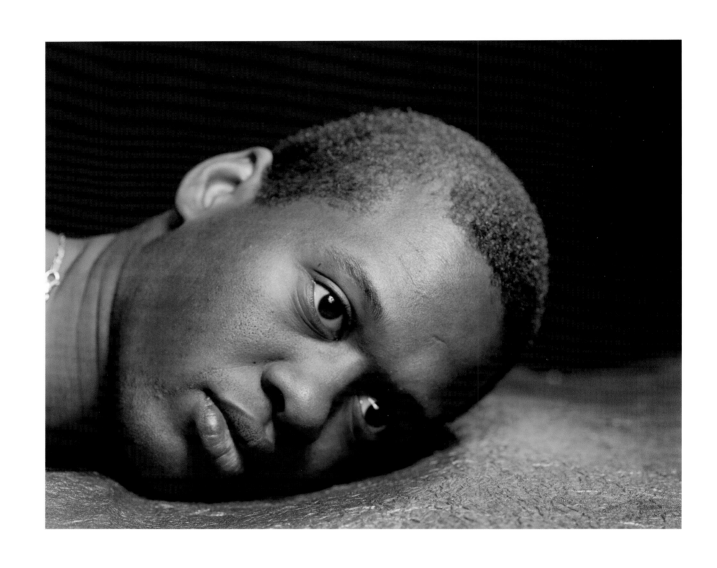

Suzanne Opton
Soldier: Kitchen—366 Days in Iraq
2004–2005
Archival pigment print

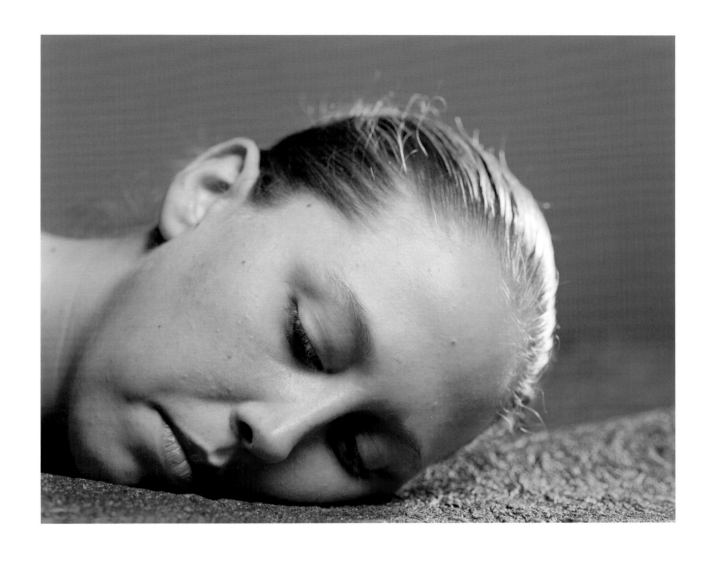

Suzanne Opton
Soldier: Morris—112 Days in Iraq
2004–2005
Archival pigment print

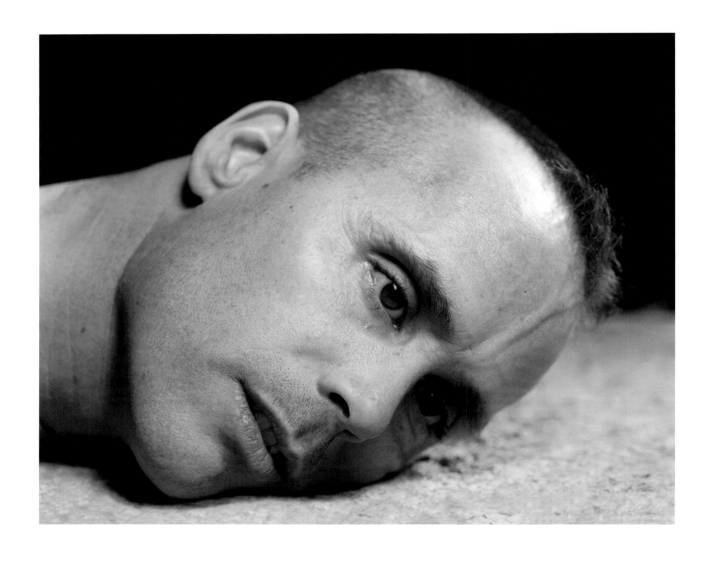

Suzanne Opton
Soldier: Dougherty—302 Days in Afghanistan
2004–2005
Archival pigment print

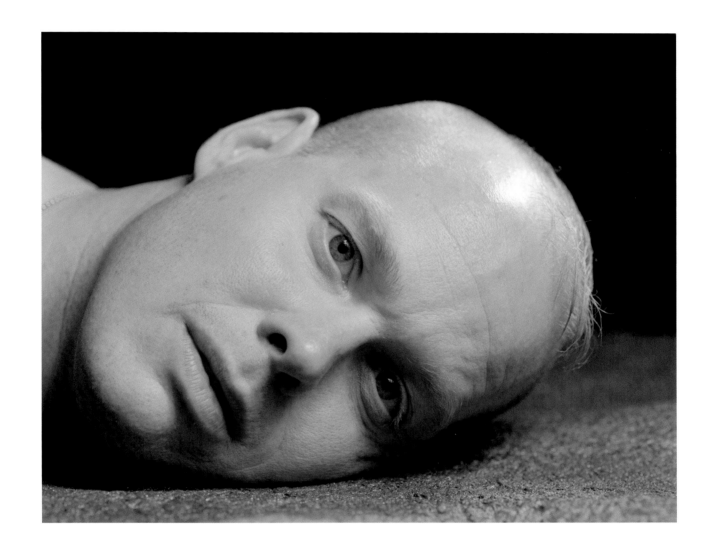

Suzanne Opton
Soldier: Bosiaki—364 Days in Iraq
2004–2005
Archival pigment print

Eman Mohammed

Palestinian

Shards

A technical failure terrible accident unfortunate
event regrettable but necessary we had
to take action there was no choice

Excuses pile up like body parts (gaping yellow-toothed
jaw separated from its head, neck slit open below the absent
chin, burned torso flaking like singed paper, brain spilling
from a broken child-size skull, severed hand still grasping)

Parts don't make a whole
Aid workers collecting heads and hands from the street in black
garbage bags lay out decapitated bodies on silver morgue trays, stack
appendages beside them like missing puzzle pieces, then go home
and hold their heads in their hands.

Maybe they pray for amnesia. Maybe they search
for answers: how many hands it takes to staunch a wound that won't
stop bleeding, how to remember the dream of an ordinary
life. Can a headless handless body cradle a child, greet
a neighbor, plant an orchard, plow a field, sign a peace treaty?

Some of the dead kept their heads. One young mother lies
waxen, holding two children in rigid embrace, slumbering portrait
belied by the blood smearing their cheeks—infant's mouth
slightly open, as if dreaming of a breast, the warm flow of milk;
tousle-haired girl-child turning in death's dream,
echoing her mother's pallid beauty.

Part of this has been screamed a million times.
Part of it will never be heard.
Part of it reflects like quiet light off the streams of untreated sewage
and pools of shimmering blood in Gaza lanes.
Part of it hides behind the headlines
where this shard of the story will never be told.

Beit Hanoun, November 2006

—Lisa Suhair Majaj

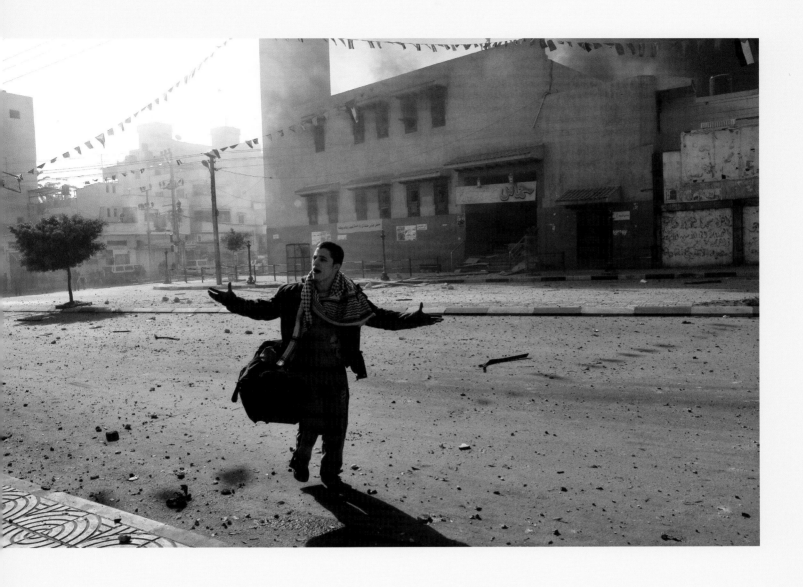

Eman Mohammed

Anguish outside Al Saraya police compound,
December 28, 2008.
Archival pigment print

A Palestinian man screams in horror outside Al Saraya
police compound after it was shelled by Israel.

Eman Mohammed
Baraa Azam sits in front of his ruined house.
Archival pigment print

Baraa Azam sits in a chair amid the ruins of his house after an Israeli air strike flattened the Al Zeitoun area in Gaza City. Baraa was slightly injured during the air strike. After going back home, he found his room and toys were destroyed. He asked his mother, "How will the school bus pick me up with all the rubble?"

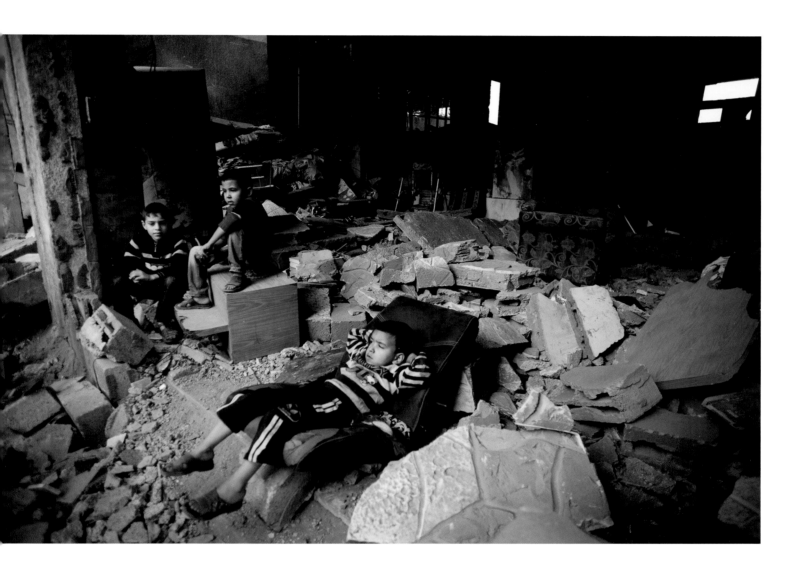

Eman Mohammed

Mohammed Khader, a Palestinian construction worker, feeds pigeons in front of the remains of his house, March 2006.
Archival pigment print

Mohammed Khader's home was destroyed during Israel's offensive, which ended in January in Jabaliya, northern Gaza Strip. Khader, his wife Ebtesam, and their seven daughters live without electricity or basic supplies.

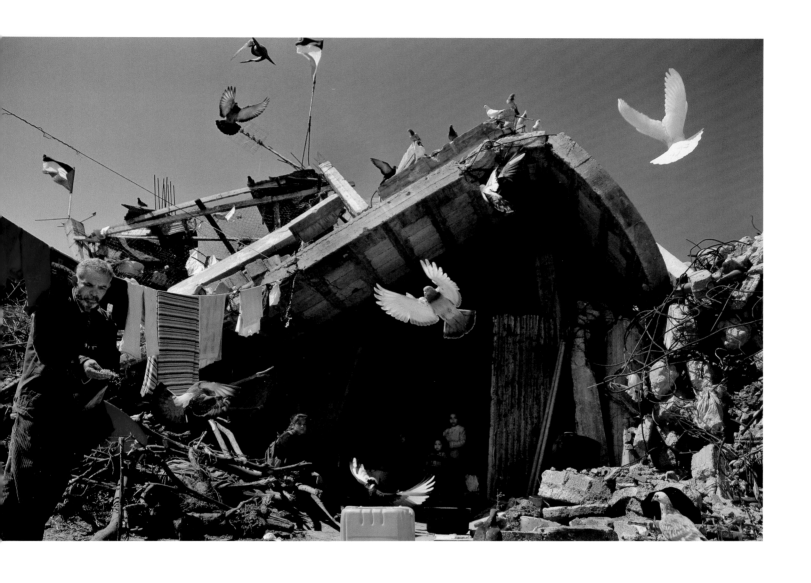

Eman Mohammed
The blood of Mazen al-Jarba, killed on July 7, 2014.
Archival pigment print

This is the blood of Mazen al-Jarba, a Palestinian militant who was killed during an Israeli air strike in Al Bureij refugee camp in the central Gaza Strip.

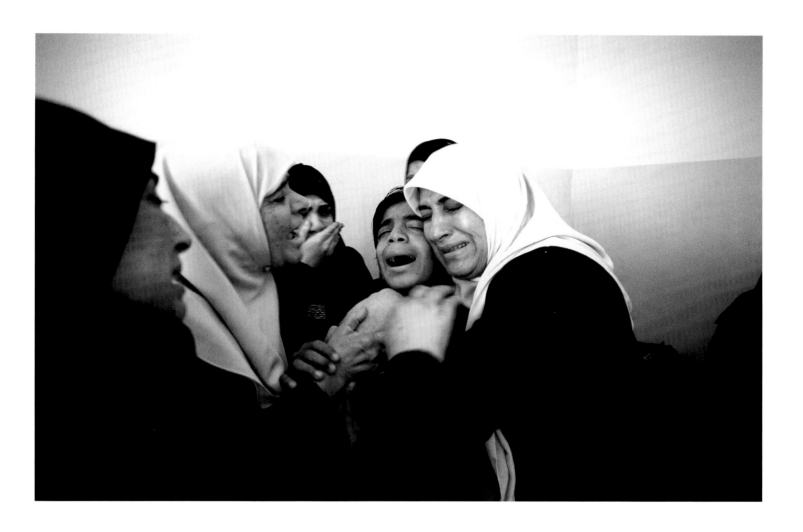

Eman Mohammed
Palestinian Marwan Sleem's relatives mourn at his funeral.
Archival pigment print

Relatives of Palestinian Marwan Sleem mourn during his funeral in the central Gaza Strip on July 7, 2014. Israeli air strikes on Gaza left nine dead and twelve injured.

Arguments

(For the people of Iraq)

consider the infinite fragility of an infant's skull
how the bones lie soft and open
only time knitting them shut

consider a delicate porcelain bowl—
how it crushes under a single blow
in one moment whole years disappear

consider: beneath the din of explosions
no voice can be heard
no cry

consider your own sky on fire
your name erased
your children's lives "a price worth paying"

consider the faces you do not see
the eyes you refuse to meet
collateral damage

how in these words
the world
cracks open

(1996)

—LISA SUHAIR MAJAJ

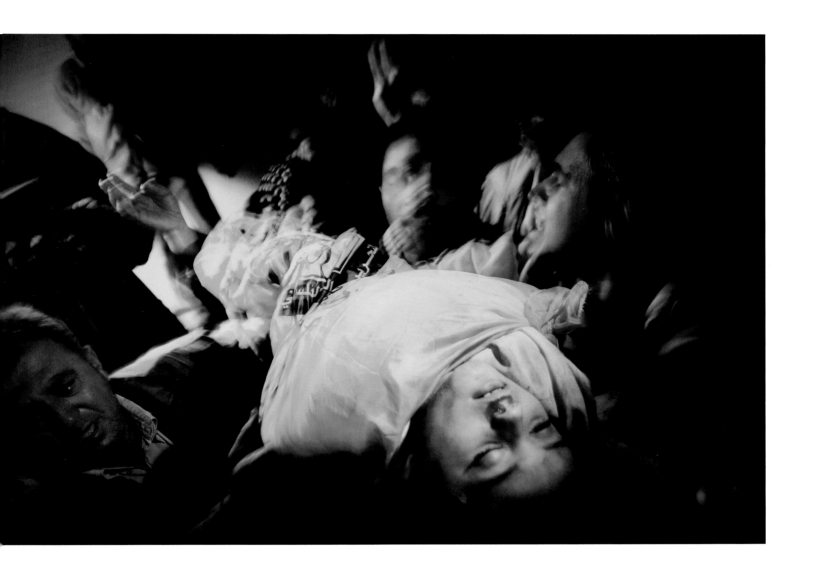

Eman Mohammed
Funeral of Lama Hamdan, December 2008.
Archival pigment print

Palestinians carry the body of four-year-old Lama
Hamdan during her funeral in the town of Beit
Hanoun, northern Gaza Strip.

Eman Mohammed
Palestinian relatives mourn Lama Hamdan,
December 2008.
Archival pigment print

Family mourns Lama Hamdan, age four, at her
burial ceremony. She was killed, along with her
older sister, during an Israeli air strike in northern
Gaza Strip.

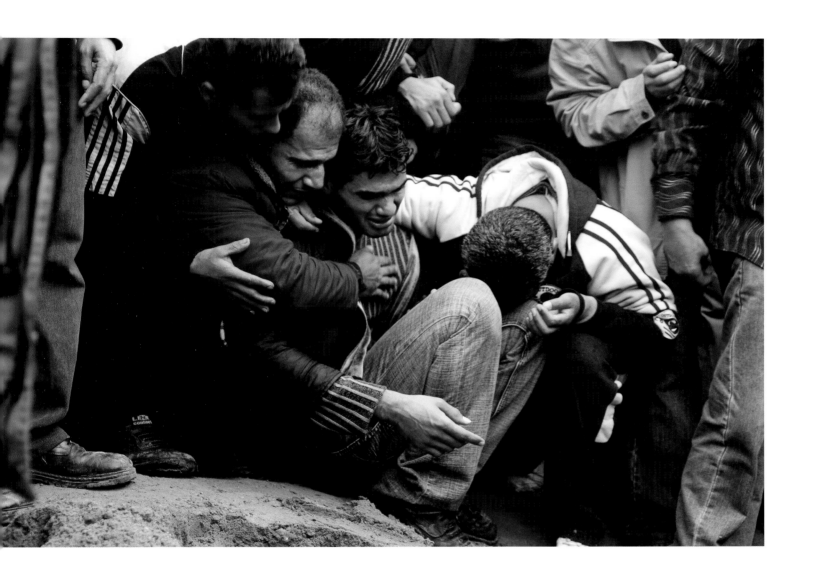

Ben Lowy

American

iLibya: Uprising by iPhone is a series created in tandem with the Arab Spring movement across the Middle East, which itself began through social media. Lowy writes: "My iPhone transmitted images from the field like many of the Libyan revolutionaries around me. Mobile phone cameras are innocuous and enable a far greater intimacy with a subject. Embracing this new paradigm of journalism—no middleman, no publisher—I posted images from Libya and gained scores of followers—Libyans, Americans, Europeans—who bypassed traditional news sources. As a photojournalist, my responsibility includes not just communicating content but also creating an aesthetic, a visual narrative that captures my audience's attention. The public today is more visually sophisticated than ever before. The overwhelming dearth of information on the internet tends to weaken the impact of content. Important stories get lost in the fray. So as a photographer, I need an image that will engage the viewer, make audiences question what they are seeing, and allow them to step closer to the image and, thus, the content."

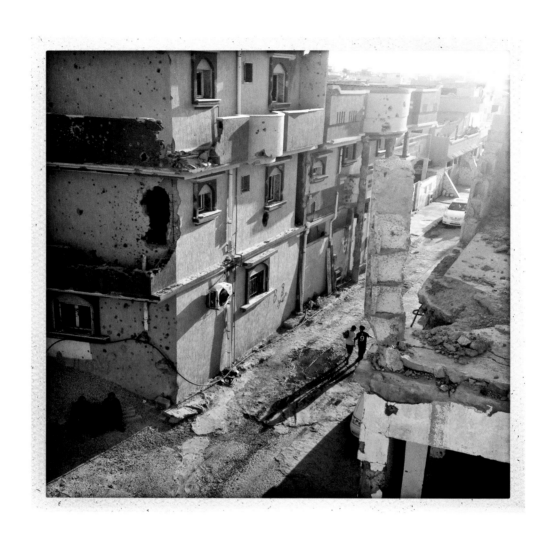

Ben Lowy
Libyan residents walk through the remains of buildings that have been riddled by mortars and bullets, July 16, 2012, Sirte, Libya.
Archival pigment print

Sirte is home to a large population of Gaddafi's tribe that still supports the dead dictator. They feel that no national reconciliation is possible while they are policed by the Misrata militia and Islamist brigades.

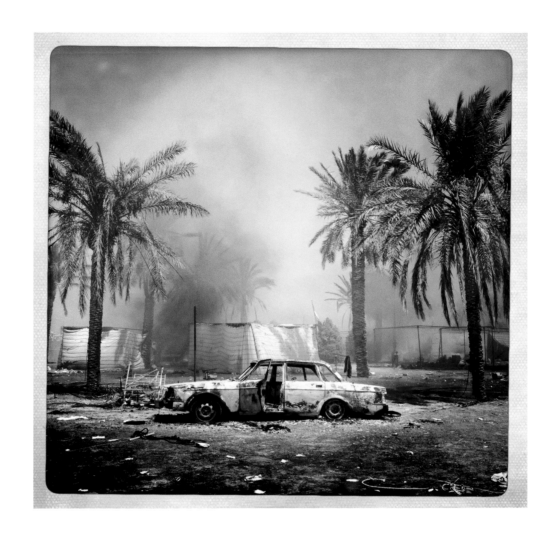

Ben Lowy
A car is torched, along with a Gaddafi loyalist
encampment, in the roundabout outside the
Bab al-Aziziya compound, Tripoli, Libya, 2011.
Archival pigment print

Ben Lowy
Ali, age eighty-three, an Internally Displaced Person (IDP) from Tawergha, stands outside his tent in a secluded Displaced Persons camp in the desert, July 9, 2012, near Benghazi, Libya.
Archival pigment print

After defeating Gaddafi government forces, rebels from Misrata destroyed the city of Tawergha, accusing its residents of supporting Gaddafi and committing atrocities alongside pro-government forces in Misrata. All Tawergha residents were forced to flee, and many are now essentially prisoners in Internally Displaced Persons camps set up throughout the country. Many Tawerghan men are still targets of revenge killings by Misrata militias and sympathizers.

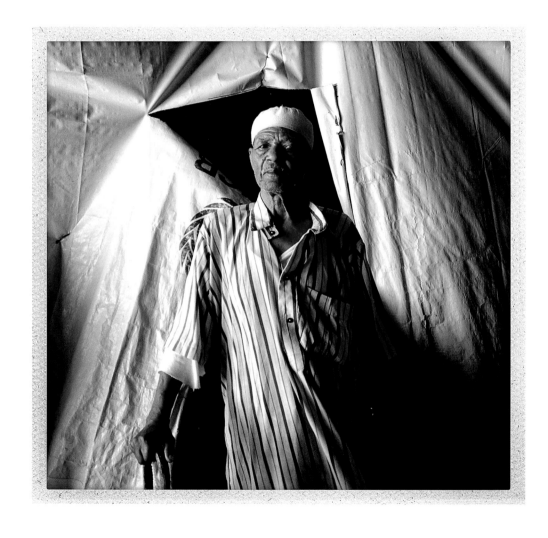

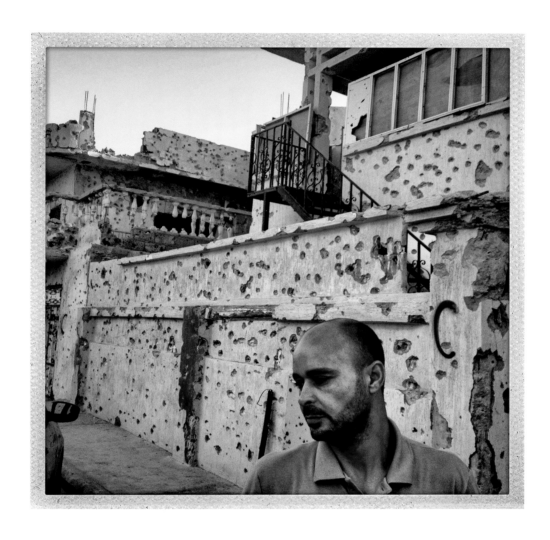

Ben Lowy
Omar stands outside his family's bullet-riddled house in
a neighborhood that is home to Gaddafi loyalists, July 16,
2012, Sirte, Libya.
Archival pigment print

Not far from Omar, graffiti artists scrawled a message
proclaiming the street to be named "Martyrdom of
Brother Gaddafi Avenue."

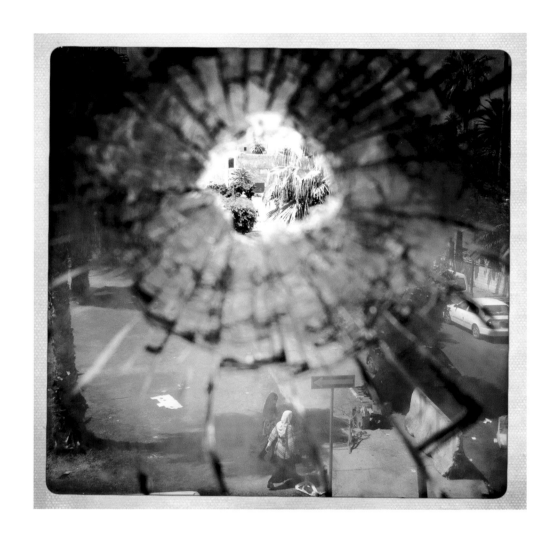

Ben Lowy
Two Libyan women walk through a park on the outskirts of Martyrs' Square, seen through a bullet-shattered window in a Gaddafi government domestic spy office, Tripoli, Libya, 2011.
Archival pigment print

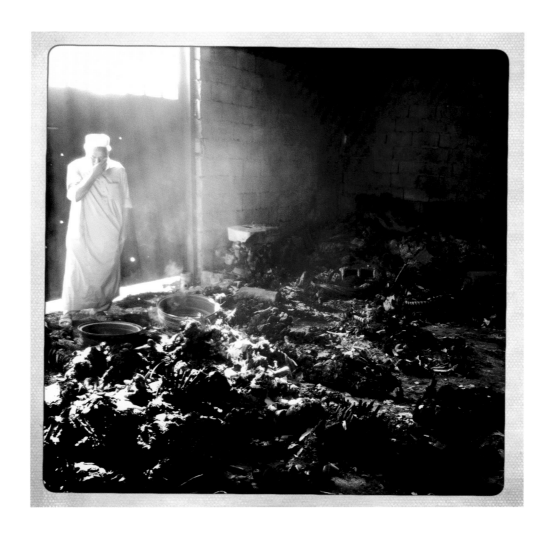

Ben Lowy
*A Libyan man cries at the sight of at least fifty burnt
bodies in a construction-site shed near the base of the
infamous Khamis Brigade, Gaddafi's security forces,
Tripoli, Libya, 2011.*
Archival pigment print

Ben Lowy
Samir, an Eritrean migrant, was shot in Kufra, Libya, by a Libyan militia member during his trek through the desert; he lies on a mat in a migrant camp, July 9, 2012, Benghazi, Libya.
Archival pigment print

The interim Libyan authorities have sequestered numerous migrants in Displaced Persons (DP) camps. Many complain about their living conditions and the lack of security from armed Libyan militias. They are virtual prisoners within the camp.

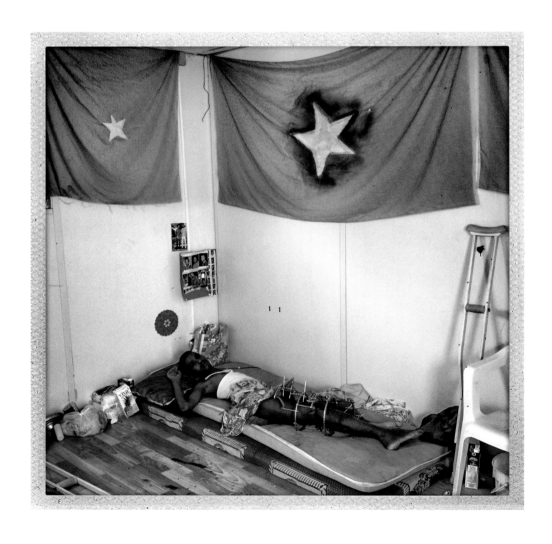

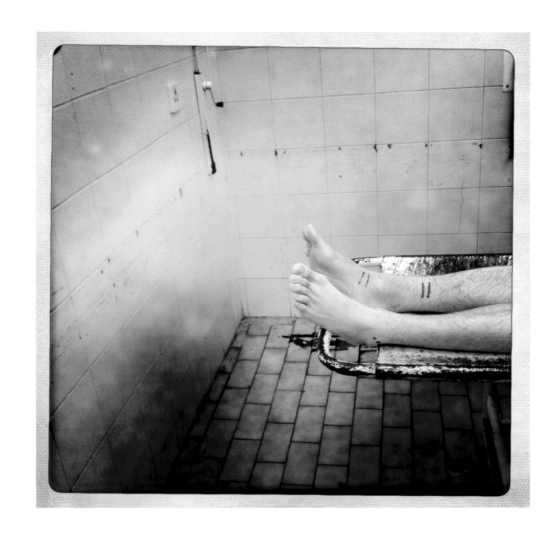

Ben Lowy
*The bodies of civilian and rebel casualties are stored
in the Jala Hospital morgue in Benghazi, Libya.*
Archival pigment print

Gloriann Liu

American

For more than fifteen years, Gloriann Liu has been photographing the people and cultures of the Middle East, Central Asia, and Southeast Asia. "After several trips to the Middle East after 9/11," Liu says, "I became painfully aware that the information I was receiving from the mainstream media in the U.S. often included half-truths and sometimes was completely false. It became my mission to address common cultural misunderstandings and to call attention to the goodness of most of the people that I met. Though their lives are filled with countless hardships, many have invited me into their homes and shown me great kindness and hospitality."

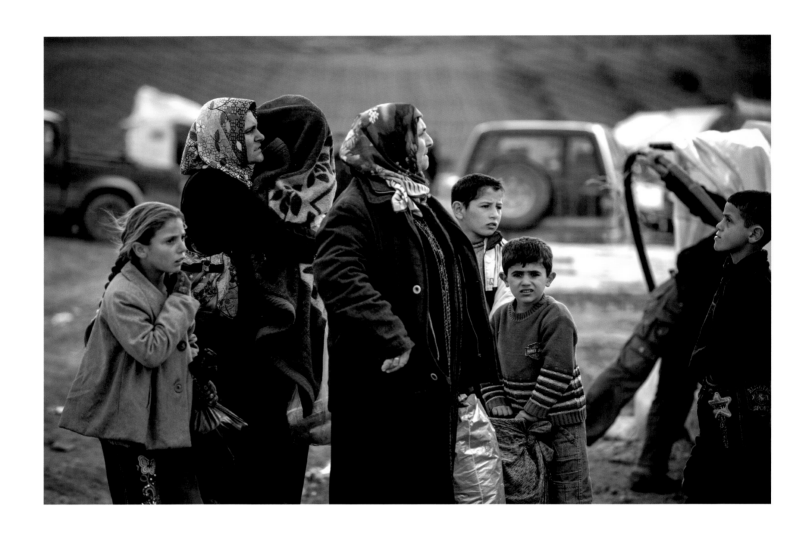

Gloriann Liu
Atmeh Refugee Camp, Syria, March 2013
Digital C-print
From the series *Breaking Apart—The Syrian Conflict*

This family had just arrived at Atmeh, a refugee camp
that is divided into five sections, each with a leader
who distributes food and supplies. Because most
bombing occurs in the daytime, thousands of refugees
leave the camp to return home at night when it is
relatively safe. The camp can have fourteen thousand
refugees during the day and only four thousand
at night.

Gloriann Liu
Fawzia from Houla, Syria, March 2013
Digital C-print
From the series *Breaking Apart—The Syrian Conflict*

Reyhanli, Turkey. On May 25, 2012, the village of Houla was surrounded by soldiers from President Bashar al-Assad's regime. Fawzia was home with twenty-five members of her family when they heard a knock on the door. It was their neighbors, who were from the Alawite sect, the same as President Assad. Although Fawzia and her extended family are all Sunnis, their neighbors had always been friendly. Not this time. After a rampage of killings, during which Fawzia and one of her daughters, Hiba, played dead among the corpses, members of the Free Syrian Army arrived. They took one hundred and ten survivors— including Fawzia and Hiba—to safety. The death toll was fifty-three children, forty-nine women, and six men. All of the animals were also killed, and several of the children were missing.

Perhaps the greatest tragedy of the conflict is what is happening psychologically to the children, many of whom show signs of mental breakdown. As there is no mental-health care available in the camp clinics, these experiences will affect this generation of children for the rest of their lives.

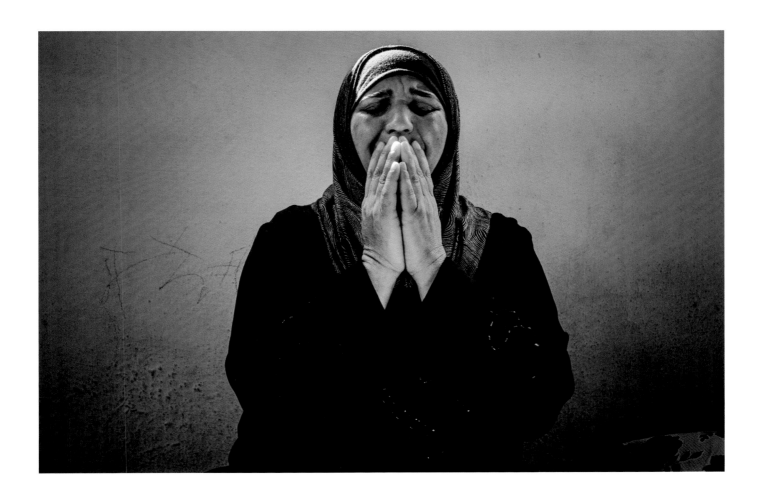

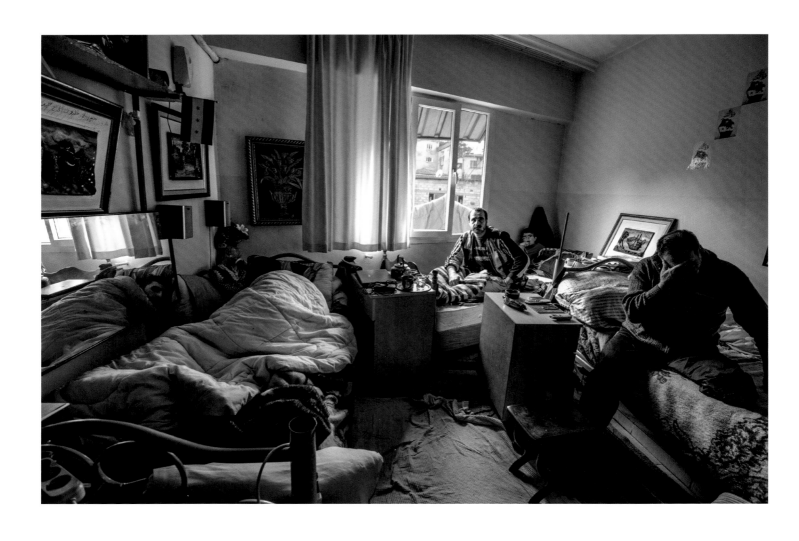

Gloriann Liu
Dar Al Salam Rehabilitation Clinic, December 2012
Digital C-print
From the series *Breaking Apart—The Syrian Conflict*

Reyhanli, Turkey. Mohammed, Ramez, and
Saifaldin—all from Homs, Syria—are soldiers with
the Free Syrian Army. Homs was surrounded by
President Bashar al-Assad's military, but the city has
an ancient sewage system that the Free Syrian Army
uses to smuggle out their wounded. It can take six
hours walking in total darkness to reach medical
help. Mohammad was shot in the chest, and Ramez
was shot by a sniper; both were taken to the Turkish
border through the sewers. Ramez's family soon joined
him, and his young son Aiman has been with him
every day. Saifaldin was wounded by a missile that
killed seven and wounded many more.

Gloriann Liu
Mohammed and Daughter, Dara, Irbid, Jordan, December 2012
Digital C-print
From the series *Breaking Apart—The Syrian Conflict*

Mohammed, age thirty-five, is from Dara'a, and he lives with his wife and daughter. He was hit in four places by a sniper in June 2012 and is now paralyzed from the waist down.

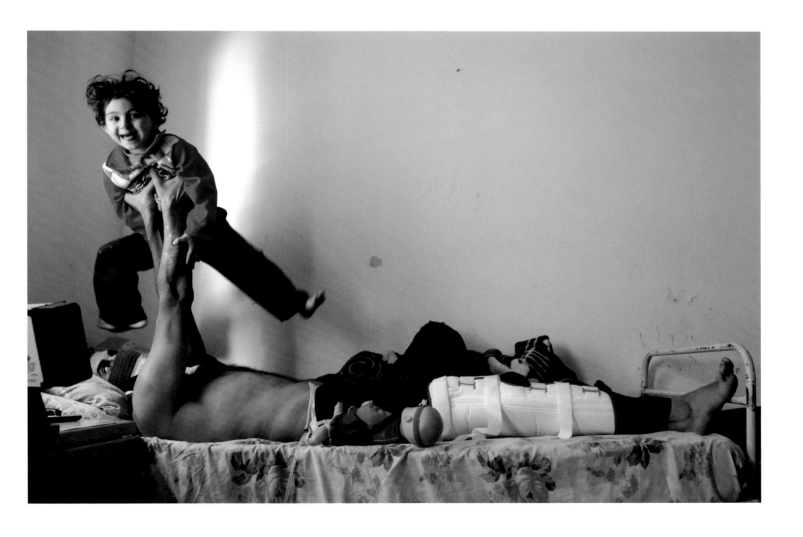

Another Place

For Andros

Who knew the past would follow us so far,
years collapsing like an ancient accordion,
scraps of memory tucked like torn photographs
into the sockets of our eyes?

Remember the gray Beirut seafront, car pulling up,
men ordering, "Get in," our hearts thudding against bone
as we broke and ran? Remember the splintered staccato
of bullets against rock, the way dust rose
in the stunned aftershock of silence?

Days were punctuated by static and news,
nights by the brilliance of tracer bullets
in flight. We huddled on campus steps,
transistor radios pressed to our ears,
strained for some echo of the future.

That day we finally fled the beleaguered city
(tanks rolling in, danger a promise waiting
patiently) the sun sank blazing behind us
into the sea, marking a trail of blood-red light:
a path offering return.

But return was a story scribbled in a notebook
misplaced during flight. We journeyed far,
exchanged one country for another,
survived one war to live a lifetime within
others. We learned to let our faces hide
our selves, to speak our story in a private
tongue, the past a shadow in our bones.

Salt water and sojourns leave their traces.
Decades later we hoard echoes,
still breathe the dust of that place
where banyan trees tangle
in the earth, gesticulate toward light.
Fragments of memory welter
in our flesh, fierce
and penetrating as shrapnel.

—LISA SUHAIR MAJAJ

Gloriann Liu
*Apartment Buildings, Shatila Camp, Lebanon,
March 2012*
Digital C-print
From the series *Shatila Camp*

Shatila and Burj el-Barajneh are long-term refugee
camps in Lebanon. The streets are more like alleyways,
and snarled electrical wires and water pipes are draped
overhead. There are several electrocution deaths
annually from the overhead wires.

The United Nations Relief and Works Agency
(U.N.R.W.A.) set up Shatila in 1949 for Palestinian
refugees who had been displaced from their homeland.
Their children still hope that they will someday return
to Palestine.

Gloriann Liu
Mohammed Agha and Mohammad Zia Mama,
November 2011
Digital C-print
From the series *Forgotten Afghanistan*

Mohammad Zia Mama (it translates to "mother's
brother") was fighting the Soviets when he stepped
on a mine. He lost both legs and his left arm. He sells
music tapes and CDs and raises small songbirds.

Mohammed Agha was collecting firewood when
he stepped on a land mine. Although both legs were
amputated above the knee, he says he does not have
time to get a prosthesis because he is too busy working
as a shoemaker

These two friends said that no one in the world
should have to experience what they have had to
endure.

Gloriann Liu
Marshallah, November 2011
Digital C-print
From the series *Forgotten Afghanistan*

We met Marshallah at the Red Cross Center where
she was being fitted for an artificial arm. When
Marshallah was nine years old, a Russian cluster
bomb was dropped in her family's garden. Later, when
running from another attack, she stepped on one of
the bomblets, destroying her left arm and leg. Her
father was killed in the explosion. She is seen here
with her two children: Miriam, who is four years old,
and Suliman, who is three.

Farah Nosh

Iraqi Canadian

In 2006, Farah Nosh was working in Damascus, Syria, when the thirty-four-day conflict between Hezbollah and the Israeli military began in July. She would leave her Damascus hotel and see taxis arriving packed with Lebanese families and their most precious belongings. A cab driver told her he charged up to $500 *from* Beirut, but he could not charge anyone willing to go *to* Beirut. She took the ride. Nosh spent the majority of the conflict working in southern Lebanon: "In all of my years as a photojournalist in Iraq, I have never witnessed such a large concentration of death and destruction in so small a geographical area. I will never know fear and sadness the way Lebanon did during the summer of 2006."

Farah Nosh
Aitaroun, Lebanon—August 1, 2006
Archival pigment print
From the series *The July War*

A traumatized Lebanese family from the village of
Aitaroun in southern Lebanon takes advantage of a
temporary halt in Israeli air strikes to flee. This family
feared leaving the father behind, as there were only
enough vehicles to evacuate women and children.

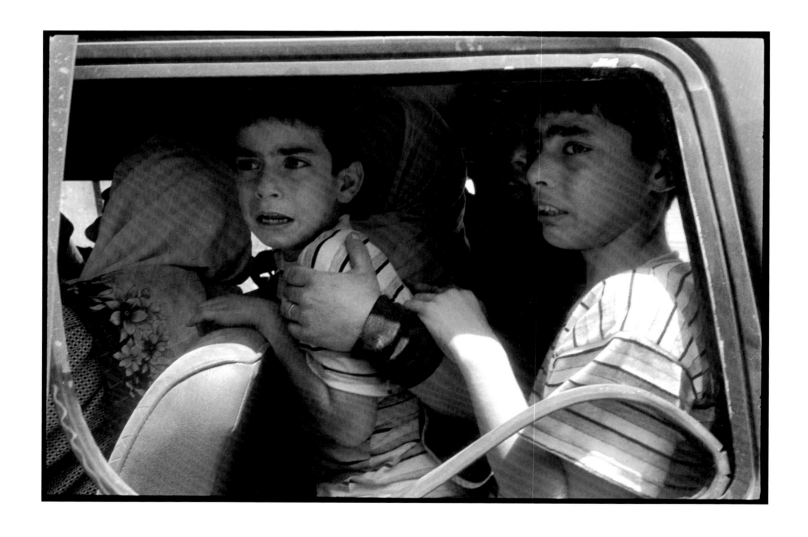

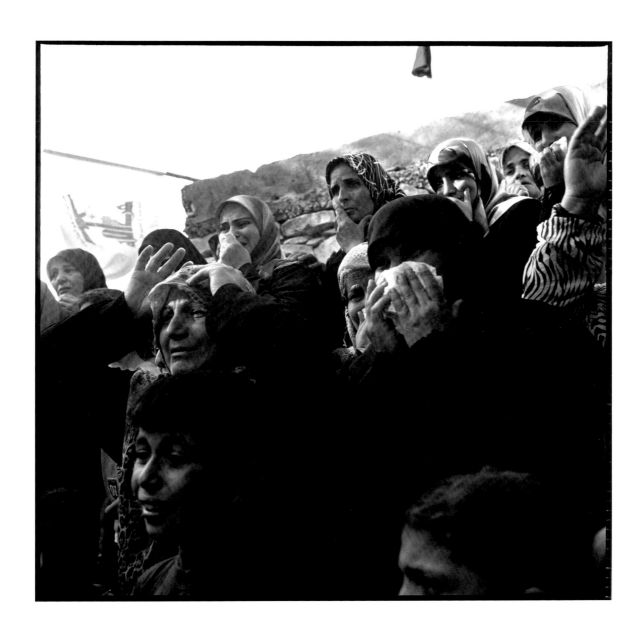

Farah Nosh
Ech Chabiye, Lebanon—August 16, 2006
Archival pigment print
From the series *The July War*

Mourners grieve at the funeral of Hezbollah fighter
Mostafa Rikan, age sixteen, in Ech Chabiye, southern
Lebanon. According to his family, Rikan had been
killed four days earlier in the village of El Ghandouriye
during heavy fighting with Israeli troops.

The Shoes

are scattered in disarray, as if kicked off tiredly
at the end of the day; one overturned by the bed,
another peering out beneath the bookshelf. Expensive leather,
smooth to the touch, still radiates the aura of life,

warmth of the feet that tapped impatiently under desks,
took stairs two at a time, strode, impetuous,
down vibrant sidewalks—that walked out the door
that last morning, confident of return. Now they lie

like shadowed footprints. Gravely I lift them from the ground,
settle them in their shoe box, tentatively close the lid—
as if they might protest, leap from their resting place,
stamp furiously out the door, reclaim the bustling avenues

and all their riches. But they lie motionless in their shroud
of tissue. I switch off the light, close the closet door, confront
the silent room: pants drooping across a chair, shirt flung
across the exercise bike, hats stacked like dusty ghosts on the ledge.

From outside the window comes a faint tapping—
footsteps of the living as they go about their business.

In memory of Faris Bouhafa

—LISA SUHAIR MAJAJ

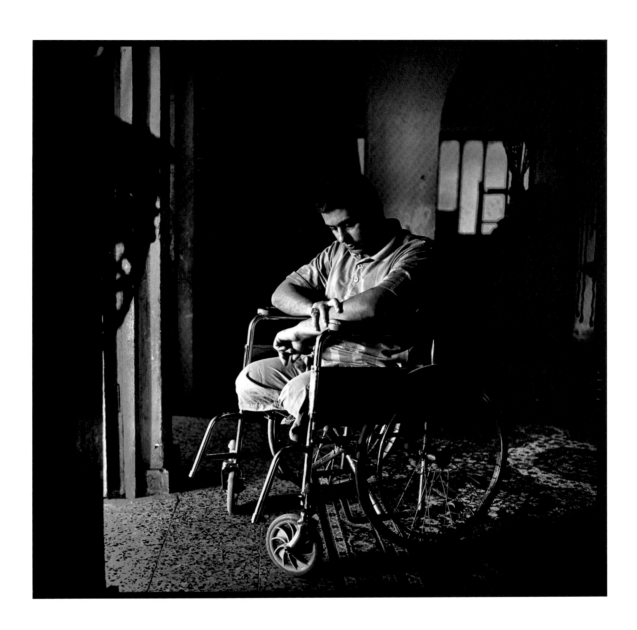

Farah Nosh
Ali Yusif Karim
2006–2009
Archival pigment print
From the series *Wounded Iraq*

Ali Yusif Karim was wounded January 2005 when
his Iraqi army vehicle ran over an IED (improvised
explosive device).

Farah Nosh
Sadr, Iraq—2009
Archival pigment print
From the series *Wounded Iraq*

When Rena was nine months pregnant, she and her youngest sister were walking in Sadr City when they were hit by a U.S. aerial strike in 2008. Rena's leg was torn off, and her unborn infant and sister were killed.

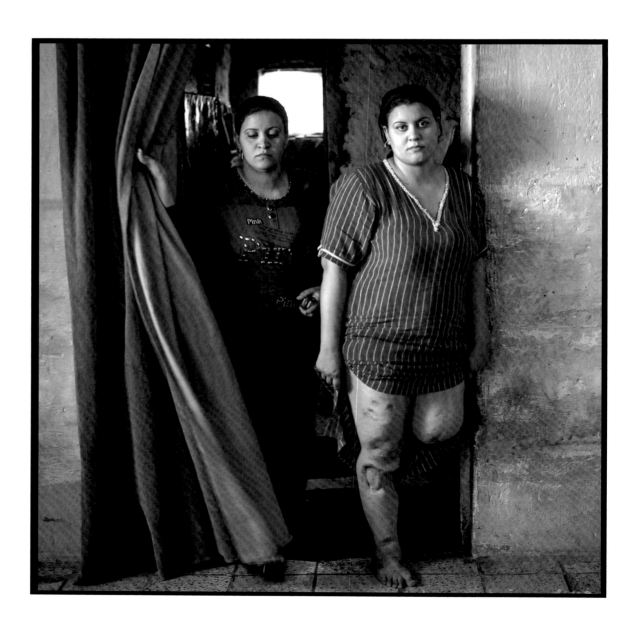

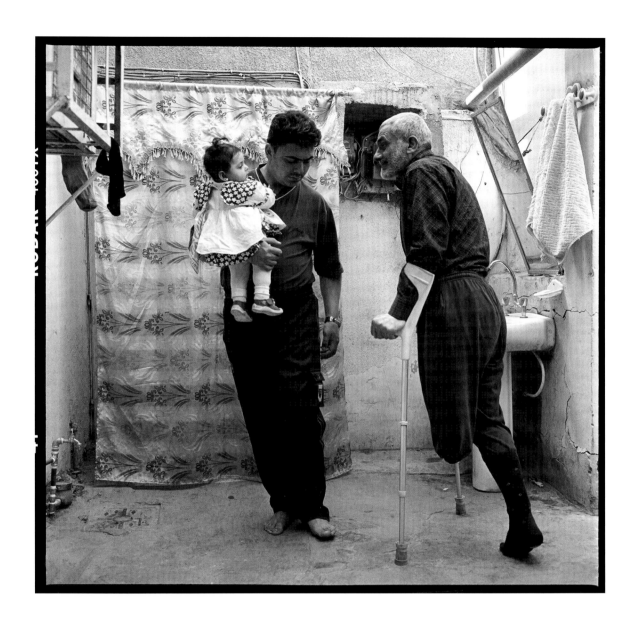

Farah Nosh
Baghdad, Iraq—2006
Archival pigment print
From the series *Wounded Iraq*

Razak Rashed Abbas, a former Iraqi police officer, at
home with his son and granddaughter in Baghdad.
As he manned the gates of his police headquarters in
2003, Abbas was injured by a suicide bomber, resulting
in a left-leg amputation.

Night Sky

(Nicosia, Cyprus)

I line the candles up in my window:
tall, short, fat, round, square.
Lit, the flames burn equally.

Outside, the sky holds constellations
I remember from childhood nights,
my mother's patient voice

directing my gaze. Big Dipper.
Little Dipper. Hunter Orion's belt.
They shine unchanged

over this divided capital
on a divided island
in our divided world

Candles and stars
are easier than news.
Television announcers describe

the infinite variety
of bombs. One flattens everything
in a two-kilometer radius:

libraries, movie theaters, schools.
Another sucks up acres of oxygen,
suffocating cats, cows, children.

From Baghdad, Barbara writes of families
so desperate to get a child out
they stop any foreigner in the street.

She pleads, "Just imagine our lives."
Tilting my head to the night sky
I watch the stars shine calmly

over our small world.
From wherever we are,
Baghdad is not so far.

—LISA SUHAIR MAJAJ

Jennifer Karady

American

For more than nine years, Jennifer Karady has worked with American veterans returning from Iraq and Afghanistan to create staged narrative photographs that depict their individual stories and address their difficulties in adjusting to civilian life. After an extensive interview with the veterans and their families, Karady collaborates with them to restage a chosen moment from war within the safe space of their everyday environment, often surrounded by family and friends. The collision of, or collapse of the barriers between, the soldier's world and the civilian world evokes the psychology of life after war, and the challenges entailed by any adjustment to the home front. Each large-scale color photograph is accompanied by a recounting of the veteran's story in his or her own words. These have become the series *In Country: Soldiers' Stories from Iraq and Afghanistan.*

Jennifer Karady

Former Sergeant Steve Pyle, U.S. Army, 101st Airborne Division, veteran of the Shock and Awe Invasion of Iraq, with wife, Debbie, and children, Steven, Brooke, Cassie, Chloe, Michaela, Mandy, and Brandi; DeLand, FL
July 2006
Digital C-print

This is the story of my survival day: May 1, 2003, Mosul, Iraq. After a routine patrol my team became engaged in small arms fire while clearing some buildings in an area near an abandoned airport. When I heard the fire, I was approximately six hundred yards in the opposite direction of my men. I positioned myself to identify the fire and saw my men taking fire from an area of buildings across the way. From my position I could see beyond the source of fire where there were Iraqi nationals running out of the back building beyond the sight of my team, so I maneuvered myself to their position to assist. We needed to get back to the Humvee in order to get out of the area. We popped smoke; my team ran as I pulled cover fire. Once they were in position I threw smoke again and ran for the Humvee.

The small arms fire had somewhat ceased when the mortars started. They were blowing up all around me when I was thrown into an Iraqi troop carrier and sustained a severe head injury. I was knocked out for a few seconds. I knew I had been injured badly. The top of my head had been smashed and several bones in my right foot were broken. I looked up and around for my guys and saw two men running toward me that appeared to be my team, so I laid back and waited for help.

Within the next few seconds, I was attacked by two Iraqi nationals. They were kicking and hitting me repeatedly. Obviously they had no weapons and were attempting to kill me and take mine. One of them tried to take the bayonet affixed to the chest of my fragmentation jacket. It was at that time that everything seemed like slow motion. I remember thinking if I didn't stop them, I was going to die, so I did what I had to do to disable these two guys beating on me. I used my bayonet on the guy directly on top of me and then engaged the other man who had been kicking me. It was then that I realized that my men had to leave the area due to the strength in numbers of the fast-approaching enemy.

I believe they thought I had been killed, so they did what they had to do to survive. I hid under some blown-up building debris for approximately six hours before I was picked up. My team returned with backup to search for me. I received medical care from a medic and was flown by Blackhawk to Baghdad. Baghdad was under heavy fire at that time so it took several hours to get me in the air to Kuwait. After being hospitalized in Kuwait I was flown to Germany and finally back home to the U.S. It was by the Grace of God and a few good soldiers that I survived that day.

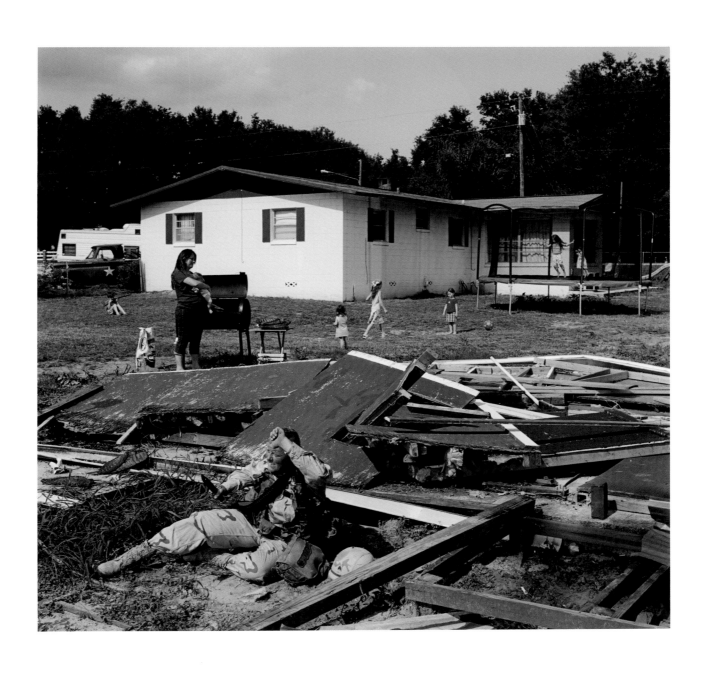

Jennifer Karady
Inactive Duty Sergeant First Class Mike Sprouse,
Virginia Army National Guard, veteran of Operation
Enduring Freedom in Afghanistan, with wife, Tammy,
and children, Peyton and Colin; Madison Heights, VA
August 2006
Digital C-print

We had one. Another platoon that operated in the same area actually hit one. They had hit one a couple months earlier too. Luckily they survived that. We lost two people from an IED (improvised explosive device) in the first two weeks we were in Afghanistan.

After coming back home, you think about Afghanistan and how it was driving there compared to here. Occasionally it will go through your mind, driving down the road, to look out for IEDs. It's an instinct that is hard to turn off. When I went to drill last month, going to Winchester on 81, it happened. And it was just a tire from a tractor-trailer recap up ahead. It doesn't happen every day. I could go a couple of weeks, a month, and not see it. But driving down the road, something's going to click in your mind.

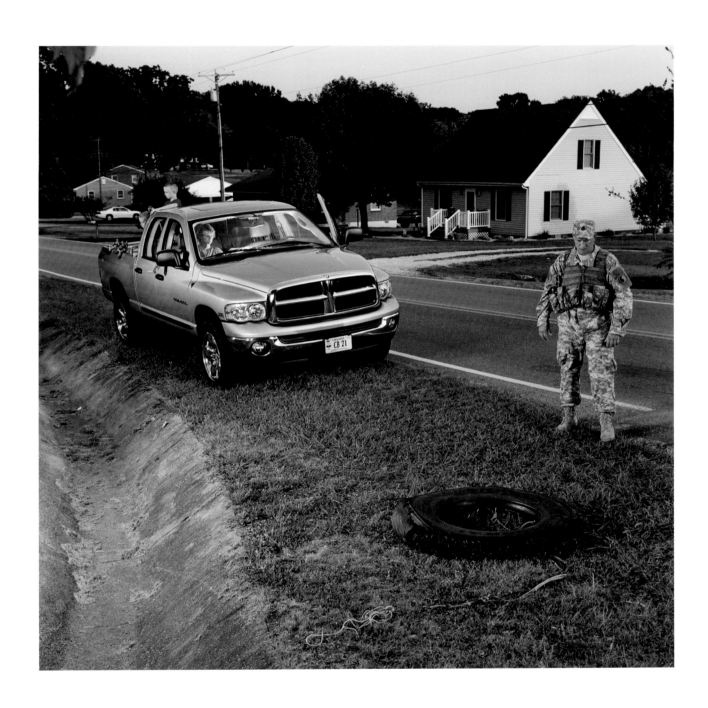

Jennifer Karady

Former Specialist Shelby Webster, 24th Transportation Company, 541st Maintenance Battalion, U.S. Army, veteran of Operation Iraqi Freedom, with children, Riley, Dillin, and Sidnie, brother Delshay, and uncle Derek; Omaha Nation Reservation, NE
October 2010
Digital C-print

I was twenty years old when I joined the Army. I was a single mom and I had two babies that I left—a two-year-old and a three-year-old. When I found out that I was deploying, I remember crying on the phone to my dad, "I don't want to go." I didn't join just to join. I joined the military thinking I would give my kids a better life.

I drove a PLS (palletized load system truck). We transported all sorts of supplies from Kuwait into Iraq when there was nothing there. Whatever they needed, we hauled. The funny thing about it is that we weren't armored. We only had flak vests and our little M16s.

When we convoyed into Iraq for the first time, it was probably two o'clock in the morning. I remember being so tired and seeing explosions and thinking, "Wow, this is like the movies. This isn't happening." Then we started getting attacked. We had a big convoy of about twenty trucks. We stopped and my squad leader, Sergeant Jackson, jumped out and said, "Be ready, lock and load!" At that point I thought, "How am I going to shoot and drive?" I remember shaking and almost freezing up. And my TC (passenger and vehicle commander), Gabe, said, "It's OK, Web. It's OK. I've been through this already." He was trying to reassure me because I was terrified.

They had us line up all the trucks in four rows. Sergeant Jackson told us to get out of our trucks just in case. So we were in the sand, lying in the prone position, just waiting. Then we hear gunfire and I remember thinking, "What am I going to do, I'm a girl." I lay there crying to myself, "God, please, I don't want to die. I want to go home to my kids." I was so scared. It was so hard.

I'm Native American and I believe in my culture. I believe in my Omaha ways. I said a little prayer to myself asking God to protect me and to watch over my babies if something were to happen to me. This feeling came over me and, I don't know if it was my subconscious or what, but I heard a voice that said, "It's going to be alright." I recognized that voice as my Grandpa Danny's voice. I was ten when he passed, but I remember him—he was a good grandpa and always protective.

In this moment I also smelled cedar and we pray with cedar. When I smelled it, I took a deep breath and I smelled and smelled. I thought, "What the heck?" I looked around and asked Gabe, "Do you smell that?" He said, "No, I don't smell nothing." I could still see and hear tracer rounds and explosions and could feel the ground shake. But a feeling of calmness had come over me and I thought, "I can do this." When I called home and told my Dad that I smelled cedar, he cried. He said, "Well, we've been praying for you. We've been having meetings for you."

My Dad had my kids while I was gone. It seemed like during those two years I saw my kids probably one or two times. My kids are ten and eleven years old now and I had another baby after I got back. My youngest is now five years old and totally different compared to my older kids, who have separation anxiety—they always have to know where I am. My youngest is more independent; she's her own kind of person. But the older two are always looking for me, asking, "Where's Mom?" And I say, "I'm right here."

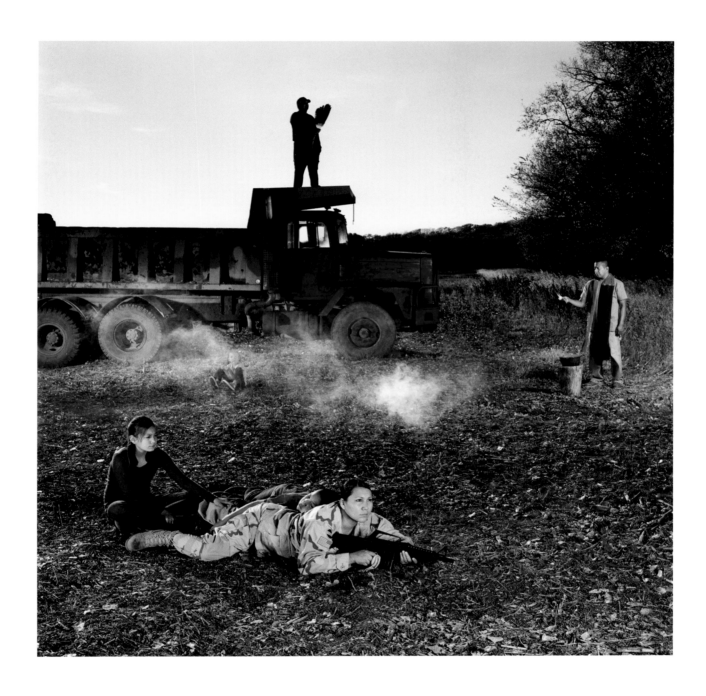

Jennifer Karady

*Former Sergeant Jose Adames, U.S. Marine Corps
Recon, Stinger Gunner, 1st Platoon, Alpha Company,
veteran of Operation Iraqi Freedom; Brooklyn, NY*
February 2009
Digital C-print

I got hit by a mortar while on a convoy, which was not a typical mission for us. Three pieces of shrapnel went through my leg. It pretty much swept me sideways, and I was knocked out cold. I was immediately helivacked over to Baghdad Hospital, and from there to Frankfurt, Germany. Eighteen Marines in my platoon were wounded. When I heard the stat reports a couple of weeks later, I found out we were hit by forty mortars and two machine gun assaults. It was in a canyon, so there was no way to go forward or back. When mortars are coming in, it's pretty much hard to cover yourself from that. That's the scariest thing I've ever been through. That's the bad part; I'll never forget it.

I am terrified of trucks, garbage trucks in particular, and it has to do with the fact that New York has so many potholes. When they hit one they make this deep, echoing sound that sounds similar to a mortar exploding. I see a dump truck rolling down the street and I just try to go to the other end as fast as possible. I black out, not in a bad way. I just tune out. Everything gets dark, and these images keep fluttering through my mind of the night we got hit. It just replays in my mind.

When I returned I was homeless for a total of five months. I spent two months in a shelter and I couldn't take it. It was just this thin line of frustration, and then my PTSD wasn't helping. So I really needed to come up with other ideas. I was stuck in a vicious circle from boarding house to a shelter at Bellevue. It was ridiculous what they did to me. I had a better chance sleeping on the A train. I felt more comfortable, actually. In New York, 85 percent of the homeless are veterans. I see a lot of veterans feeling very, very angry.

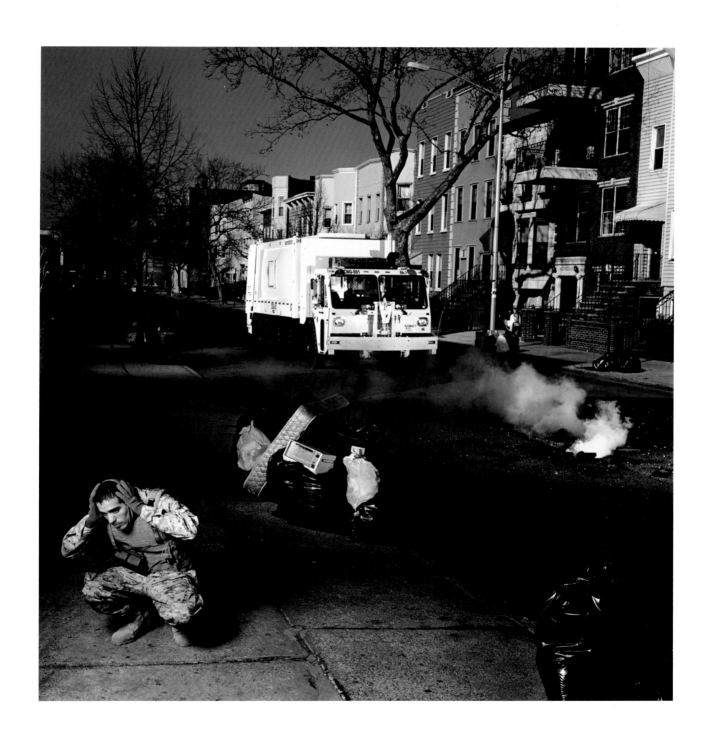

Jennifer Karady

Former Lance Corporal West Chase, U.S. Marine Corps, Combat Service Support Company 113, I Marine Expeditionary Force, veteran of Operation Iraqi Freedom and Operation Enduring Freedom, with fiancée, Emily Peden; Ann Arbor, MI
May 2014
Digital C-print

When I was in Fallujah for the elections, we had to go through the city from site to site dropping people off. We were always on high alert because our convoys normally didn't go through a whole lot of heavily populated areas. I was the most experienced person next to the staff NCO (noncommissioned officer). He put me in charge. He said, "All right, Chase is in charge because he's already done one deployment. You guys are all fresh, new." Having to constantly monitor them put me on edge all the time. I was in a constant state of alertness because we were in a crowded area.

When we were getting to one of the election sites and slowing down through a neighborhood, people were waving to us like, "Hi." They were trying to be peaceful and friendly, like, "I'm friendly, don't shoot me." This new kid was yelling "F you! F you!" and flicking them off. I told him that if I saw him doing that again, I would personally come back there and butt-stroke him with my weapon. Because one, this is their neighborhood. Two, this is their country. Three, by being aggressive when they're not showing any signs of aggression or suspicion, you're putting your teammates' lives at risk.

I'm always aware of my surroundings. I don't like crowds. I become very—not unnerved, but there's a sense of possible anger that comes out—or, I wouldn't say anger but I'm very alert and I'm very intolerant of how other people can be careless in a very crowded environment.

There was a football game. Everyone was going to the stadium—my fiancée and I were not, but the sidewalk is designed for both directions of walking. People were just walking five people wide, involved in their conversation. I understand that a sidewalk should be kind of like fifty-fifty, not one hundred-zero. At a certain point I got in front of her and I would actually stop in front of a group and let them part around us, or run into me, and I would shove them. The lack of consideration is what irritates me the most. So I will actually move people out of my way, but I'll say "Excuse me" at the same time.

In combat you don't allow yourself to be scared, you don't allow yourself to be startled, and you don't let your emotions get the better of you. So now, trying to find a way to become emotionally involved in things is tricky. My fiancée says that I need to open up more. She's not pushing me to but she says, "I'm not everyone else. I'm your person. You have to be able to open up to me." I've never had that before, actually. She's very patient, which is lucky for me.

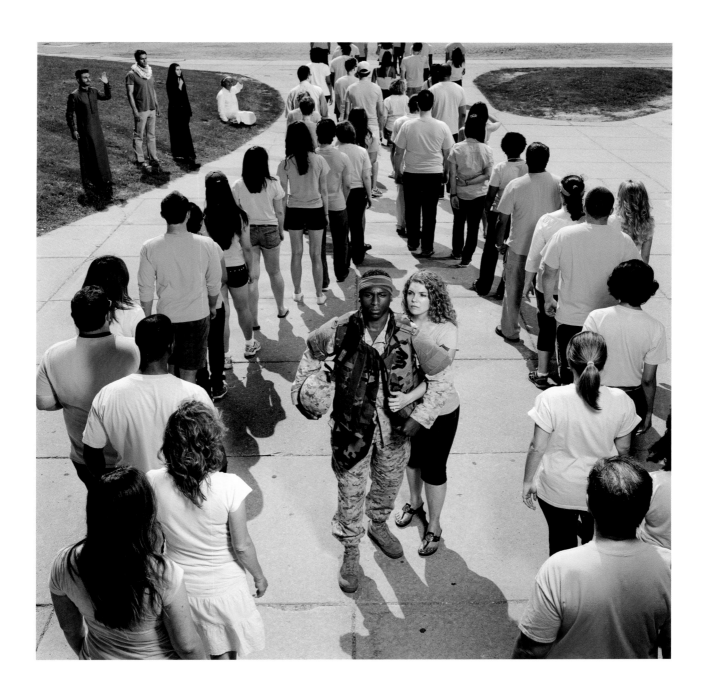

Jennifer Karady
*Captain Elizabeth A. Condon, New York Army
National Guard, veteran of Operation Iraqi Freedom,
with daughter, Kate, and mother, Elizabeth; Troy, NY*
June 2008
Digital C-print

One of my missions in Iraq was to check the water levels in remote areas, because the underground water infrastructure had been destroyed by Saddam Hussein. We were curious to find out how the locals were getting water to sustain themselves and what we could do to help them. An Iraqi man approached us and asked if somebody could take a look at his wife or daughter or whoever she was. She was just a girl, maybe sixteen years old. We had a doctor with us, but they didn't want the male doctor to examine her. They looked to me because I was the senior ranking female person.

I went into this room, and the girl was lying on a runner-like rug on the dirt floor. She lifted her black burka to show me her stomach. She recently had a cesarean. She was cut from hip bone to hip bone, like somebody just took a knife, cut her open, and took the baby out. The wound was held together by thin, one-inch-wide box tape, the kind with little strings in it. It was obviously infected, so I just kind of cleaned up her wound with rubbing alcohol, antibiotic cream, and sterile dressings. It was healing but it was nasty. She was very thankful. No one responded until the eldest

woman did. There must have been eight women and twenty kids all watching me. The eldest woman came over and started kissing my cheek and thanking me. One by one, she introduced me to her whole family, never saying a word.

When I came back I couldn't deal with the welcome home—everyone glad to see me, trying to give me hugs—because I had been so cold, isolated, and nonemotional. A lot of people had died, and I'd been to too many memorial services. I said to myself, "Okay, the Muslims have Mecca, where's my Mecca?" I'm a Catholic, so it's the Vatican. So I went to Italy.

I volunteered to go to Iraq when I was told I couldn't have children. I was thirty-six or thirty-seven at that time and was engaged and wanted kids. Having a family was always very important to me, but my career in the military and my goals had always gotten in the way because I wanted to be educated. I wanted to be a commander.

In Italy, I went into the Sistine Chapel. It was like the place where it was OK to release my emotions. I walked up the steps to the altar and bawled my eyes out. I don't know how long I was there. I remember that before I left for Italy, my mother told me, "Sometimes men don't listen, you need to speak to their mothers. Mothers have a way with their sons. So if you have any special requests while you're there, talk to Jesus's mother." So I did. I went to the Basilica and just prayed, "Mary, I've always wanted to have a family, but it's totally up to you. Maybe I could adopt or whatever, I've got my money saved." That was in December. Four months later in April I was pregnant. I got this wonderful gift out of all that tragedy. I really attribute my daughter to the Iraqi woman with the cesarean.

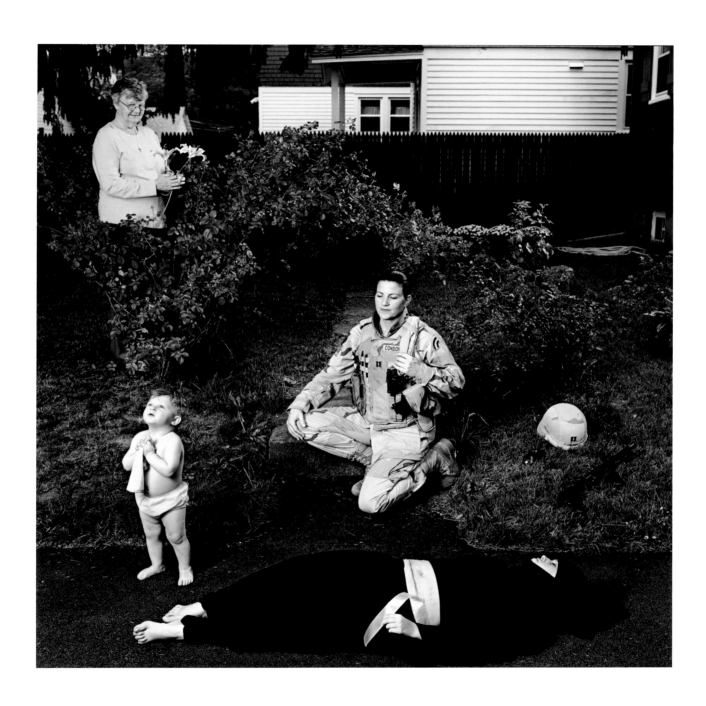

Jennifer Karady

Staff Sergeant Kyle Winjum, Explosive Ordnance Disposal Technician, U.S. Marine Corps, veteran of Operation Enduring Freedom and Operation Iraqi Freedom, with fellow Marines; Twentynine Palms, CA
April 2014
Digital C-print

During my deployment in Afghanistan, we got information from one of our sources that there were improvised explosive devices (IEDs) set on a hilltop, so we went out looking for IEDs. We found two around eight o'clock that morning and set them off. We pretty much woke up the whole town because it was early. In our search, we went up the hill sweeping with our metal detectors.

My team leader, Jeremy, was in a little low area between a couple of trees. I was watching him investigate an area—he was kneeling down probably within five meters from it when it went off. Time slowed down when I saw the explosion. I saw the fireball and the blast wave come out and push the trees and the dust and the dirt out and I also watched it suck itself back in, creating a mushroom cloud. I saw the fragmentation flying up in the air, and it was white and it was red and it was orange and it turned yellow. It goes up white-hot and as it's coming down, it's cooling down. I was watching it change colors. It was a very intense experience for a brief moment but it seemed like forever.

I looked up and down at both of my arms and thought, "OK, I don't see any holes, I don't see any blood, I feel OK." I looked at my legs and did the same thing. Then I started getting up and yelled for Jeremy to make sure that he was OK. I heard him and I knew that he was at least coherent. Our third team member, Matt, was on the other side of the hill and he was OK too.

We all regrouped in our little safe area. My right ear was ringing, as was everybody else's. We calmed ourselves a little bit, we all smoked cigarettes. We replaced the batteries on our countermeasures equipment and we went back in. We had to do an investigation. I was scared shitless going back again. I was thinking, "What the fuck!?" My whole body was shaking as I was sweeping. But I kept calm enough to know, "This is part of the job. This is what we're doing. And this one's already gone off so it can't be too bad."

It was almost a year later—I was out in a bar with a bunch of my friends. People were taking pictures and one photograph flash caught my eye in the same manner that that IED had gone off. And I lost it. I was freaking out. I was wondering where my friends were. "Where am I? What am I doing? Is everybody OK?" I walked around the bar searching for my friends and picking them out. "OK, there's my friend—he's safe. There's my friend—he's safe. There's my friend—he's safe. There's his girlfriend—she's safe." I knew physically I was still in a bar but mentally and emotionally, I was back in Afghanistan. I saw the camera flash and my brain instantly saw that explosion flash, and it went back to seeing everything.

After that, I talked with my friend because he's been in some past experiences, and he suggested that I go to see his therapist. I went the very next day. I'm glad that I did because the therapist I saw really helped me.

That's the only experience I've had with more or less being blown up so far. I hope it doesn't happen again, but I'm still on the job. I mean, there's still always the potential and possibility whether we have to go back to Iraq or Afghanistan or wherever else in the world.

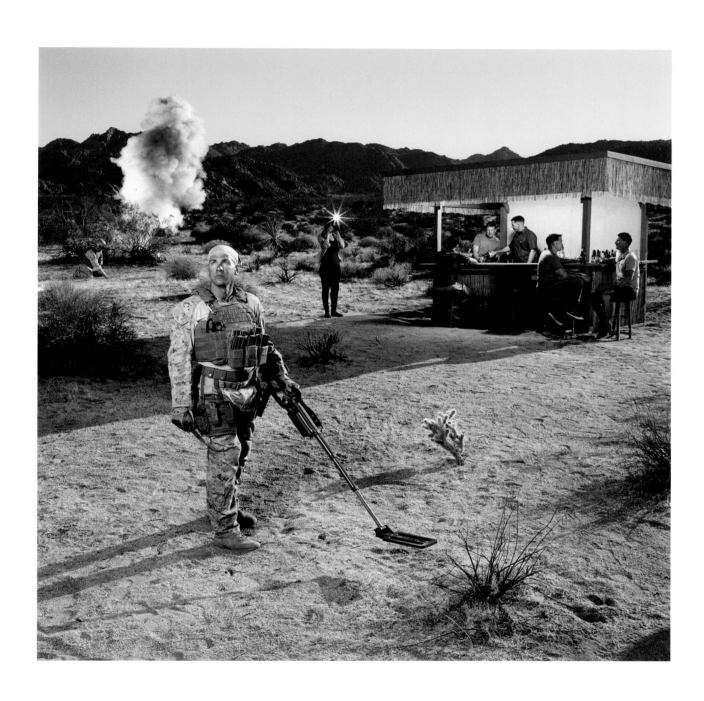

Rania Matar

Lebanese American

Rania Matar's several series on Lebanon depict life *after* the numerous wars that country has endured. Whether in the refugee camps, the streets or suburbs of Beirut, or southern Lebanon, Matar was "humbled by people's resilience, kindness and hospitality." Her series *Ordinary Lives* focuses mostly on people, while *What Remains* concentrates on personal objects that are now debris in silent, broken homes. Despite everything her subjects have been through, Matar never loses sight of their humanity and dignity. In her series *Invisible Children*, Matar photographs the increasing number of Syrian refugee children on the streets of Beirut, almost faceless and invisible to the locals, giving them dignity and portraying their individuality.

Beirut, 1982

tilting walls careen
sliced edges collide
 with harsh flat planes of sky

gray dust billows
 from rubble
 raw flesh of buildings
 ripped from steel bones
 twisted
 maimed

sun bleeds into gray light

 behind web-cracked hospital glass
 a taut man grimed with stubble
 contours of eyes torn hollow
 clutches a child limp rag
 of bones and blood
 a steady splatter
 onto swabbed tile floors

 gunfire
 a staccato

 drumming

—LISA SUHAIR MAJAJ

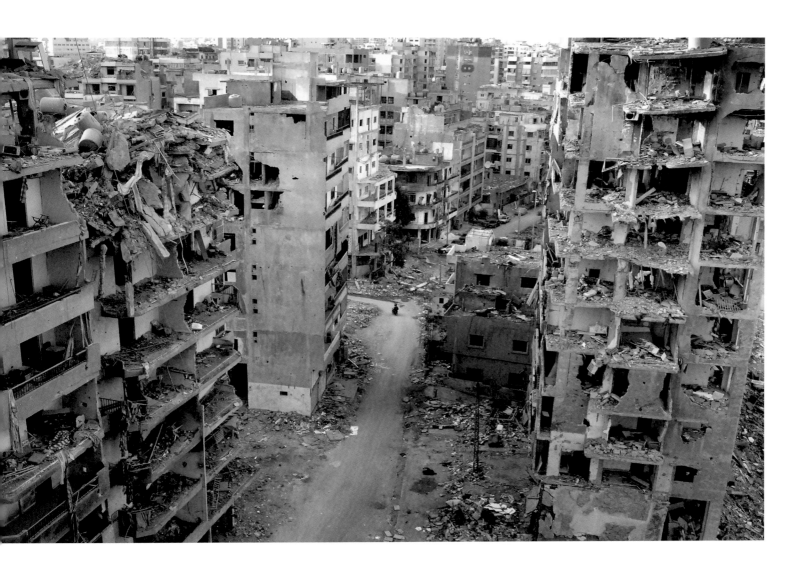

Rania Matar
Beirut
2006
Archival pigment print
From the series *What Remains*

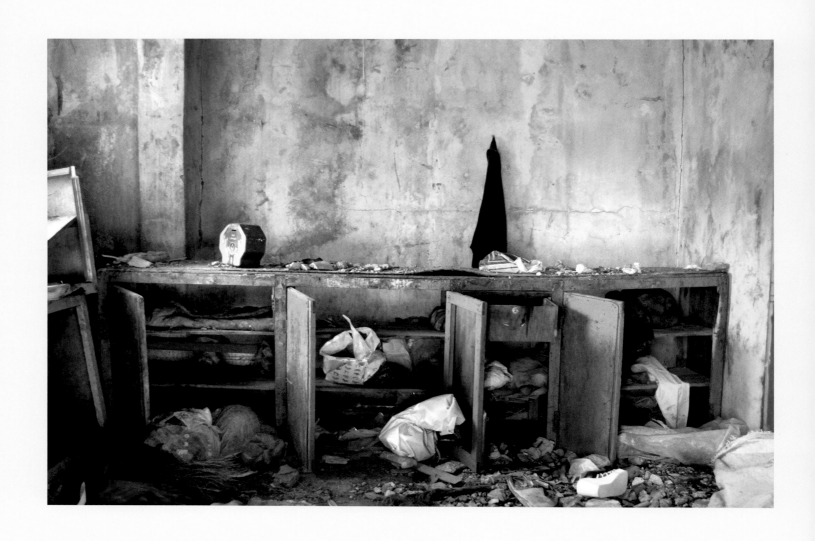

Rania Matar
Hanging Towel, Aita El Chaab, Lebanon
2006
Archival pigment print
From the series *What Remains*

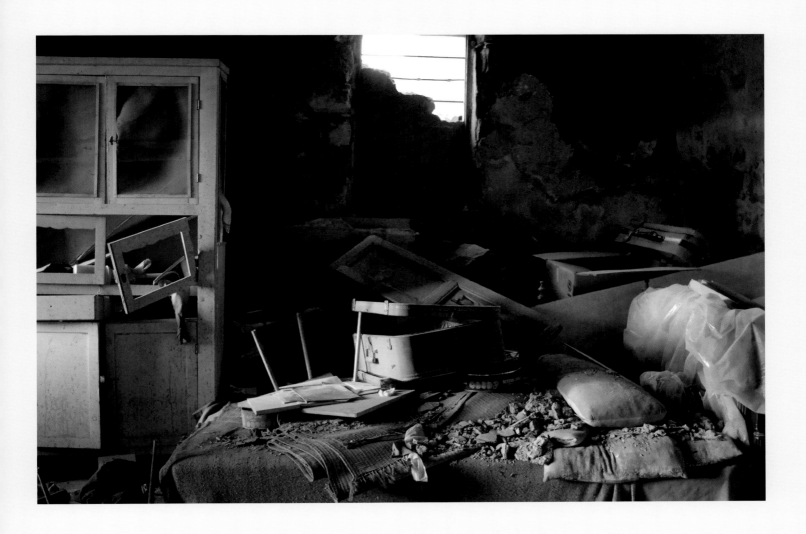

Rania Matar
Open Suitcase, Bint Jbeil, Lebanon
2006
Archival pigment print
From the series *What Remains*

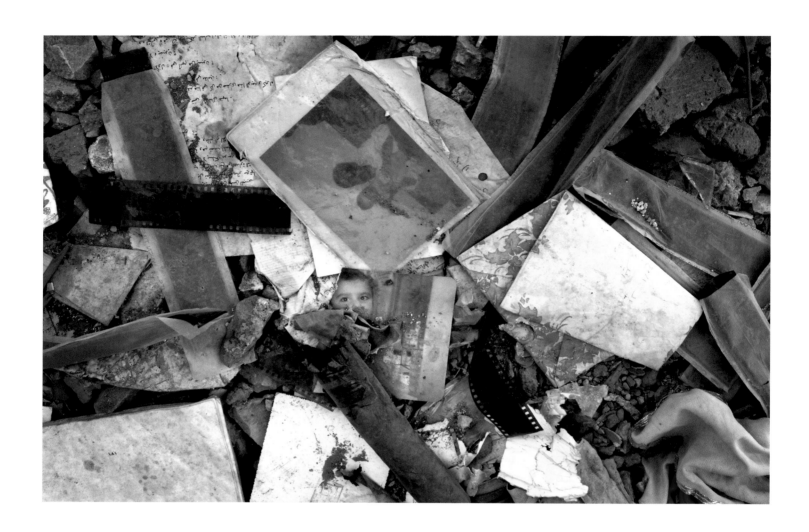

Rania Matar
Negatives, Beirut
2006
Archival pigment print
From the series *What Remains*

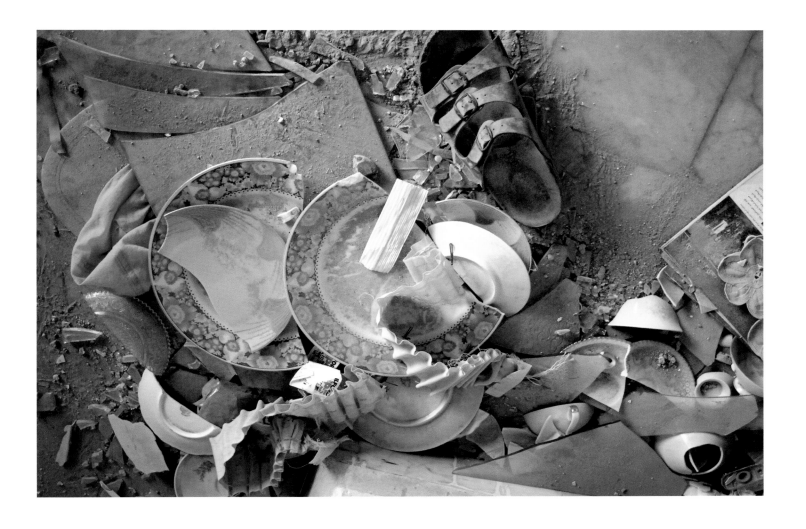

Rania Matar
Plates, Beirut
2006
Archival pigment print
From the series *What Remains*

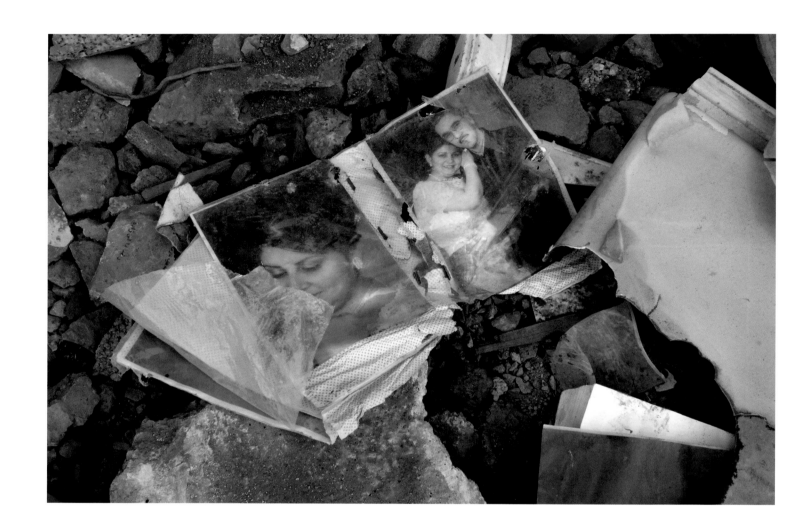

Rania Matar
Wedding Album, Beirut
2006
Archival pigment print
From the series *What Remains*

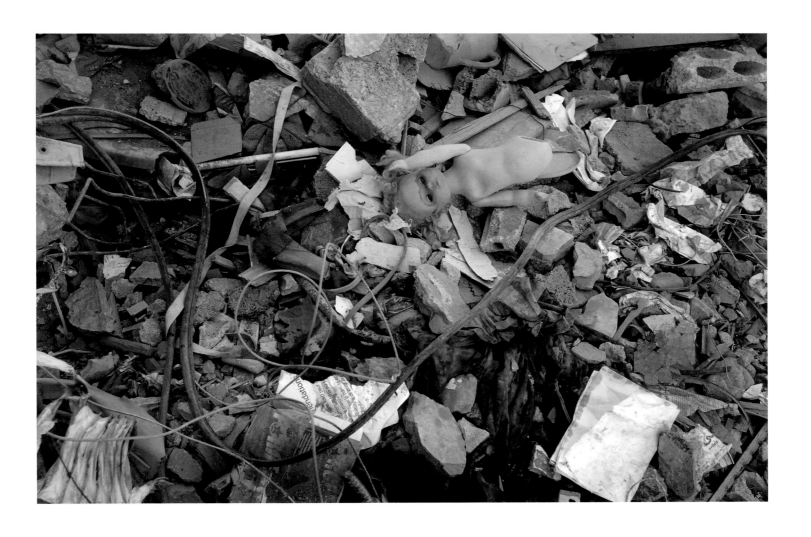

Rania Matar
Broken Doll, Beirut
2006
Archival pigment print
From the series *What Remains*

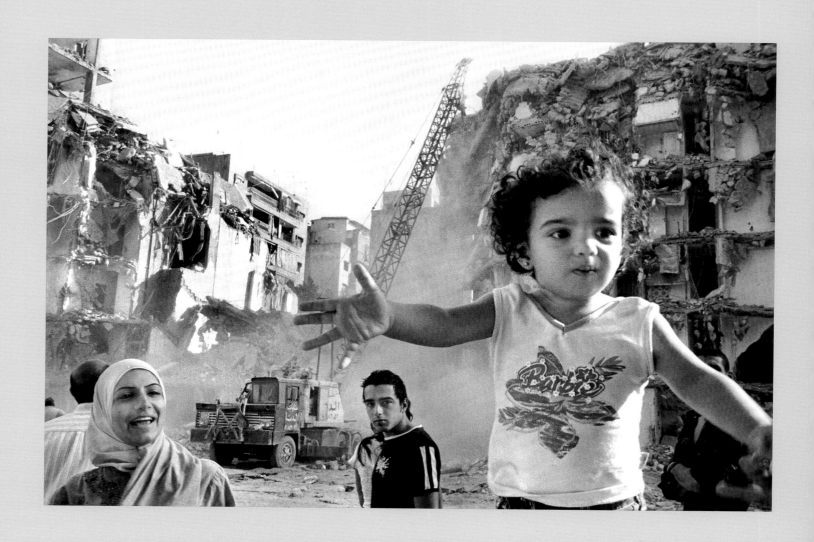

Rania Matar
Barbie Girl, Haret Hreik, Beirut
2006
Archival pigment print
From the series *Ordinary Lives*

As people watch a wrecking ball demolish the
destroyed buildings that were once their homes, a
toddler, oblivious to the commotion, brings a smile
to her mother's face.

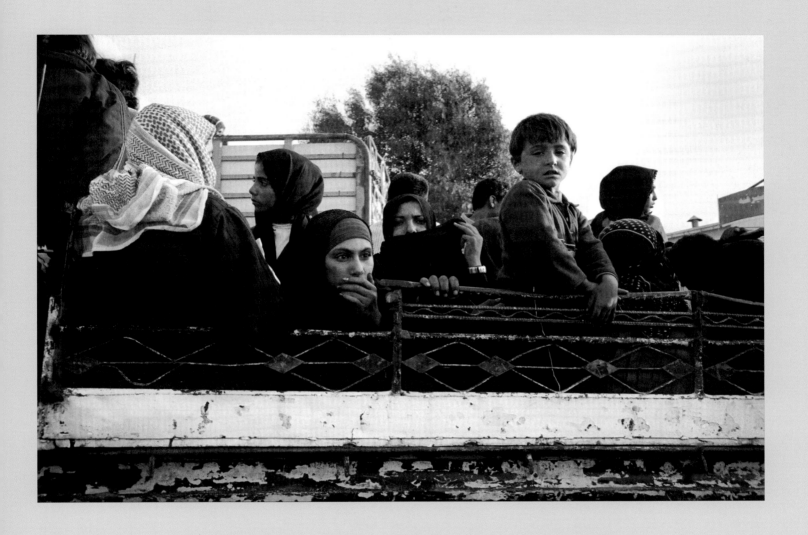

Rania Matar

On the Truck, Lebanese/Syrian Border
2006
Archival pigment print
From the series *Ordinary Lives*

During the war between Israel and Hezbollah,
people left Lebanon by the truckload to cross the
border into Syria.

Rania Matar
Tamer 6, Beirut
2015
Archival pigment print
From the series *Invisible Children*

Rania Matar
Yasmine 13, Beirut
2014
Archival pigment print
From the series *Invisible Children*

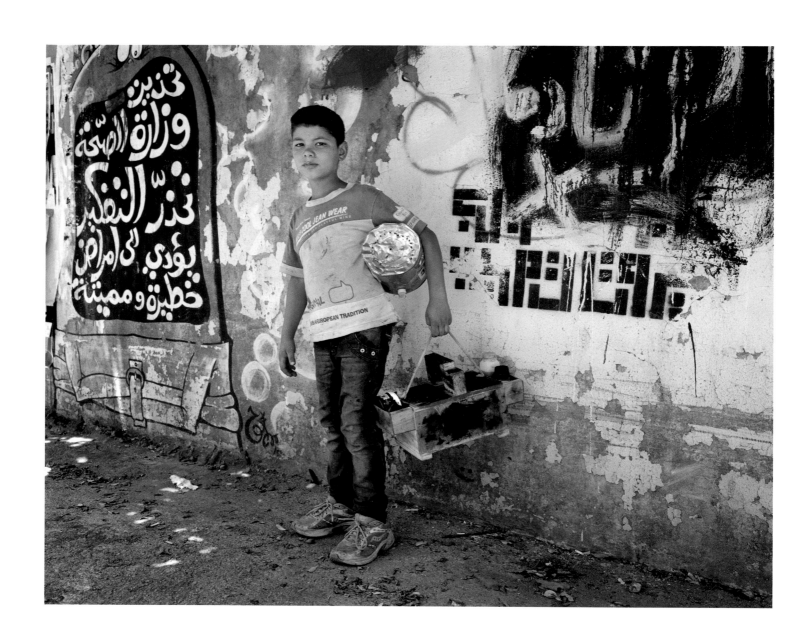

Rania Matar
Ahmad 9, Beirut
2014
Archival pigment print
From the series *Invisible Children*

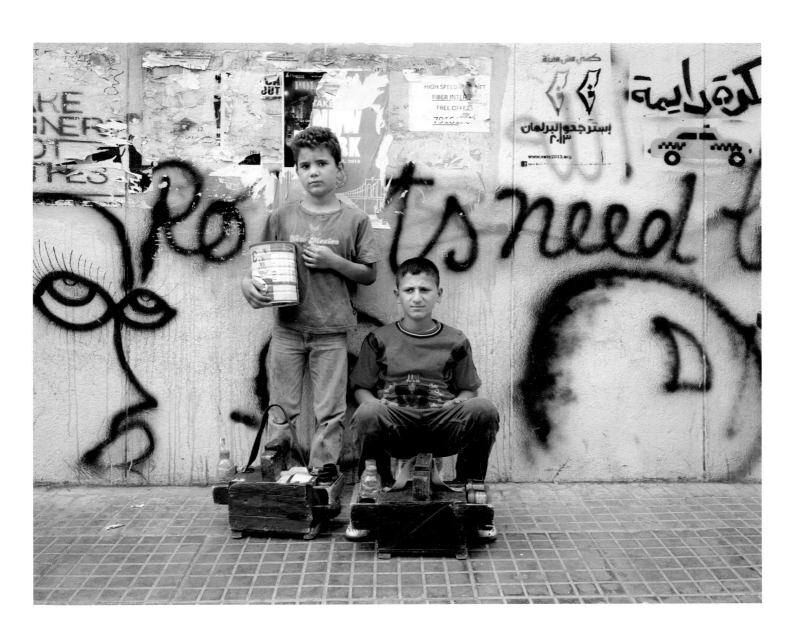

Rania Matar
Mohammad 7, Assaad 12, Beirut
2014
Archival pigment print
From the series *Invisible Children*

Stephen Dupont

Australian

Axe Me Biggie, or Mr. Take My Picture is a series of Polaroid portraits taken on the streets of Kabul, Afghanistan, in 2006. "'Axe Me Biggie'— a crude Anglo phonetic rendering of the Dari for 'Mister, take my picture!'—is Stephen Dupont's answer to the plea he heard all over Kabul," writes journalist Jacques Menasche. "It seems to mean something in English, 'axe' being just a more visceral, violent version of the camera verb 'to shoot.' And because Stephen has that pulverizing Aussie rugby body, 'Axe Me Biggie' also seems a request addressed to him personally. Stephen is Biggie. And on this day Biggie finally answers them all, en masse, saying, 'Yes, alright. I will axe you, shoot you, take your bloody picture. Have a seat!'"

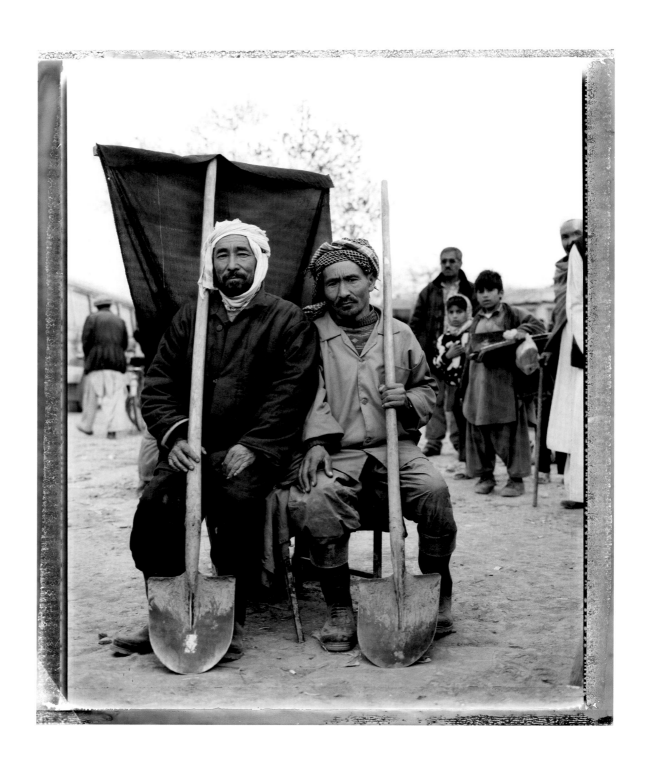

Stephen Dupont
Kabul, 2006
Gelatin silver print

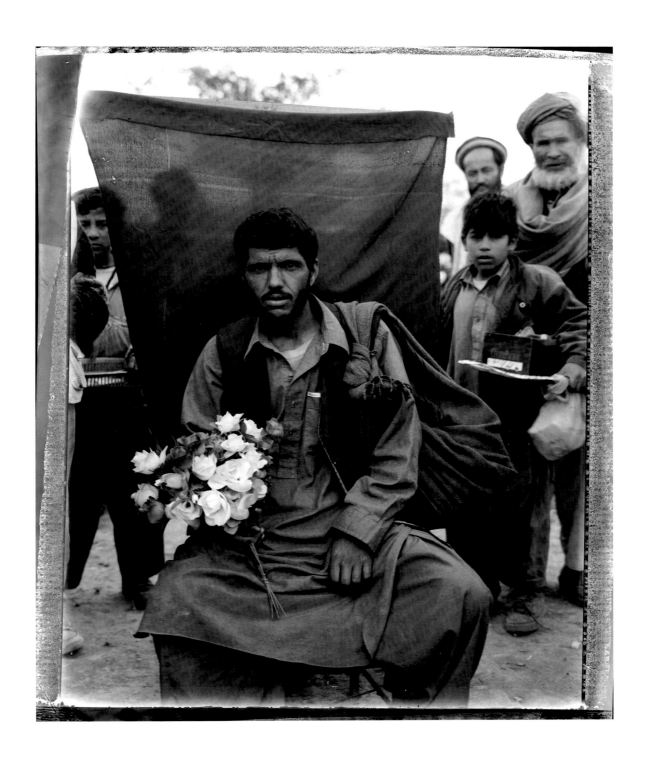

Stephen Dupont
Kabul, 2006
Gelatin silver print

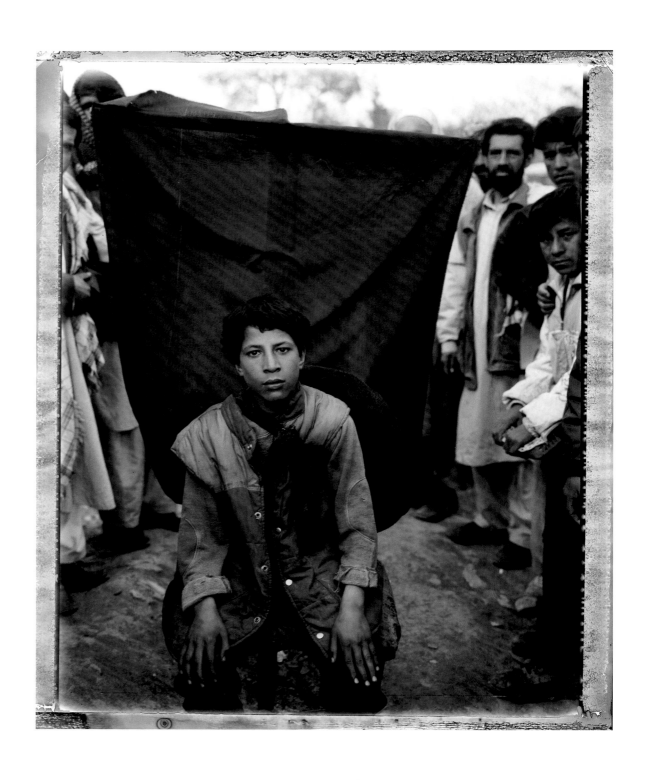

Stephen Dupont
Kabul, 2006
Gelatin silver print

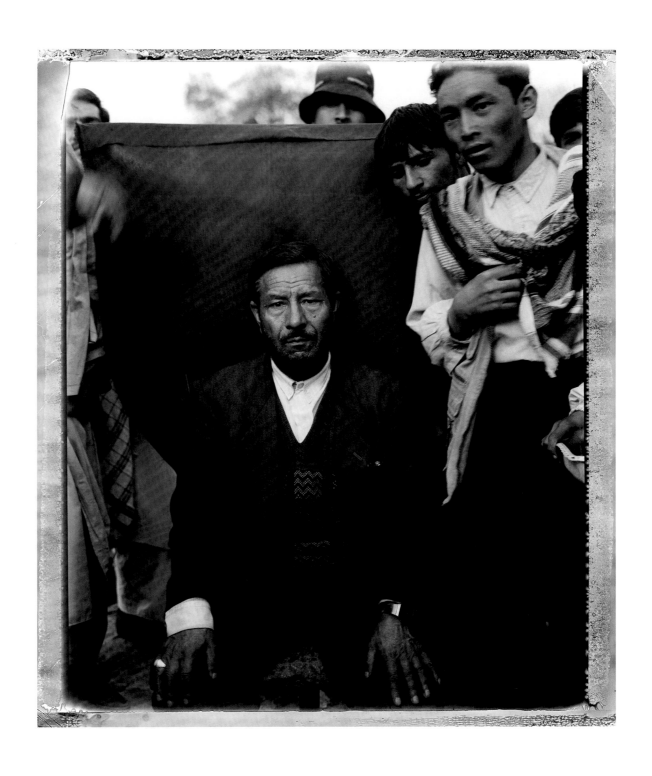

Stephen Dupont
Kabul, 2006
Gelatin silver print

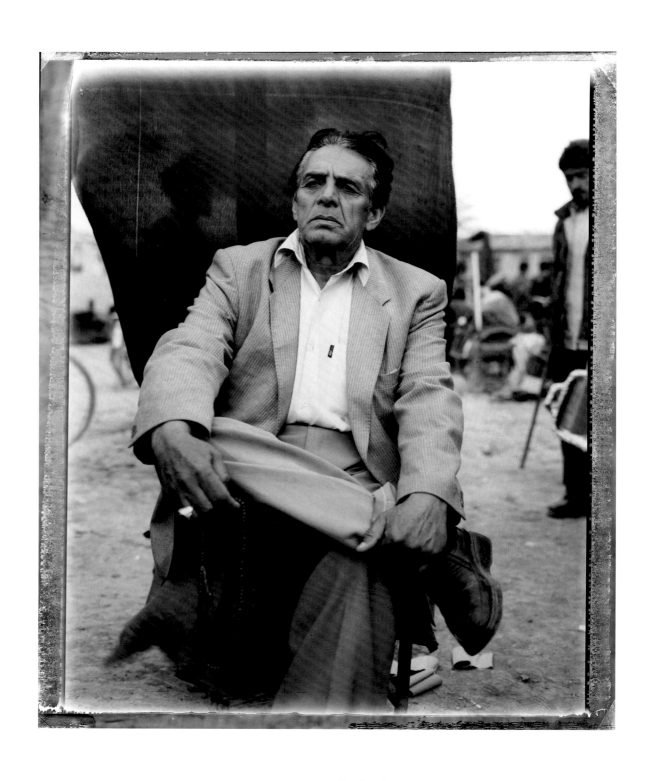

Stephen Dupont
Kabul, 2006
Gelatin silver print

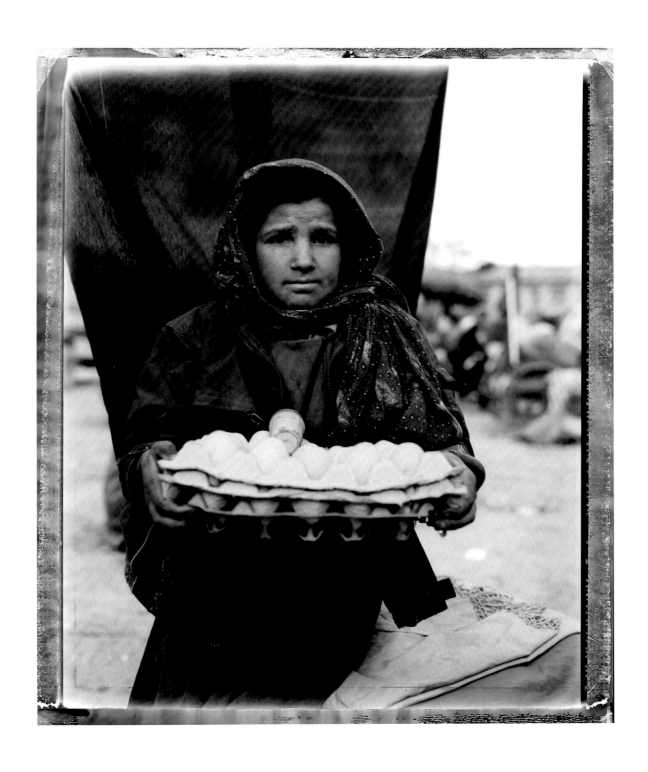

Stephen Dupont
Kabul, 2006
Gelatin silver print

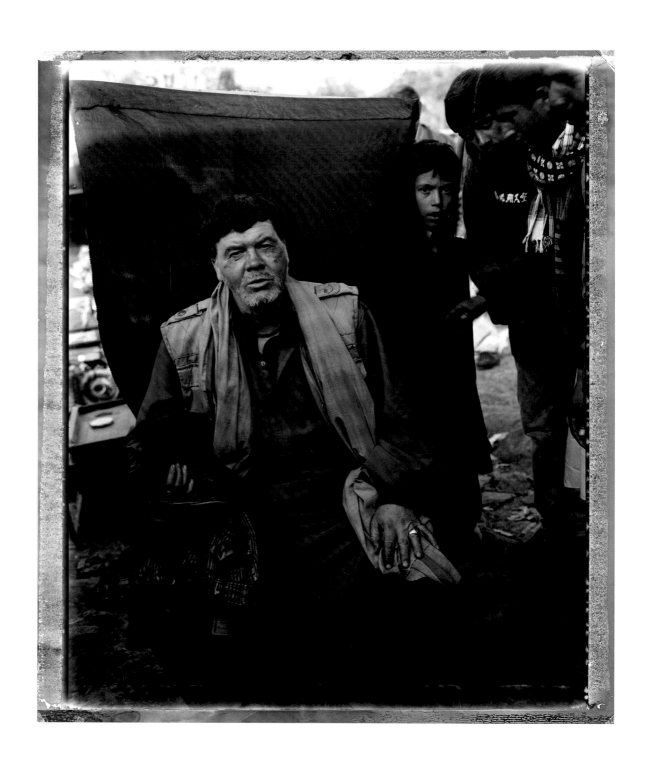

Stephen Dupont
Kabul, 2006
Gelatin silver print

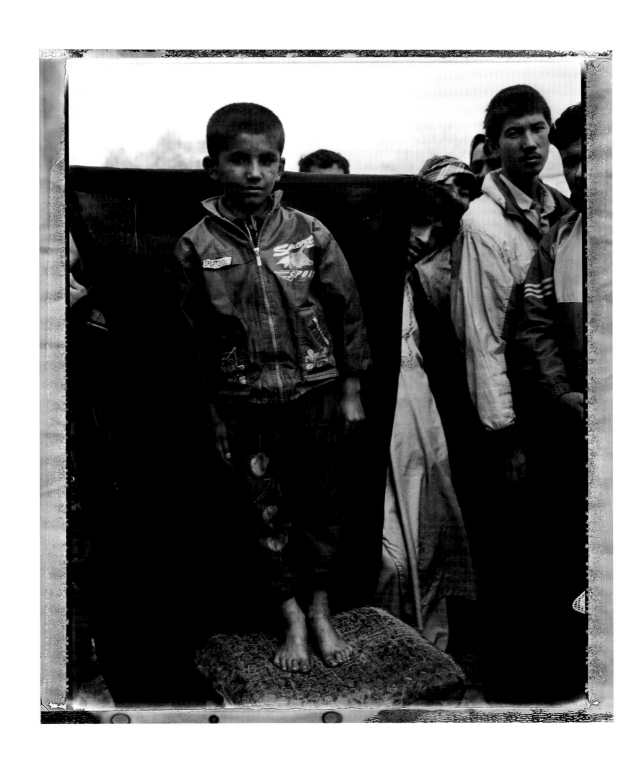

Stephen Dupont
Kabul, 2006
Gelatin silver print

Simon Norfolk

British

Photojournalist Simon Norfolk uses a large-format camera, similar to those used in the nineteenth century, to document distinctly modern terrains. This allows him to record the light, details, and mood of a place, alongside the remnants of battle that have shaped it. With an aesthetic that harks back to the European Romantic's love of ruins, Norfolk's photographs evoke a "military sublime." Warfare, not time, is the great avenger; the fragile transience of life is quickened by war's pervasiveness. Says Norfolk: "My photographs form chapters in a larger project attempting to understand how war, and the need to fight war, has formed our world. How so many of the spaces we occupy, the technologies we use, and the ways we understand ourselves are created by military conflict. Yet none of this is permanent. All empires rise and fall eventually."

Simon Norfolk
Date Grove along Haifa Street, Atifya,
Northern Baghdad
April 2003
Archival pigment print
From the series *Scenes from a Liberated Baghdad*
Loan and image courtesy of the photographer
and Gallery Luisotti, Santa Monica, CA

This grove was used as an artillery position.
Iraqi soldiers fled, leaving behind their boots and
other clothing.

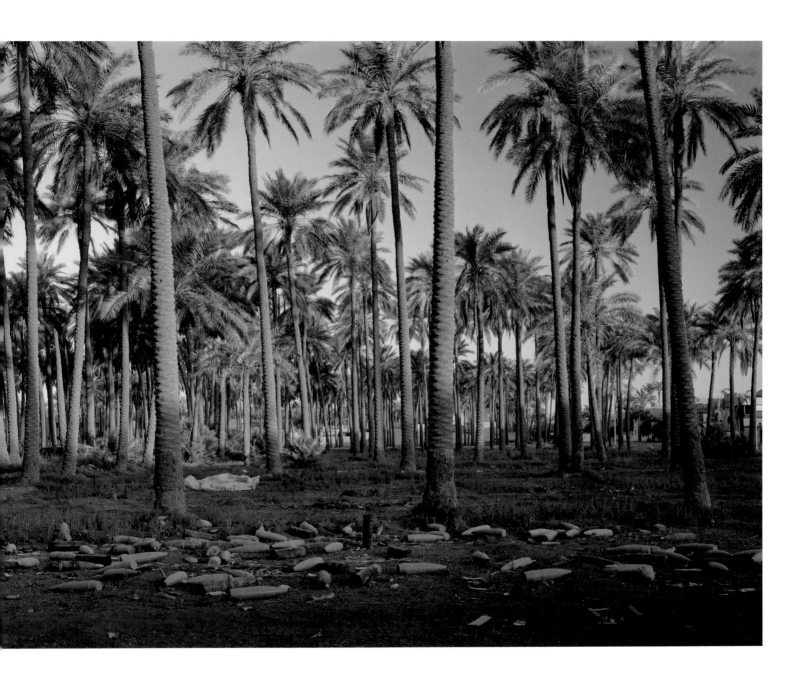

Warbreak

Outside the U.S. embassy, barbed wire imprisons everything:
empty lot with its chant of wildflowers
tired shadows of olive trees, broken sky.

Memory flaps like a bat in the attic.
We've been here before: war and coffee,
full-color photos in the glossies.

Only this time they're calling them
"decapitation strikes."
Every war needs a bit of variety.

Low sun flares its crimson light
across the land. It will rise again tomorrow,
vigilant and weary as hope.

—LISA SUHAIR MAJAJ

Simon Norfolk
Rusting Anti-Aircraft Canon Castings, Kohe Asmai,
Kabul, Afghanistan
Archival pigment print
From the series *Afghanistan: Chronotopia*
Loan and image courtesy of the photographer and
Gallery Luisotti, Santa Monica, CA

145

Simon Norfolk
The Illegal Jewish Settlement of Gilo, a Suburb of Jerusalem
2003
Archival pigment print
From the series *Israel/Palestine: Mnemosyne*
Loan and image courtesy of the photographer and
Gallery Luisotti, Santa Monica, CA

A wall has been erected to deter snipers from the
adjacent Palestinian village of Beit Jala (seen in the
distance). The Israeli side has been painted with the
view that would exist if there were no Palestinians and
no Beit Jala.

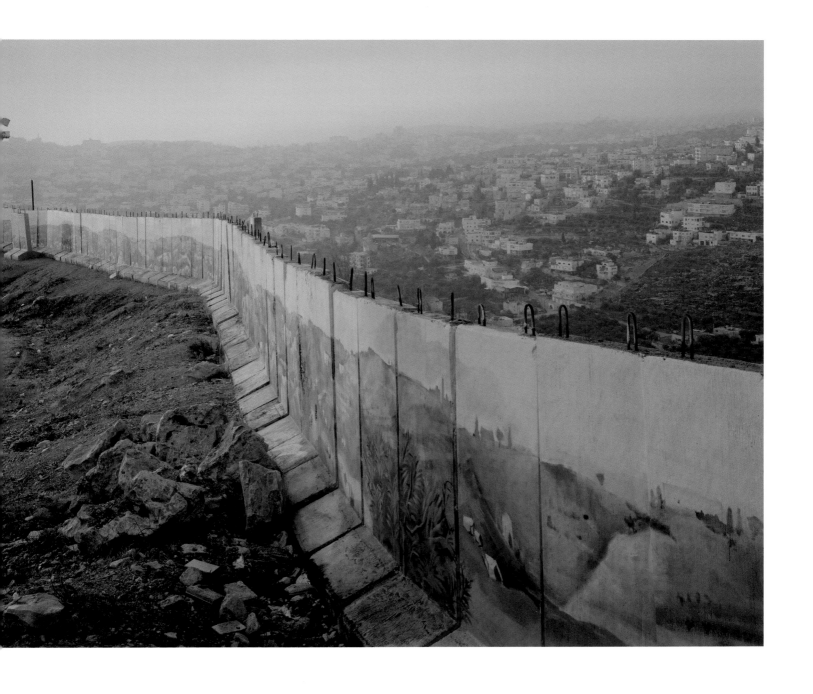

Simon Norfolk
Fidar Bridge, Bombed by the Israelis early
on 4 August 2006
Archival pigment print
From the series *Beirut: How did you come to smell*
of smoke and fire?
Loan and image courtesy of the photographer and
Gallery Luisotti, Santa Monica, CA

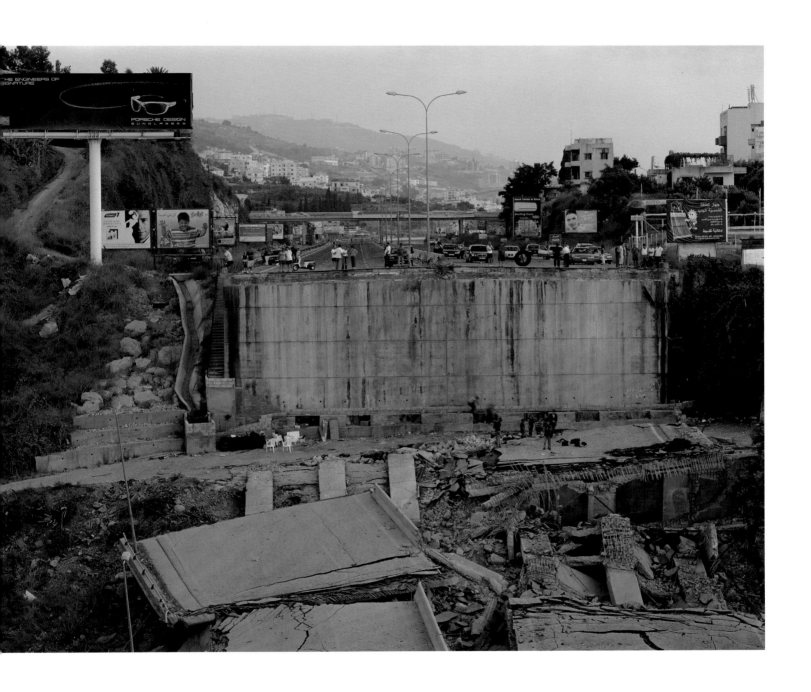

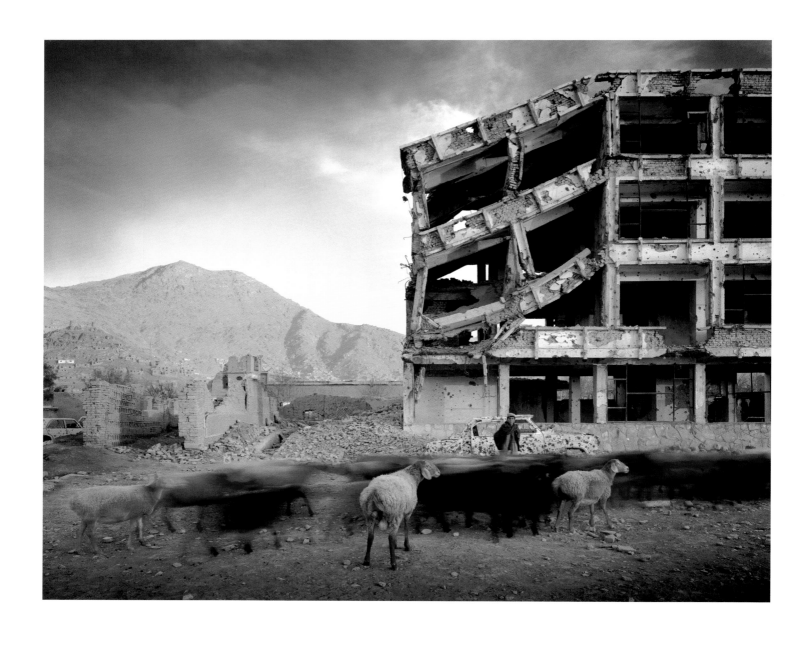

Simon Norfolk
*Bullet-Scarred Apartment Building and Shops,
Karte Char District, Kabul, Afghanistan*
Archival pigment print
From the series *Afghanistan: Chronotopia*
Loan and image courtesy of the photographer
and Gallery Luisotti, Santa Monica, CA

Simon Norfolk
Victory Arch in Bamiyan Built by the Northern Alliance
at the Entrance to the Local Commander's HQ
Archival pigment print
From the series *Afghanistan: Chronotopia*

These empty niches in the distance housed the
buddhas destroyed by the Taliban in 2001.

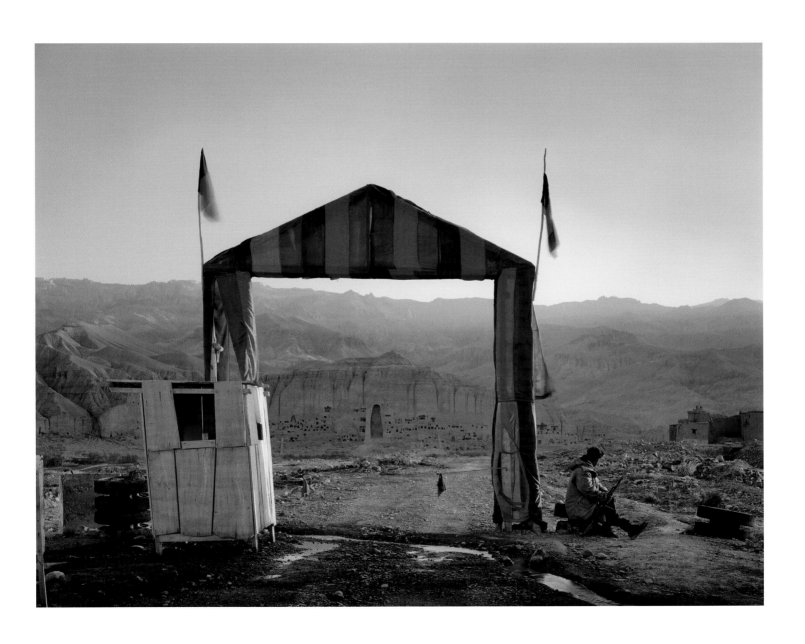

Living in History

It's true, whatever we do or don't do may come to haunt us.
Outside a man walks by: blue shirt, bald head. He blends
into the dusk, like the olive tree outside my window,
the blue-gray sky washed clean by recent rain,
the bird whose twittering heralds the evening.
May we all fit together like this: trees, birds, sky,
people, separate elements in a living portrait,
outlines smoothed by the forgiving wash
of lingering light. Whatever the skins we live in,
the names we choose, the gods we claim or disavow,
may we be like grains of sand on the beach of night:
a hundred million separate particles
creating a single expanse on which to lie back
and study the stars. And may we remember the generosity
of light: how it travels through unimaginable darkness,
age after age, to light our small human night.

—Lisa Suhair Majaj

Burke + Norfolk

Burke + Norfolk is a series created by Simon Norfolk. It combines photographs by John Burke (British, ca. 1843–1900), who documented Great Britain's Second Anglo-Afghan War (1878–1880), with Norfolk's contemporary images of the present Afghan war in 2010–2011. Norfolk takes his cues from Burke, reimagining or responding to Burke's Afghan scenes in the context of the contemporary conflict. It is conceived as a collaborative project between the two photographers across time.

John Burke

Nautch Girls. These dancing girls would have performed for the Amir in his private chambers and were a popular motif for Indian photographers like Burke. Because they are not Muslim women, they could take employment as dancers and could show their faces to foreign photographers. 1878–1880

Contemporary photograph made from original albumen print

Loan and image courtesy of Simon Norfolk and Gallery Luisotti, Santa Monica, CA and Wilson Centre for Photography

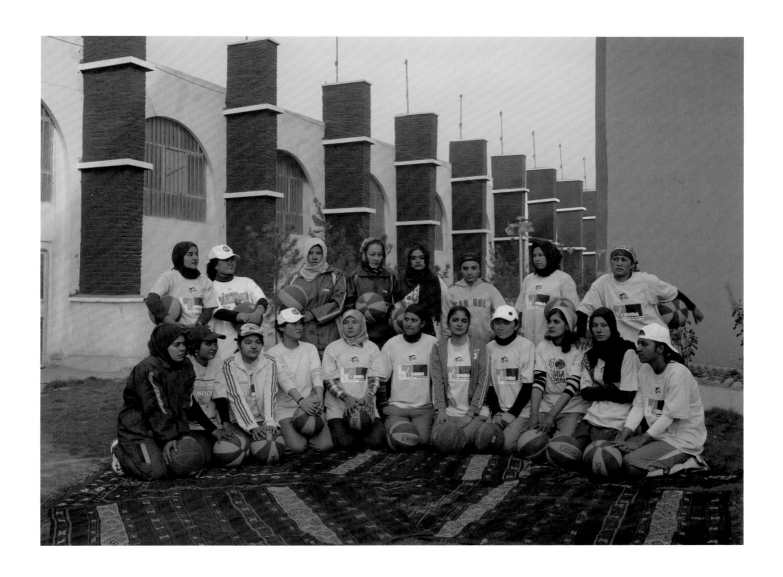

Simon Norfolk
Afghan Women's National Basketball squad.
2010–2011
Archival pigment print
Loan and images courtesy of Simon Norfolk and
Gallery Luisotti, Santa Monica, CA

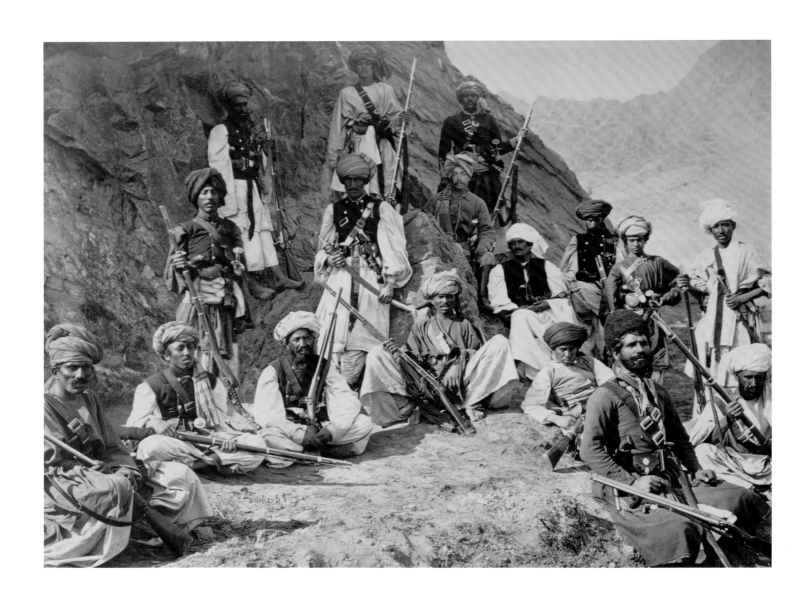

John Burke

Khan of Lalpura & Followers with Political Officer. At the back of this picture, hard to distinguish in his turban, is the British Political Officer Robert Warburton. With an Afghan mother and British father, and a fluent speaker of Pashto, he enjoyed a long, distinguished military career.

1878–1880

Contemporary photograph made from original albumen print

Loan and image courtesy of Simon Norfolk and Gallery Luisotti, Santa Monica, CA and Kodak collection/National Media Museum/Science & Society Picture Library

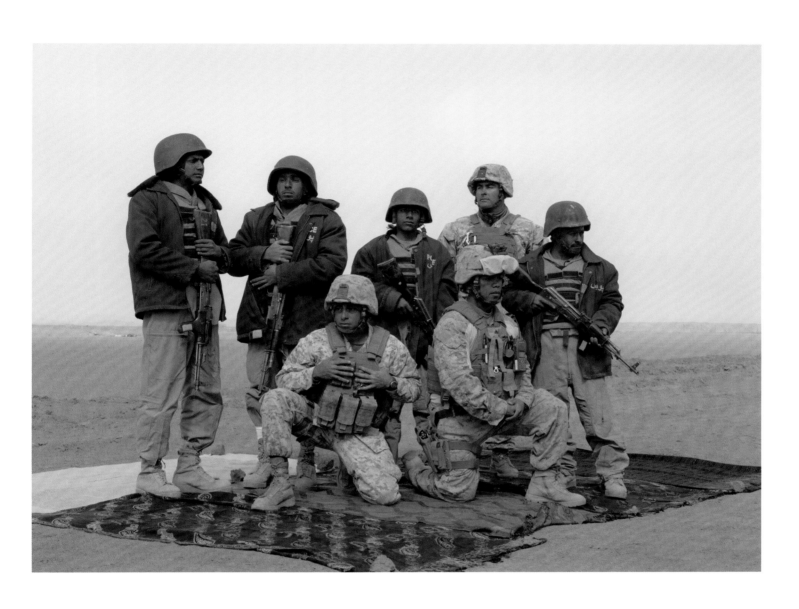

Simon Norfolk
Afghan Police being trained by U.S. Marines,
Camp Leatherneck.
2010–2011
Archival pigment print
Loan and images courtesy of Simon Norfolk and
Gallery Luisotti, Santa Monica, CA

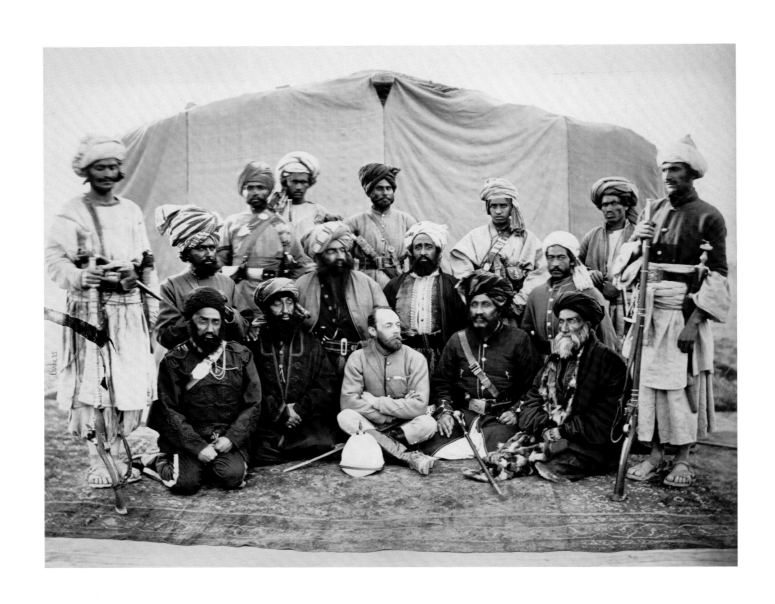

John Burke
*Major Cavagnari, C.S.I. and chief Sirdars
with Kunar Syud.*
1878–1880
Contemporary photograph made from
original albumen print
Loan and image courtesy of Simon Norfolk
and Kodak collection/National Media
Museum/Science & Society Picture Library

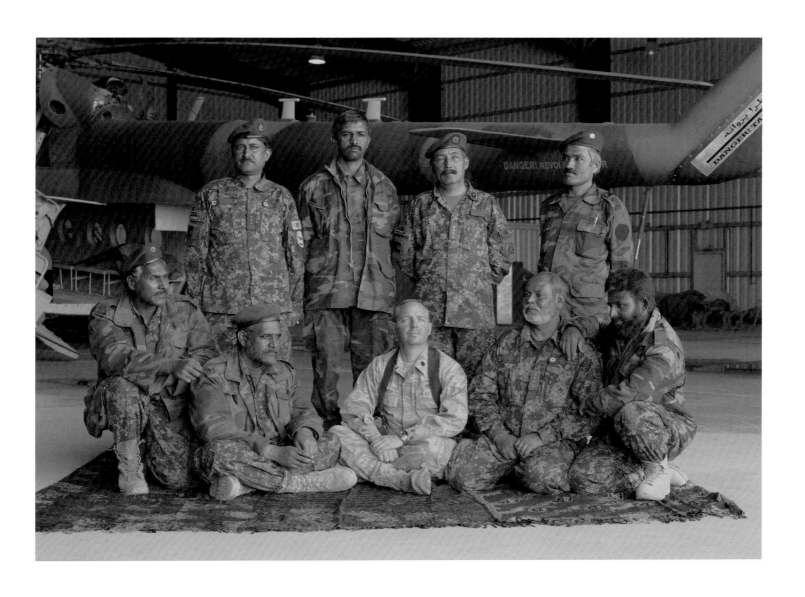

Simon Norfolk

*The future leadership of the Afghan Air Force
with Maj. Jason A. Church of the U.S. Marines
who is training and funding them.*

2010–2011

Archival pigment print

John Burke

Officers. (QO) Guides. The Queen's Own Guides, a battle-hardened regiment with a somewhat maverick reputation, were headquartered near to Burke's home in Murree. Veterans of many frontier campaigns, Burke would have known them socially and would have often photographed their parades and medal ceremonies. 1878–1880

Contemporary photograph made from original albumen print

Loan and image courtesy of Simon Norfolk and Kodak collection/National Media Museum/Science & Society Picture Library

Simon Norfolk

Young women in the indoor skatepark of the NGO 'Skateistan,' set up by American volunteers to help young Afghans improve their skateboarding and indoor rock-climbing skills.

2010–2011

Archival pigment print

John Burke
Landholders and Labourers
1878–1880
Contemporary photograph made from original
albumen print
Loan and image courtesy of Simon Norfolk and
Wilson Centre for Photography

Simon Norfolk
*A de-mining team from the Mine Detection Center
in Kabul with a member of the German Police who is
mentoring them.*
2010–2011
Archival pigment print

Michal Rovner

Israeli

Michal Rovner uses video, photography, and sculpture to express conflict, the cyclical nature of history, dislocation, and human interaction. Her newest images on LCD screens show figures slowly moving through an abstract landscape, ancient and contemporary, disturbing and reassuring. Who are these people, what land is this? Such details appear unimportant; the place and movement of people signal the human condition itself. Living on a farm in Israel, Rovner says, "I regularly see the processes of life sprouting from the ground and on to the land. Also, being in Israel, [I'm] always aware of the presence of history . . . and the presence of both construction and destruction. It's intense . . . encountering different layers of time . . . and feeling the footnotes of people and history. Sometimes I feel I'm just part of an archaeological era. It's wonderful, though, because there's a continuity in this" (from Alexander Glover, "Michal Rovner," *Studio International*, May 11, 2015).

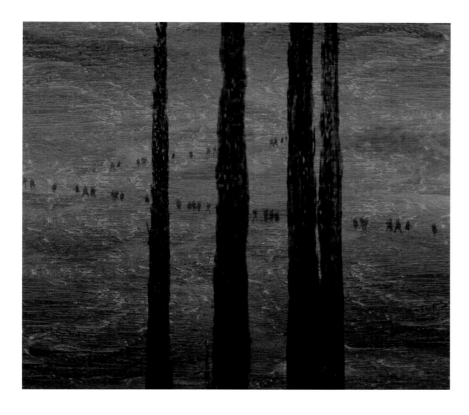

Michal Rovner
Shayara
2013
LCD screen, paper, and video
Loan and image courtesy of the artist
and Pace Gallery, New York
© 2016 Michal Rovner / Artists Rights Society
(ARS), New York

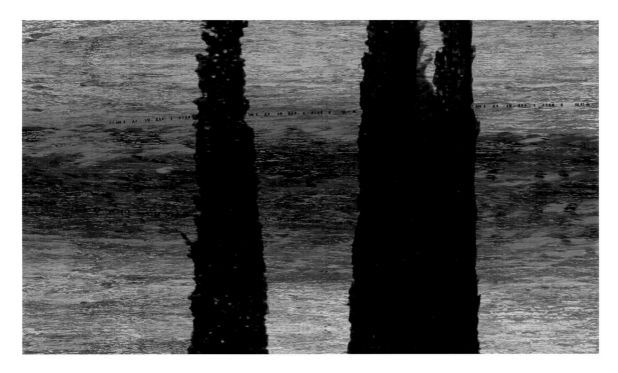

Michal Rovner
Tracing II
2013
LCD screen, paper, and
video
Loan and image courtesy
of the artist and Pace
Gallery, New York
© 2016 Michal Rovner /
Artists Rights Society
(ARS), New York

Jananne Al-Ani

Irish Iraqi

Shadow Sites II is a film that takes the form of an aerial journey. It is composed of images of a landscape bearing traces of natural and human activity as well as ancient and contemporary structures. Seen from above, the landscape appears abstracted, its buildings flattened and its inhabitants invisible to the human eye. Only when the sun is at its lowest do the features on the ground, the archaeological sites and settlements, come to light. Such "shadow sites," when seen from the air, map the latent images held by the landscape's surface. Much like a photographic plate, the landscape itself holds the potential to be exposed, thereby revealing the memory of its past.

Historically, representations of the Middle Eastern landscape, which provides the context for Al-Ani's film—from William Holman Hunt's 1854 painting *The Scapegoat* to media images from the 1991 Desert Storm campaign—have depicted the region as uninhabited and without signs of civilization. Responding to the military's use of digital technology and satellite navigation devices, *Shadow Sites II* takes an altogether different viewpoint of the land it surveys. As one image slowly dissolves into another, excavating what cannot otherwise be seen, the film burrows into the landscape like a mine shaft tunneling deep into a substrate of memories preserved over time (Sharmini Pereira, *Footnotes to a Project*, published on the occasion of the 2011 Abraaj Capital Art Prize).

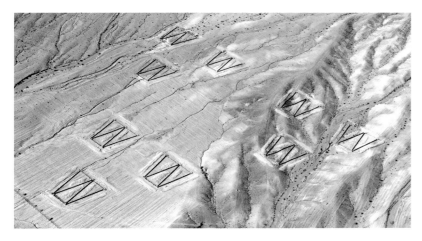

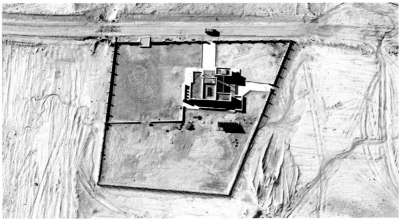

Jananne Al-Ani
Film stills from Shadow Sites II
2011
Single-channel digital video
Courtesy of the artist and Abraaj Capital Art Prize
Photography by Adrian Warren

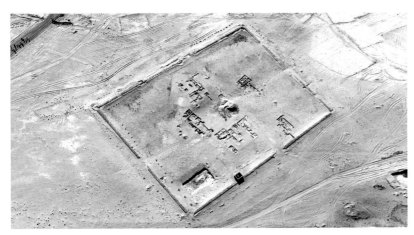

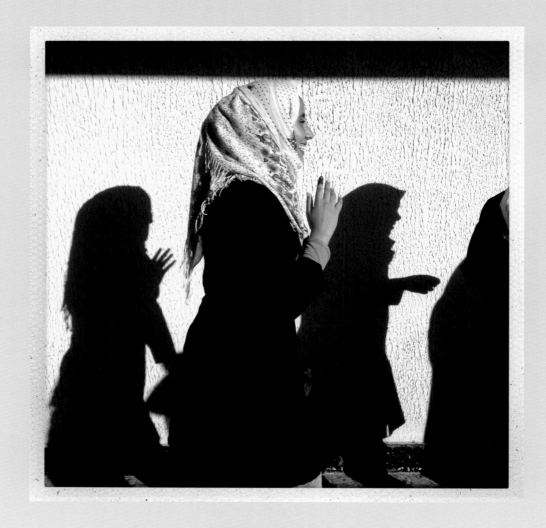

Ben Lowy
Women wait in line to vote in the first free Libyan elections in decades, July 7, 2012, Benghazi, Libya.
Archival pigment print
From the series *iLibya: Uprising by iPhone*

NOW WHAT?

CAROL MCCUSKER with MELANIE LIGHT

By now, the general feeling these photographs evoke may leave you feeling helpless. We invite you to channel your energy into action no matter how small.

Human suffering, human rights abuses, unchecked prejudices, and environmental degradation are the ingredients for recurring global disasters. Here is a list of ideas and practices that can steer despair and cynicism toward more positive outcomes:

VOTE. Each of us must participate and influence the outcomes of the future.

LISTEN. We become less fearful when we hear and better understand another person's story.

CHANGE THE CHANNEL. Get news from multiple sources and do your own research. Don't believe everything in the media.

READ. Educate yourself on environmental concerns, and current U.S. and world politics. America's presence around the globe in the last century has not always been honorable. What are the reasons for the resentment toward the U.S. from other countries?

LEARN FROM HISTORY. Man's inhumanity to man casts a long, bitter shadow. Can we learn an alternative to war?

REDIRECT AGGRESSION. More connection, less disaffection or antipathy.

Collectively, we face grave challenges that demand that we act. This is a critical time for people to come together and work toward the higher purpose of preserving life and peace on this planet.

Further Resources

Below is a list of resources related to the subjects discussed in *Aftermath*.

Books

Jimmy Carter, *A Call to Action: Women, Religion, Violence, and Power* (2014)

Mohsin Hamid, *Discontent and Its Civilizations: Dispatches from Lahore, New York, and London* (2015)

Leslee Goodman, "The Mystic and the Warrior: Radical Priest Matthew Fox on Loving and Defending Our World," *The Sun* (July 2015)

David J. Morris, *The Evil Hours: A Biography of Post-Traumatic Stress Disorder* (2015)

Matthieu Ricard, *Altruism: The Power of Compassion to Change Yourself and the World* (2015)

Phil Klay, *Redeployment* (2014)

Cihan Aksan and Jon Bailes, *Weapon of the Strong: Conversations on US State Terrorism* (2012)

Errol Morris, *Believing Is Seeing: Observations on the Mysteries of Photography* (2011)

Dexter Filkins, *The Forever War* (2009)

Kaja Silverman, *Flesh of My Flesh* (2009)

Leo Braudy, *From Chivalry to Terrorism: War and the Changing Nature of Masculinity* (2005)

Chalmers Johnson, *Blowback: The Costs and Consequences of American Empire* (2004)

Books (*cont.*)

Chris Hedges, *War Is a Force That Gives Us Meaning* (2003)

Jonathan Shay, *Odysseus in America: Combat Trauma and the Trials of Homecoming* (2003)

Susan Sontag, *Regarding the Pain of Others* (2003)

Gore Vidal, *Perpetual War for Perpetual Peace: How We Got to Be So Hated* (2002)

Websites

Breaking the Silence: http://www.breakingthesilence.org.il/

The Lysistrata Project: http://www.lysistrataproject.org/

Truthdig: http://www.truthdig.com/

World Beyond War: http://worldbeyondwar.org/

Films

Of Men and War (dir. Laurent Bécue-Renard, 2014)

The Return to Homs (dir. Talal Derki, 2013)

Standard Operating Procedure (dir. Errol Morris, 2008)

Battle for Haditha (dir. Nick Broomfield, 2007)

No End in Sight (dir. Charles Ferguson, 2007)

Iraq for Sale: The War Profiteers (dir. Robert Greenwald, 2006)

Control Room (dir. Jehane Noujaim, 2004)

The Fog of War (dir. Errol Morris, 2003)

Photographers

LYNSEY ADDARIO is an American photojournalist whose work regularly appears in the *New York Times*, the *Los Angeles Times*, *National Geographic*, *Time* magazine, and other media venues. Her work vividly portrays on-the-ground war and postwar conditions, most recently Syrian refugee camps and ISIS. She won the 2010 MacArthur Award, a Pulitzer Prize, and an Overseas Press Club Award, among others, and she is published and exhibited internationally. Her focus is on global freedom of the press, women's rights, and human rights.

JANANNE AL-ANI is an Irish Iraqi filmmaker working in London. She has exhibited at the Hayward Gallery (London), the Tate Britain, the Museum of Fine Arts, Boston, and the Freer and Sackler Galleries (Washington, D.C.), among others, and her work is in the permanent collections of the Victoria and Albert Museum, the Tate Modern, the Centre Pompidou, the Smithsonian Institution, and the Darat al Funun (Jordan). Her videos explore memories of the past specific to the Middle East. By gathering aerial landscape imagery, she reveals a land bearing the scars of history in traces of natural and human activity as well as ancient and contemporary structures.

STEPHEN DUPONT is an Australian photographer whose work captures the fragile cultures and marginalized peoples who exist in some of the world's most dangerous regions. His images have received international acclaim for their artistic integrity and valuable insight into peoples, cultures, and communities that have existed for hundreds of years, yet are fast disappearing from our world. Dupont has received a Robert Capa Gold Medal Citation, a World Press Photo First Prize, and a W. Eugene Smith Grant for his mindfully intimate and dignified depictions of his subjects.

JENNIFER KARADY is an American photographer with a focus on dramatized portraiture. Her work has been widely exhibited, and it has been featured on *PBS NewsHour* and National Public Radio, as well as in the *New York Times*, the *Los Angeles Times*, *Frieze* magazine, and more. Karady has won numerous awards, and her photographs are in the collections of the San Francisco Museum of Modern Art, Albright-Knox Art Gallery (New York), and the Palm Springs Art Museum, among others. Her series, *Soldiers' Stories*, pictures the psychological traumas faced by returning American veterans through portraits that allegorically reflect their experiences.

GLORIANN LIU is an award-winning photographer with a background in art education. For more than fifteen years, she has been traveling, photographing the many cultures and peoples of the Middle East, Central Asia, and Southeast Asia. Liu's work has been featured in solo exhibitions worldwide and included in a number of group exhibitions, one of which was held at the Los Angeles County Museum of Art. By taking risks, abandoning comfort, and establishing relationships with people before picking up her camera, Liu explores common misconceptions about the regions she visits and exposes the inherent goodness of people.

BEN LOWY completed his BFA at Washington University in St. Louis and began his career in 2003, covering the Iraq War. He has since covered major stories worldwide. Lowy has received awards from World Press Photo, Communication Arts, American Photography, and the Society for Publication Design. His work from Iraq, Darfur, and Afghanistan has been featured in the Tate Modern, the San Francisco Museum of Modern Art, the Houston Center for Photography, and Rencontres d'Arles, among others. In 2010 Lowy's *Iraq / Perspectives* won the Honickman First Book Prize in Photography. In 2012, the Magnum Foundation Emergency Fund enabled Lowy to continue his work in Libya, and he received the 2012 International Center of Photography Infinity Award for Photojournalism.

RANIA MATAR was born and raised in Lebanon, moving to the United States in 1984. Trained as an architect at the American University of Beirut and Cornell University, she studied photography at the New England School of Photography (Boston). Her work documents the personal and the mundane in an attempt to portray the universal. She has won numerous awards, and her work has been featured in several publications and widely exhibited in the U.S. and abroad. Her work is collected by the Museum of Fine Arts, Houston; the Nelson-Atkins Museum of Art (Kansas City); the George Gund Foundation; and the emir of Kuwait, among others. Matar returns to Lebanon regularly and, in 2009, she led photography workshops for girls in Lebanon's refugee camps.

EMAN MOHAMMED is the only female photojournalist working in Gaza today. Her documentation of the recurring conflict between Israel and Palestine has been published in the *Guardian*, *Le Monde*, the *Washington Post*, *Geo*, *Mother Jones*, and *Haaretz*. Mohammed has exhibited in New York, Dublin, Montreal, and The Hague, and her work is collected by the British Museum and other institutions. She is a TED Fellow, and she won the Special Prize Carmignac Gestion, among other awards.

SIMON NORFOLK is a prolific British photographer working internationally. He traverses both the mass-media and museum worlds, publishing in the *New York Times* and exhibiting at the Tate Modern. His work is collected by the Tate, the San Francisco Museum of Modern Art, and Deutsche Bourse/Frankfurt, among others, and he received the the 2004 International Center of Photography Infinity Award for Photojournalism and Le Prix Dialogue (Arles). Norfolk investigates the "battlefield" in all its forms, from war-torn cities to Middle Eastern histories to remote military sensing devices to war's environmental impact.

FARAH NOSH is an award-winning Iraqi Canadian photographer whose assignments include Iraq, Afghanistan, Lebanon, Pakistan, Syria, the West Bank, Gaza, and Egypt. Her work, which focuses on war's impact on civilians, appears regularly in leading international publications. Nosh was one of the few freelance photographers in Baghdad under the Hussein regime. Determined to draw attention to the plight of Iraq's civilians, Nosh traveled covertly around Baghdad, documenting wounded civilians as well as intimate daily life. The series *Wounded Iraq* was published in *Time* magazine and the *New York Times* and won her the Overseas Press Club award for feature photography. She has been exhibited in New York, Chicago, Los Angeles, Vancouver, London, and Dubai.

SUZANNE OPTON is an American photographer, an instructor at the International Center of Photography, and the recipient of a 2009 Guggenheim Fellowship. Her soldier portraits, icons of the aftermath of current wars, were presented as billboards in eight American cities and sparked a passionate debate about issues of art and military service. Her photographs are included in the permanent collections of the Brooklyn Museum; the Fotomuseum Winterthur (Switzerland); the Library of Congress; and the Museum of Fine Arts, Houston, among others. Opton's work lives on the edge between documentary and conceptual, asking for simple performance from her subjects as a means of illustrating their circumstances.

MICHAL ROVNER is an internationally acclaimed Israeli artist with more than sixty solo exhibitions at venues such as the Whitney Museum of American Art (New York), the Israeli Pavilion at the Venice Biennale, the Jeu de Paume, and the Musée du Louvre. She created *Traces of Life* for the Auschwitz-Birkenau State Museum and *Fields of Fire* and *Makom* at the Louvre. Rovner's work combines ideas of history, memory, and time that are sensitive to the diaspora of all peoples.

Contributors

DEXTER FILKINS is an American journalist who has written for the *New York Times*, *Miami Herald*, and the *Los Angeles Times*. His reporting on the wars in Pakistan and Afghanistan for the *New York Times* garnered him a Pulitzer Prize in 2009. His 2008 book, *The Forever War* (Vintage Books), received widespread acclaim from the *New York Times* and *Time* magazine, among others. *The Forever War* synthesizes Filkins's war correspondence in tracing the development of American relations with the Middle East. Filkins has been a contributing writer for the *New Yorker* since 2011.

KIRUN KAPUR grew up in both Honolulu and New Delhi and has lived and worked in North America and south Asia. She won the Arts & Letters Rumi Prize in Poetry and the Antivenom Poetry Award for her first book, *Visiting Indira Gandhi's Palmist*. Her poetry explores our most fundamental stories and enduring human bonds. Kapur is director of the New England arts program the Tannery Series, and she serves as poetry editor at *The Drum* literary magazine. Her poem *The Blade*, inspired by artist Moustafa Jacoub, was originally published by Broadsided Press.

AIDA A. HOZIĆ, PhD, serves as associate professor of international relations in the University of Florida's Department of Political Science. Hozić grew up in the former Yugoslavia, and she bases much of her current research on the overlapping political and economic causes of Balkan regional instability. She has described her body of work as occupying "the intersection of international political economic, international security and cultural studies." Her most recent book is *Hollyworld: Space, Power, and Fantasy in the American Economy*.

PHIL KLAY is a writer and U.S. Marine Corps officer who served in Iraq's Anbar Province from January 2007 to February 2008. Klay returned from duty to earn an MFA in creative writing from Hunter College in 2011. His collection of short stories, *Redeployment*, won the National Book Award for Fiction in 2014. *Redeployment* recounts his return to civilian life and addresses the lack of understanding between veterans and civilians in contemporary culture.

LISA SUHAIR MAJAJ is a Palestinian American poet and scholar whose works have appeared in various international literary and political contexts. Her collection of poems *Geographies of Light* won the Del Sol Press Poetry Prize in 2008. She has also co-edited three volumes of essays: *Intersections: Gender, Nation, and Community in Arab Women's Novels*; *Etel Adnan: Critical Essays on the Arab-American Writer and Artist*; and *Going Global: The Transnational Reception of Third World Women Writers*. Born in Iowa and raised in Jordan, Majaj focuses her poetry on universal nuances in the human experience in light of recent tragedies in the Middle East.

CAROL MCCUSKER, PhD, is curator of photography at the University of Florida's Harn Museum of Art. She was previously curator of the Museum of Photographic Arts, San Diego, and adjunct professor at the University of San Diego. McCusker has organized more than thirty-five exhibitions. She was juror for the 2010 International Center of Photography Infinity Awards, and she received a Center for Creative Photography Ansel Adams Research Fellowship, two National Endowment for the Arts awards, and a Warhol Foundation grant, among others. Her publications include *First Photographs: William Henry Fox Talbot and the Birth of Photography*, *Breaking the Frame: Pioneering Women in Photojournalism*; and *James Fee: Peleliu Project*; as well as numerous essays on landscape, portraiture, and the history of photography.

TERJE ØSTEBØ, PhD, is associate professor of religion and African studies at the University of Florida. Østebø previously taught in Scandinavia and Africa on the interactions between ethnic and universal religions in the twentieth century, and he has written and edited many books on this and other subjects that relate religion to the modern definition of identity, including *Muslim Ethiopia: The Christian Legacy, Identity Politics, and Islamic Reformism*. His work focuses on contemporary Islamic development in the Horn of Africa, notably in Ethiopia.

PHILLIP PRODGER, PhD, is head of Photographs for the National Portrait Gallery in London, where he curated the exhibition *Hoppé Portraits: Society, Studio and Street* in 2011. Prodger has held several curatorial posts including the Saint Louis Art Museum, the National Gallery of Canada, and the Peabody Essex Museum, where he was founding curator of photography. He has curated numerous exhibitions and is the author of fourteen books and catalogues.

Who sees all beings in his own self, and his own self in all beings, loses fear.

—The Upanishads (Sanskrit texts about the path to salvation, 800 BCE)